New Acrylics Essential Sourcebook

New Acrylics Essential Sourcebook

Materials, Techniques, and
Contemporary Applications
for Today's Artist

Rhéni Tauchid

Watson-Guptill Publications
New York

Jonathan Sugarman (www.sugarman.ca) was the photographer behind my first book, *The New Acrylics,* and is proud to be the image creator for a second time with this exciting new book. Jonathan, an avid photographer and art aficionado with a degree in graphic design, teaches photography and digital imaging at St. Lawrence College in Kingston, Ontario. He also runs Sugarman Design, a graphic design and photography business and Sugarman Imaging School, a private photography and digital imaging school.

Copyright © 2009 by Rhéni Tauchid
First published in 2009 by
Watson-Guptill Publications, an imprint of the Crown Publishing Group,
a division of Random House, Inc., New York
www.crownpublishing.com
www.watsonguptill.com

Library of Congress Cataloging-in-Publication Data

Tauchid, Rhéni.
New acrylics essential sourcebook : materials, techniques, and
contemporary applications for today's artist / by Rhéni Tauchid. -- 1st ed.
p. cm.
Includes bibliographical references and index.
ISBN 978-0-8230-9926-9 (pbk.)
1. Acrylic painting--Technique. 2. Artists' materials. I. Title.
ND1535.T39 2009
751.4'26--dc22

2009000415

Executive Editor: Candace Raney
Editor: Alison Hagge
Art Director: Jess Morphew
Designer: Patrice Sheridan
Production Director: Alyn Evans

Printed in China

First Printing, 2009

1 2 3 4 5 6 7 8 / 16 15 14 13 12 11 10 09

For my daughter.
If ever a muse there was, it is she.

ACKNOWLEDGMENTS

Throughout the process of producing this book, which was inspired by the success of *The New Acrylics,* I had the help of so many people and businesses, for which I am truly grateful.

I have been very fortunate to have the Watson-Guptill team's encouragement and unrelenting support in the push to produce this sequel. I am thankful, in particular, to Candace Raney's continued enthusiasm and faith in me over the years, despite all those lapsed deadlines. To Alison Hagge, my amazing editor, who finessed this work beautifully, making clear sense and giving flow to the heaps and heaps of information thrown her way, for calming me down, and giving me countless boosts along the way. I thank you big! Patrice Sheridan, the visual flow of the book is flawless and sophisticated. You wove my words and images into a piece of art.

Jonathan Sugarman, thank you first of all for your patience and humor, without which I surely would have crumbled. We make a great team, and your photos have defined the standard of these books. You are a super genius. Thanks to Grace Paulionis, for just being generally fabulous, and a fount of visual wisdom. Your help with styling the overall concept of the book and the photos is appreciated. A shout-out and thanks to Pamela Smith Hudson, who inspired (with great enthusiasm) the title for this book.

Big thanks to my family and friends, so many of you have helped in ways you may not even be aware of. I appreciate every one of you. Ma, Pa, and Sandy, thanks for being excellent parents and readers. Those of you who fed me, provided childcare and lots of walks, that help was invaluable. I am lucky to have such a great team of cheerleaders . . . Pid, Bretzke, Shari, Fellers, all of you!

My love for acrylics has been kept fresh by having the absolute luxury of being backed by Tri-Art, whose unrivaled acrylic products continue to inspire and fuel my work. This fortune in inspiration I owe fully to Steve Ginsberg, my paint champion, partner, and most stalwart supporter. A further thanks to Connie Morris, for your hard work, support, and ability to keep me laughing through even the toughest bits. Thanks also to the great folk at Jack Richeson & Company—those palette knives have changed my life. Also, thank you to the staff at Wallack's Kingston for their support. The help with research, and invaluable advice that I received from the Art Conservation Department at Queen's University, in Kingston was an integral part of creating this artists' resource. My particular thanks to Barbara Klempan and Alison Murray, who have added immeasurably to my acrylic education and validated many of my assumptions.

And finally, a heartfelt thank you to each and everyone who supported my first book, without whose interest this sequel would not have been possible.

contents

introduction

Acrylics, the Vanguard of Art Materials

I've tried to put this book together in a linear way, and it has defeated me at every turn. Mastering a medium like acrylics is not a linear progression—it is tangential and interconnected in ways that are impossible to map. Every section references the ones that come before and after it, the threads weave and connect continuously, every aspect of the paint and the paint methods are dependent on and influenced by each other. This book is an attempt at deconstructing master craft while remaining noncommittal on dictating style choices and thematic "landscape." As such, I have attempted to take a simplistic, almost narrow approach to each heading. So if you find this reference to be lacking somewhat in flow, I hope that you will find within its puzzle of pages abundant and useful information that will inspire while informing you.

What about painting a picture? How will this book help me do that?

If you are looking for step-by-step instructions on how to put together a painting, from a compositional point of view, or to hone your skills at rendering images, you may be looking in the wrong place. Nevertheless, do not dismiss material lessons out of hand. Realize that an adept, fluid handling of your materials is crucial to learned execution. Aside from inspiration, an educated hand and mind can be the most powerful tools you can bring to a fresh canvas. You may find that how and what you paint becomes significantly dictated by which materials you choose to use. A transparent color might have an undertone that screams to become the backbone of the painting—its chroma brought to its saturation zenith with just the right brush, amplified by a liberal swath of stained glass–like tinted medium, crested by sweeps of texture and crisp details. This is a conversation between disparate elements brought into harmony through deft handling.

Consider the sculptor who brings forth a form that "lives" in the stone or wood, drawn out by skill, patience, and a feel for the material. There could be a masterpiece lurking in that jar of paint or that pot of medium, waiting for you to coax it onto your canvas. You can bring it to life if you know how to use your tools. Do not undermine the imperative of materials knowledge.

How is this book different than your first book, *The New Acrylics*?

I had a thought about *The New Acrylics* as being a complete entity, in the same sense that an apple is a complete fruit entity. What this new book offers is an exploration of what that apple can become, or add nuance to.

The New Acrylics has the dubious subheading of being a "complete" guide to modern acrylics. While it is my belief that no exploratory text of this sort can be truly

Rhéni Tauchid, *Signatures*, 2006, acrylic and metal leaf on 300-lb. paper, 22 x 33 inches (55.9 x 83.8 cm). This demonstration piece features acrylic relief created by gelled stencils, collaged with gold and silver leaf, and enhanced with interference fingerprints and tidbits of acrylic "lace."

complete in the larger sense of the word, I do believe, however, that *The New Acrylics* offers a whole picture of modern acrylics—whole, or complete, in the sense, again,

Rhéni Tauchid, *Untitled,* 2006, acrylic on medium density fiberboard, 12 x 12 inches (30.5 x 30.5 cm). This demonstration piece showcases layers of acrylic glazes and washes, producing deep, resonant color. The simplicity of the composition gives full attention to the rich colorfield.

that an apple is complete as a stand-alone object. Within this new book, I offer up an in-depth exploration of the acrylic entity. To further the metaphor, I will examine the skin, the pulpy flesh, and the seed of the object.

What this sequel offers is an extended foray into the possibilities of that particular fruit, this acrylic medium. This is the cookbook that will show beyond what an apple *is*. It will explore what it has the potential to become—jam, jelly, juice, salad, sauce, liqueur, and so forth. *The New Acrylics* could not encapsulate the entirety of acrylic possibility; however, within these ensuing pages I hope to provide a substantial springboard toward that endeavor.

Do you consider yourself to be a master painter?

I'm aware that I may not necessarily meet the criteria of a master painter, but I am a lifelong acrylic painter, and because I also work professionally in the field of acrylic paint design and production, I do have an inkling of what it takes to be one—at least when it comes to the rudimentary groundwork. Establishing the groundwork is something that, in this age of the shortcut, we are prone to skipping, hoping it will all just work itself out eventually. That attitude—akin to the adolescent habit of cramming the Cliffs Notes and forging ahead half blind—is endemic to the cultural wasteland that modern art has the potential to become. Shortcuts form the norm in our everyday lives. Text messaging has broken language down to emoticons and acronyms, blockbuster films offer us abbreviated history lessons, and so forth. From ordering our coffee to mass emailing our entire address book holiday cards, we use a type of shorthand in almost every aspect of our lives. The art materials world has not escaped the shortcut infiltration. The percentage of painters who stretch and prepare their own canvases is dwindling, and the advent of the Giclée print has given artists easy status as prolific producers.

Gone are the days of junior artists learning through apprenticeships, or learning firsthand how to grind, mix, and produce their own materials. Art supplies now are available from a vast network of suppliers, easy to procure by clicking the computer mouse or buying off the shelves of the chain craft stores. The leagues of uninformed artists far outnumber those who have taken the time and effort to become informed. It is not necessary or required that what is considered to be successful art be backed up by experience and education. However, boosting these aspects will inevitably elevate the outcome as well as the artist's merit.

So how will I benefit from reading this book?

Whether you read this book page by page or take a more tangential approach, you will find here the bones, the muscle, and the flesh of how to produce an enduring work using modern acrylic paints. You will find that it is not merely an act of creativity but a process that is at once alchemical, environmentally conscientious, and experimental. Rooted in a base of science and tradition, making art with paint has never been this complex—or this much fun.

Chapter 1
the acrylic idiom

There is some rudimentary terminology, some words and concepts, without which a truly advanced understanding of acrylic paint cannot be achieved. If you have already been working with acrylics, you will no doubt be familiar with some of these concepts. In an effort to be thorough, I am outlining what I call the "magic words and concepts" to augment and perhaps drive home the absolute imperative of knowing your tools and the rules that govern their behavior.

Much frustration with, and misunderstanding of, the acrylic paint family can be dispelled once this base of knowledge is firmly set in place. Experimentation is all fine and good. In fact, it is necessary. Coming at experimentation from an informed place is what brings us toward a successful as well as innovative mastery of technique. It is what clearly distinguishes the artist from the dabbler.

Your tactile vocabulary will be built upon the following four terms: *viscosity, rheology, relative coverage,* and *luster.* Within each of these character groups there are two poles, and within the family of acrylic paints and mediums there exists the middles as well, what are referred to as the "semis." Knowledge of these referential values are required

"Improvisation can only take you so far if the groundwork is not solidly in place."

to becoming adept at properly understanding and manipulating acrylic paints.

In addition, I will present a number of other key terms. The concepts behind these words are not complicated, neither are they exclusive to the acrylic lexicon. However, gaining a thorough understanding of their place within this lexicon will increase your knowledge, and ability to wield it, a thousandfold. I'm not saying that one has to become an expert in fluid dynamics or polymer chemistry, but it will give your method greater focus to have and employ a cursory knowledge of the rudimentary aspects of acrylic paint.

Taken together, these are the basic terms around which process and technique are formed. Many of the missteps and accidents that occur during the composition of a painting can be avoided if the working properties of the material are kept clearly in mind. Without a firm handle on these aspects, you will be on stage with only half your script memorized—up the paint creek without a brush, so to speak.

Improvisation can only take you so far if the groundwork is not solidly in place. However, once you grasp these concepts, they will become second nature. All together, these "magic words" are your arsenal with which you can enter the acrylic painting arena with confidence and muscle, in the form of wisdom.

Viscosity

Thick → Thin

We begin with viscosity, as it is the most elementary concept. Thick to thin. Sounds pretty basic, but it is surprising how confusing viscosity can seem at first. This is mostly to do with the fact that *thick* and *thin* are not the words employed on the product labels. The words that are used are generally more accurate, but not as common, hence the occasional confusion.

Describing the viscosity of a material gives us a precise picture of its malleability and its mechanical properties within the parameters of a given technique or application. By contrast, a paint can be described as dense, which tells us that it has mass. However, this description will not tell us anything about how the paint moves, nor will it provide a clear picture of its handling properties. Therefore, *viscosity* is one of the magic words in the acrylic lexicon.

Viscosity is the measure of a material's resistance to flow. A high-viscosity paint or medium is generally thick. But to simply say that it is thick is an oversimplification—and often somewhat misleading. A paint can be thick, but then so can a wall, or a pile of whipped cream. Viscosity encompasses a material's movement as well as its density. The wall may be thick, but it is not viscous, as it is incapable of movement. The whipped cream, on the other hand, is thick and has a high viscosity as well.

There are various degrees of viscosity. For example, both a basic gel medium and a self-leveling gel medium can have a high viscosity. The gel medium, however, will hold a significant quantity of texture, whereas the self-leveling variety will hold none at all. (This is in part due to their rheologies, but more on that later.) The point is, they are both thick and are both considered highly viscous; however, they exhibit completely opposite rheologies.

And what about low-viscosity materials? Water is the bottom end of the viscosity meter and is considered to have none, although it does move. The difference is, it does not resist flow. Other thin liquids, oil for example, can be as thin as water but have a higher resistance to flow. This oozing quality is the manifestation of its higher viscosity.

There is more to it than that, of course, but for the purposes of this book, we only need to understand the mechanics of viscosity within the context of paint. On the shelves you will find both colors and mediums labeled as being high- and low-viscosity. What follows is a brief description of the various acrylic formats available to artists today.

Note: Viscosity is measured from high to low.

"Color is life and the life of color is everything to me. It must be vibrant, dynamic, and captivating. I want to have the highest-quality pigments that natural light can embrace. I want this strength of pigment to last and I need my vibrant paint to flow across my canvas. This is why I use and love acrylics."

—Olan

Opposite page: Olan, *Liquid Charlotte*, 2007, acrylic and mixed media on canvas, 48 x 48 x 1.5 inches (122 x 122 x 4 cm)

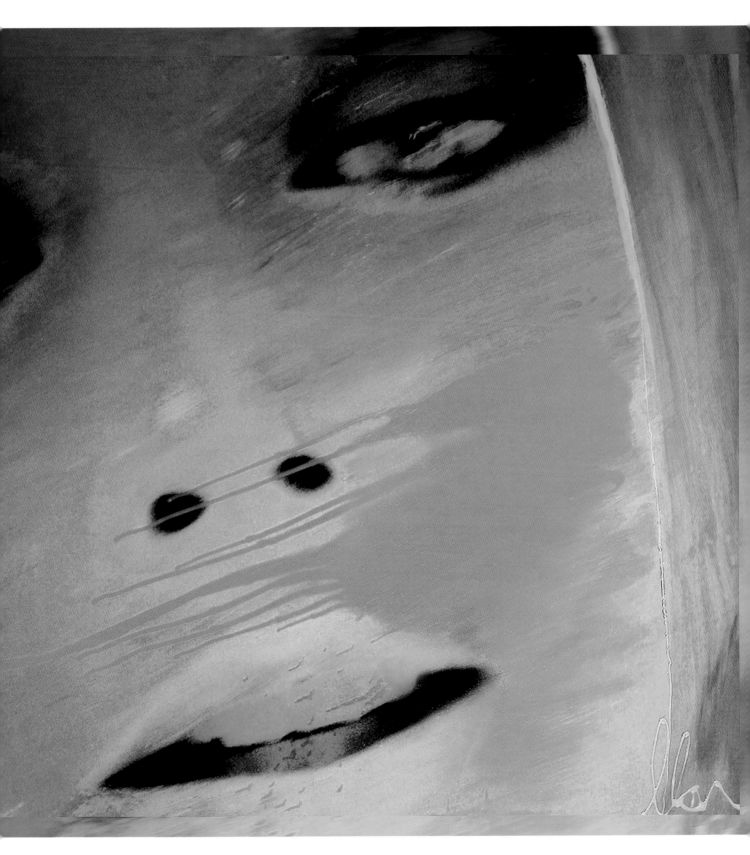

High Viscosity

This is the most familiar of the paint formats. However, it is not the most natural format for an acrylic paint. High-viscosity colors are pastelike, with a luscious, buttery feel, and they hold rigid textures. The higher the quality of the paint, the more saturated the color, and the more crisp the peaks and valleys when applying impasto textures.

Liquid

The liquid format acrylic paints, though currently not the most popular, are the purest form of acrylics. Formulated with just enough thickening agent to keep the mixture homogeneous and hold a modest texture, these flowing, low-viscosity paints are the simplest to formulate, and if you use a lot of mediums, the easiest to utilize. With the same or similar

(depending on the brand) pigment load as their paste counterparts, high-viscosity liquid acrylics can accommodate more painting styles than any other format. Their versatility, ease of use, and purity will likely eventually push them into place as the popular leader of acrylic paint formats.

Ink and Airbrush

These are the thinnest of the bunch, as they are designed to flow through precision tools. Having a viscosity similar to that of cream, acrylic inks and airbrush paints, at an artist-quality level, contain the same types of pigments as the more viscous paints, though some brands have a lower concentration. As some pigment can settle in very low-viscosity formats, they should be well stirred prior to use. Those with higher viscosities require tweaking of a different order and should be thinned with the accompanying medium, flow enhancer, or water before use.

Right: Although (from top to bottom) high-viscosity, liquid, and ink/airbrush acrylic formats exhibit dramatically different profiles, they maintain similar properties.

Celine Cimon, *Cloak of Blue Dawn,* 2001, acrylic on basswood, 9 x 50 x 3 inches (22.8 x 127 x 7.6 cm)

Low viscosity acrylics
as "liquid"
High viscosity - heavy body

UNDERSTANDING THE VARIOUS FORMATS AND PROPERTIES OF ACRYLIC PAINT

Accuracy in descriptive terminology is essential to fully explain the characteristics of a particular product. For this reason, I refer to low-viscosity acrylics as liquids. They are also commonly referred to as fluid, which is less accurate, as fluid can also refer to a gas (basically anything that exhibits flow). High-viscosity colors get to keep their name, though they are also commonly referred to as heavy-body or paste acrylics. Acrylic inks and airbrush colors are referred to as such and do not have alternative terminologies.

There is a time and place for everything, and a time when anything will do. That's pretty much the way it is with the variations on acrylic paint format. In truth, there is very little within their formulation, beyond viscosity, that differs. Some painters choose one over the other, usually depending on their preferred process.

Each format has its forte, but they are interchangeable and can be made to resemble each other in substance and appearance with minimal manipulation. Paint brands vary in their composition, thus I am describing these types of paints in fairly general terms.

The categories listed on the facing page describe the basic characteristics of each format and inform painters as to how and when to use each of them. This list should not be viewed as a rigid guideline, as its purpose is merely to illustrate the possibilities of the paints. Deviation from this guide is definitely possible and entirely encouraged.

Rheology

Rheology

mediums w/ short rheology (pert + perky)

Long Rheology (retreats into themselves)

Note: Rheology is measured from short to long.

Defined as the study of the deformation and flow of matter under applied stress, rheology is the best way to describe various behavior in acrylic paints and mediums. No other concept will give you as clear a picture of the tactile qualities of a medium, without physically getting your hands into it.

Remember the viscous regular gel and the self-leveling gel? The regular gel has a shorter rheology than the self-leveling gel, which has a long rheology. Think of it this way: If you dab a palette knife into a gel with a short rheology and then pull it up, you get a short, stiff peak that should retain its shape as it dries. The same action in a self-leveling gel will give you a long string of gel that will ooze back down into the gel and eventually level out completely. It is akin to comparing whipped cream with honey.

This is not a detail that you will see on a label, however, so as a general guideline here are the basics qualities for the various medium groups: Basic gels have a short rheology. Self-leveling gels have a long rheology. Gesso has a medium rheology. Modeling paste has a short rheology, as does a liquid medium. The rheology of every medium varies by degrees, so long, medium, and short are fairly vague terms.

If it helps, you can use less technical adjectives. Mediums with a short rheology are pert and perky, showing off with brash and dramatic textures. Long-rheology mediums retreat into themselves; they are selfish, secretive, mysterious, and seductive. However you choose to describe or categorize them, each medium, each color, each brand of paint has a rheology that is unique, giving you infinite possibilities for creating your paint surfaces.

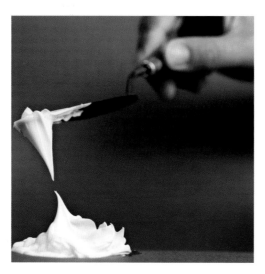

Regular gels exhibit a short rheology.

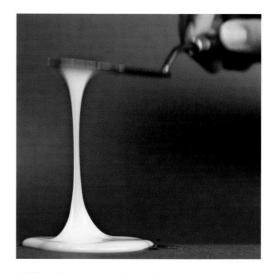

Self-leveling gels exhibit a long rheology.

Relative Coverage

Relative coverage is the technical terminology given to the measurement of transparency in a color—in other words, how well it covers (obscures) what is beneath it. Relative overage is listed in color charts and on paint labels, and it is crucial information for the painter. It's a simple formula:

T = transparent, SO = semiopaque, and O = opaque. Just about every paint manufacturer uses this universal legend to describe color. Among other things, understanding the covering power of a pigment helps us to place it in our process categories, facilitating our choices for various techniques.

Note: Relative coverage is measured from transparent to opaque.

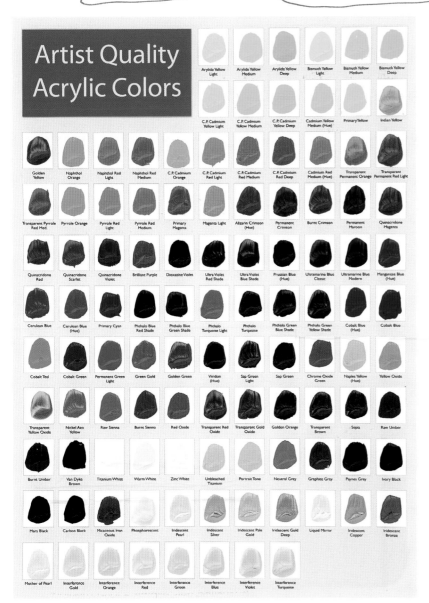

PY 42 (O)

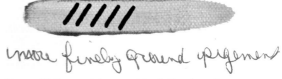

PY 42 (T)

more finely ground pigments

Above: Yellow oxide over black (top) and transparent yellow oxide over black (bottom). Both colors are derived from the same pigment. However, since the transparent version is much more finely ground, it imparts a richer chroma and transparency.

Left: A hand-painted color chart is a coveted item for most painters because it provides a clear, true taste of the manufacturer's colors. On product charts, colors are usually labeled with their relative coverage.

Luster

Acrylics are a lustrous material; it's what we put into them that modifies the surface—super shiny to soft satin or velvety matte. Matting agents, present in semigloss and matte mediums as well as in modeling pastes and other specialty mediums, are one component to the gloss factor of the paint.

When it comes to the colors, however, the pigments (or rather, the fine or coarse size of the pigment particles) impart their own characteristics to the paint surface. Manipulating the gloss factor of a surface is an easy thing with mediums, as they mix in readily with the colors.

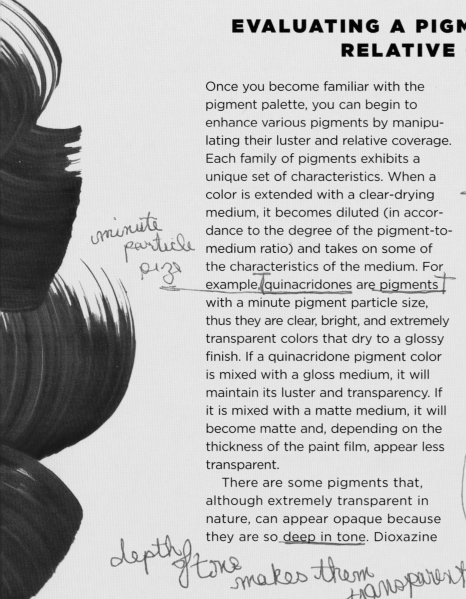

EVALUATING A PIGMENT'S LUSTER AND RELATIVE COVERAGE

Once you become familiar with the pigment palette, you can begin to enhance various pigments by manipulating their luster and relative coverage. Each family of pigments exhibits a unique set of characteristics. When a color is extended with a clear-drying medium, it becomes diluted (in accordance to the degree of the pigment-to-medium ratio) and takes on some of the characteristics of the medium. For example, quinacridones are pigments with a minute pigment particle size, thus they are clear, bright, and extremely transparent colors that dry to a glossy finish. If a quinacridone pigment color is mixed with a gloss medium, it will maintain its luster and transparency. If it is mixed with a matte medium, it will become matte and, depending on the thickness of the paint film, appear less transparent.

There are some pigments that, although extremely transparent in nature, can appear opaque because they are so deep in tone. Dioxazine violet is such a pigment. This fathomless violet is so intense, so profoundly dark, that in mass tone it is often mistaken for black. It is only through drastic dilution that its chroma can be fully drawn out. To maintain the intensity of a color with the addition of a medium, keep to a gloss format, and begin dilutions at around 20% to 50%. Generous medium-to-color mixes will take a considerable amount of time to clarify. Keeping a diligent record of dilution ratios for your favorite colors will save time when mixing glazes, and you will likely find that as you familiarize yourself intimately with them, you will develop a type of shorthand for your processes.

When acquainting yourself with new a color, to explore its scope, you can do a dilution test with both a clear medium and titanium white. This will help with every aspect of your color use—be it for creating washes, glazing, or a la prima applications.

minute particle size

depth of tone makes them transparent

Record dilution ratios

Nuances of a color. Transparent pyrrole orange in full shade, glaze, and wash. Both the full color and glaze are glossy, while the water imparts a matte appearance to the wash.

LUSTER AND RELATIVE COVERAGE

Acrylic Color	Luster	Relative Coverage	Acrylic Medium	Resulting luster (thin film) with 50% medium	Resulting luster (thick film) with 50% medium	Resulting relative coverage (thin film) with 20% medium	Resulting relative coverage (thick film) with 20% medium	Resulting relative coverage (thin film) with 80% medium	Resulting relative coverage (thick film) with 80% medium
quinacridone red	G	T	gloss medium	G	G	T	T	T	T
quinacridone red	G	T	matte medium	M	M	T	T	T	SO
chrome oxide green	SG	O	gloss medium	G	G	O	O	T	SO
ultramarine blue	M	T	gloss medium	SG	G	T	T	T	T
burnt umber	M	O	gloss medium	G	G	O	O	T	SO
burnt umber	M	O	matte medium	M	M	O	O	T	SO

LEGEND: G = gloss, SG = semigloss, M = matte; T = transparent, SO = semiopaque, O = opaque

IDENTIFYING THE PHYSICAL CHARACTERISTICS OF ACRYLIC

Continuing our scrutiny of the various terms critical to understanding acrylic paint, next come some physical characteristics that play an important role in acrylic behavior. The four key words here are *adhesion, absorption, volatility*, and *coalescence*. These terms are all interconnected actions that form the matrix of how acrylic paints perform and change. The paint first adheres to a surface. Next, the paint is absorbed into the surface. And finally, the paint releases its volatile components as it cures to form a coherent and successful paint film. These words are likely to be more generally familiar than the previous four, but let's take a look at how they are specifically used in the arena of acrylic painting.

Adhesion

This term is pretty straightforward, and usually it is used to refer to how well something will cling to the acrylic film, or vice versa. The best scenario is when acrylic bonds with more acrylic and the separate films coalesce, forming a single entity.

Absorption

In the context of supports as well as paint films, the porosity of the surface determines the rate and volume of evaporation. The volatile components in the paint evaporate upward and out of the film as well as through porous supports. The more absorbent the support is, the further into it the paint will sink, burrowing its plastic claws and holding tight as it dries. Good absorption increases the strength of the adhesion. Nonabsorbent supports provide a poor grappling ground with which the acrylic can bond.

Volatility

Volatile chemicals in acrylic paints are those that will evaporate from the film. A general definition of volatility refers to materials that are readily vaporizable; however, in the acrylic world two specific examples of volatile compounds are water and propylene glycol. Water is the most abundant volatile compound in acrylic paint, particularly with lower-quality paints (where the acrylic and pigment content is much lower and water and fillers are added to extend the paint). For the paint to cure and clarify, the majority of the water needs to evaporate. Propylene glycol, used as a humectant and as a freeze-thaw stabilizer, keeps the paint wet while it is being worked. As propylene glycol evaporates, the paint becomes less tacky and no longer workable. Other components, such as biocides and fungicides, are also present in the wet paint film. These, too, have to make their way out through the tiny channels formed by the exiting water.

Coalescence

This is the stage at which all of the volatiles in the wet paint have successfully evaporated from the film, the acrylic polymers have fully coalesced, and a state of permanence has been achieved. In other words, the paint film becomes "fully cured."

MASTERING THE CHEMICAL TERMS

Here are four more obscure chemical terms that, though not necessarily crucial to the painting process, may be handy to know when troubleshooting your working methods and identifying problems within the material itself.

Thixotropic

Thixotropic paints or mediums are those that will change (from a gelatinous state to a more liquid state) when agitated or disturbed. The tendency for an acrylic material to do this usually depends on the type of thickener used to amplify its viscosity. Some paints will maintain the same rheology no matter how vigorously it is manipulated with a brush or knife, while others will become more stringy or lose their ability to hold texture. In the domestic world, ketchup is a perfect example of a material that embodies this behavior.

Flocculation

It sounds like a dirty word, but it can actually be used in polite conversation. This is when components in a suspension separate, often causing the solids to coalesce, or amass, together. Once acrylic paint has flocculated, it is no longer possible to reintegrate them by mixing. Flocculated paint resembles cottage cheese, and it is virtually impossible to paint with. This problem can occur due to a sudden decrease in pH.

Hydrophobic

It means what it sounds like: to have an aversion to water. Pigments, for example, are hydrophobic. They are repelled by water and need to be forced into it. Add some sheer force and a dash of surfactant and pigment and water will put their differences aside and enjoy a harmonious and loving relationship.

Surfactant

These are the facilitators, the mediators, between the hydrophobic element and the water. They break down the barriers by lowering the surface tension of the water, and when it is thus relaxed, the pigment can make itself at home and will become enveloped, or wetted out, by the water.

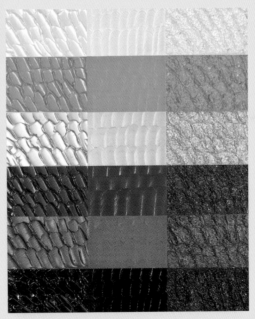

Neutral tones of acrylic paint can capture a wide range of textural detail, depth, and reflectivity. From top to bottom this chart features: iridescent pearl, neutral gray, iridescent silver, graphite gray, micaceous iron oxide, and Payne's gray. From left to right these colors are mixed with gloss gel, shown on their own, and mixed with extra coarse nepheline gel.

Chapter 2
the paint

Every now and then, when I have just finished giving a demonstration on the versatility of acrylic paint—having made it look like molten wax, created a mosaic, built a garment with it, or coated bagels in it (yes, I have done that, and no, it was not a particularly successful experiment)—I am faced with this question: "So . . . can I also just paint with this stuff, like, as in, a picture?"

Being so wonderfully capable of bending itself to our whim, acrylics have been too often touted as a gimmicky material, as if their only and best virtue is to perform the equivalent of art material carnival acts, rather than just settling down and behaving like proper paints. It is unfortunate that this, in fact quite cutting-edge and changeable ability is sometimes seen as a detriment, when it clearly is exactly the opposite. The problem lies in the fact that it strains the credulity of traditionalists that a paint can be really terrific at being a paint and at the same time can inhabit quite comfortably the guise of being something else entirely, and do it well.

Yes, you can "just paint" with acrylics, and when you are not busy doing that, consider the possibilities that acrylics offer you toward alternative applications. You will find that these most plastic of paints are capable of being molded to your creative whim. Let them take you further into your development as an artist—and along with this medium discover the breadth of your, and their, potential.

"Artists working with this medium need to do more than use it; they must seek to understand its essence."

Every great jazz musician is a technician first, and only with that can he or she take the craft to the place where it becomes great art. Within the contemporary art world, we have only to look back at the beginnings of the iconographic modern painters to experience a visual diary of their progression into the highest extremes of experimental, improvisational works. Pablo Picasso, Piet Mondrian, and other great modernists were obsessed with simplification and were the first to really push the acrylic medium and seek out a material that would bend to their will. Mark Rothko, Morris Louis, Helen Frankenthaler, and Paul Jenkins pushed the medium in groundbreaking ways.

In sculpture, Constantin Brancusi used to aspire to Auguste Rodin's oeuvre but went further toward seeking to reveal essence, illustrated by simpler forms in his revolutionary search for "pure form." Acrylics artists now, regardless of their choice of subject or path toward a certain aesthetic, owe it to themselves at one point in their creative evolution to explore the concept of "pure paint" and to gain from that exploration a crucial understanding of the fundamental aspects of their tool. Acrylic painters, to progress, must be in and of their time with respects to the changeability of their medium and evolve alongside it. In simple terms, artists working with this medium need to do more than use it; they must seek to understand its essence.

Material Integrity

Material integrity:
The quality of your paint materials—substance, substrate, and all additives

Within every art form there is a movement that pulls toward capturing the essence of the medium, when the painstaking effort of mastering the formal aspects of the process gives way to a form of improvisation whose target is to embody and bring forth the purest expression. The tools of art are the instruments through which this articulation is channeled. The more malleable, the more refined they are, the greater ease with which they can be used. Acrylics are such a medium—they are the crux of our modern materials evolution.

Artists' acrylic paints, in comparison to some of the more academic paints, come at a premium. There is a reason for these higher prices. The hidden costs of packaging and labor aside, it is the fundamental components of the paint that make up the price difference. In the finest-quality paints, the quantity as well as the caliber of the pigments are the primary contributors to their costs. Along with that comes the resin and additives, which are carefully balanced.

The finest-quality paints will contain more acrylic solids than their subsidiaries. A low-quality acrylic binder will contain a larger quantity of water, in addition to other fillers, in order to maintain the delicate liquid-to-solids ratio. The higher the acrylic content is, the better the adhesion factor, elasticity, superior clarity upon drying, and higher water impermeability. It is a simple tenet: Higher quality equals better performance.

The paint is but one component in the interest of working toward a well-constructed piece of artwork. Too often, we allow price to become an

"There came a point in my acrylic exploration when the paint began to move away, in increments, from the support. Evolving from working on back-lit paper, to Plexiglas and Mylar, I eventually did away with the support altogether. This painting was an homage to one of my favorite pigments, which had just been discontinued. The acrylic paint thus became both the substrate and the surface of the piece—a complete work of art, needing nothing but an armature to showcase its transparency, strength, and beauty."

—*Rhéni Tauchid*

issue when purchasing our supports, balking at what may seem at the time to be exorbitant prices. Let's keep in mind, however, that even in the highest cost brackets, the initial outlay for your materials is a very small fraction of the price for which most will ultimately be selling their artwork. Unlike food items, the ticket price on a painting has little to do with the materials with which it was created. This is set by size, the professional status of the artist, gallery percentages, current pricing trends, and so forth. What the artist should focus on when considering materials is that if a substantial price will be charged for the work, it should, at the very least, maintain its appearance for a significant period of time.

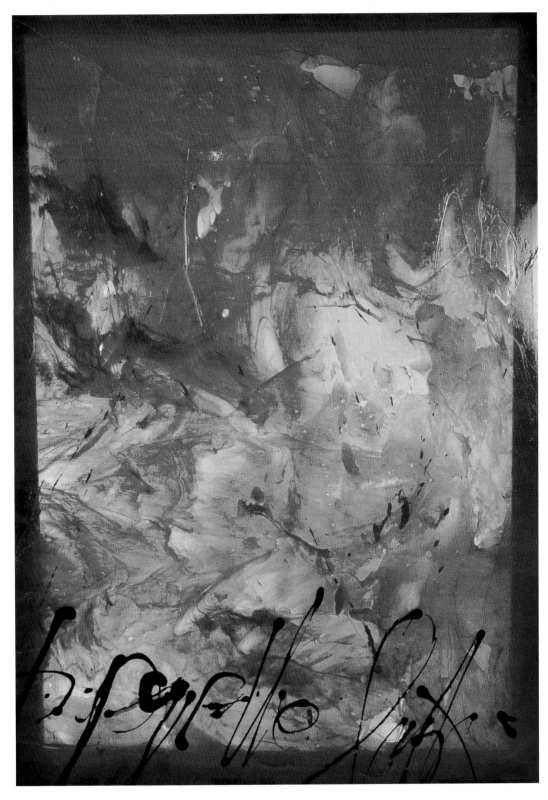

Rhéni Tauchid, *Ode to Pyrrole, Written in Light*, 2006, acrylic skin stretched over a wooden frame, 42 x 30 inches (106.7 x 76.2 cm)

Pigment Costs

In all artist-quality paint lines, and in some economy lines, colors are grouped by price, rather than by pigment family or hue. This is because the colorant price is the most significant factor in determining the production cost of the paint. For example, the price of a CP (chemically pure) cadmium red pigment is several times the price of the same quantity of red oxide. Pigment quantity per volume of paint varies from color to color, as adjustments have to be made to accommodate the various sizes of pigment.

Pigment prices are themselves a fluctuating quantity, yet within the retail art marketplace, their value needs to remain fairly constant. Price series are set entities, groups of colors bound by their similar cost. Titanium white, the single-most utilized pigment in the world, is the standard and classic "series one" color. No matter which line, which paint format, this color occupies the lowest cost bracket. A little known fact, however, is that in the world marketplace, titanium white pigment is a continuously fluctuating commodity, its price rising and falling several times in the course of a year. To change the price of something so entrenched would cause a public outcry, so manufacturers are forced to absorb the difference, regardless of the pigment's true cost.

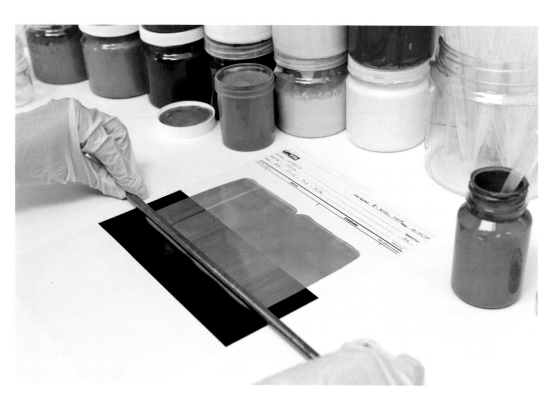

Quality-control color testing. In the labs of acrylic manufacturers, colors are tested for strength, dispersion, covering power, and color accuracy by being pulled onto a specially made paper with a precision-machined metal rod or bar. These "draw downs" are created for every color during various stages in development and testing, as well as to compare colors from batch to batch to maintain colors characteristics.

Fillers

The synthesis of materials that make up acrylic paints is a delicately balanced formula. For the paint film to be usable, remain stable, and coalesce into a solid film, a precise ratio of liquids to solids must be maintained. At the level of artist-quality paint, this combination is balanced and fulfilled by the sheer quantity of pigment and acrylic. Lesser-quality paints are produced by reducing both of these solids and adding more water. This bumps up the liquid factor and reduces the solids, which then have to be replaced. This is where and why inert fillers come into play. Without them, the paint fails on a chemical level. Adding one or more types of filler does bring the overall cost of the paint down, which is why they are used in the first place. Nowadays, some typical fillers used are calcite, silicates, and quartz, among others.

Obviously the more transparent these filler materials are, the less they will affect the chroma of the paint. Even the most translucent of these, however, will impart a certain matting effect to the paint, which is why student-grade acrylics are significantly less glossy than artist-grade paints. Artist-grade acrylics are fairly glossy, and in some cases the gloss factor of the colors will vary. When you see a fluctuation of sheen in a range of high-end colors, this is due to the characteristics of the pigments themselves. Unencumbered by fillers, the natural sheen of the pigments (which is dictated by pigment particle size) comes forth.

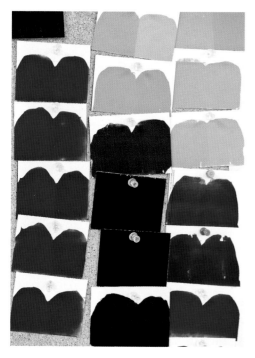

The daily "draw downs." This image shows side-by-side comparisons of color tests in the lab.

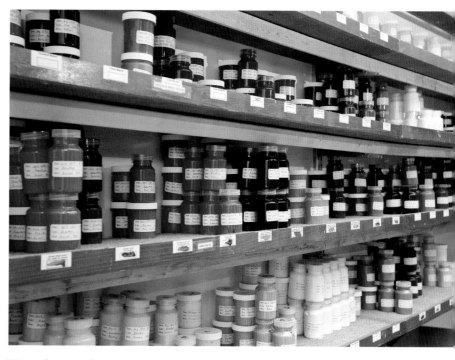

Wet color sample retains at an acrylic manufacturer. A retain of color is kept from every batch produced. This shelf represents a few months of production of student-grade paints. These samples are used for testing—both for when specific problems arise and for routine ageing tests.

The Colors

Note: Hue is measured from light to deep.

How you manipulate your tools can bring out the dual nature of colors—bright in their undertone with saturated darks in their mass tone.

The acrylic binder is so clear, so transparent, that it serves to amplify chroma, elevating colors to their full potentials. Acrylic paint is not so different than other color media, but the acrylic color palette has the unique quality of remaining clear rather than yellowing as it ages. It is rumored that acrylics do not enjoy the same pigment saturation level as oil paints. While this is true of them in their wet state, once cured, acrylic paints can and do hold as much pigment as oil paints. In the oil formulation, the oil and pigment quantities remain constant from wet to dry. The film changes from a fluid to a solid through chemical reaction with the air but does not shrink or lose mass. The acrylic dispersion, on the other hand, loses its volatiles as it cures. Water, glycol, and other volatile fluids emanate from the film as it dries and coalesces into a solid paint film, leaving the pigment tight in the grasp of the acrylic polymer binder. At this point the acrylic-to-binder ratio balances itself out and can be, in some formulations, as saturated as their oil equivalent. Regardless of how it stands up against other media, acrylic is an ideal vehicle through which to show off the nuances and characteristics of the wide array of modern and traditional pigments available to painters today.

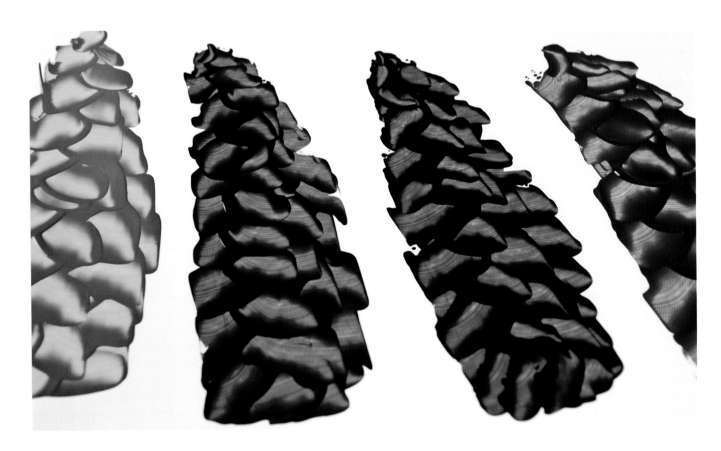

EXAMINING COLOR WORDS

As the vehicle through which mood is expressed and implied, color is elemental to the poetry of painting. On a more pragmatic level, color is a visual fact, and to explore it properly, it is necessary to grasp the vocabulary of color. The following words are the descriptive facets of color comprehension.

Chroma

Chroma: Purity, color depth

Chroma is short for chrominance. The chroma of the color is its intensity and saturation. For example, a finely milled pigment will exhibit a higher chroma than will a coarsely ground one. The color will appear more vivid, deeper, and more saturated.

Hue

Hue: Spectrum placement

The word *hue* can mean a few things. Most simply, it is another word for color. It also is used to describe the specific wavelength of a color, or our perception of it. It should also be noted that when the word *hue* is used with reference to a pigment (e.g., on a color product label) this implies that the product is mimicking the referenced pigment. For example, cobalt blue (hue) refers to a color that has been manufactured (from pigments other than cobalt) to have the appearance and working properties of that pigment.

Saturation

Saturation: Intensity

Saturation marks the vividness of a hue. The less saturated a color is, the less intense its appearance will be. Color saturation is determined by its intensity and depth. Desaturated color appears muted or faded. Reducing a color's saturation brings it to a neutral point of gray.

Value

Value: Lightness

The value is defined by the relative darkness or lightness of a color. Colors can have different hues but have a similar value. For example, certain shades of red and green, while distinctly opposed in hue, appear to be the same to someone who has a form of color blindness, because they have the same value. The addition of white or black to a color will increase or decrease the color value, respectively. Adding white creates a tint, while the addition of black produces a shade.

Though rich in chroma, transparent colors such as transparent pyrrole red medium and phthalo blue are fully transparent and ruthlessly staining.

PIGMENT CLASSIFICATION

Pigment Name	Color Index	Chemical Components	Pigment Classification	Hues and Color Names	Light-fastness	Relative Coverage	Gloss Factor	Price Series
arylide yellows	PY1, PY3, PY65, PY74	arylide	synthetic organic	yellow (light, medium, deep)	I/II (PY74 = I)	SO	G	L
bismuth yellow	PY184	bismuth vanadate	synthetic organic	yellow (light, medium, deep)	I	O	G	H
CP cadmium orange	PO20	cadmium sulphoselenide	synthetic inorganic	orange	I	O	SG	H
CP cadmium reds	PY108	cadmium sulphoselenide	synthetic inorganic	red (light, medium, deep)	I	O	SG	H
CP cadmium yellows	PY35, PY37	cadmium sulfide	natural inorganic	yellow (light, medium, deep)	I	O	SG	H
carbon black	PBk7	amorphous carbon	natural inorganic	black	I	O	G	L
cerulean blue	PB36:1	cobalt and chromium oxides	synthetic inorganic	blue	I	O	SG	H
chrome oxide green	PG17	chromium oxide	synthetic inorganic	green	I	O	SG	L
cobalt blue and green	PB28, PG26	cobalt and chromium oxides	synthetic inorganic	blue, green	I	SO	SG	H
dioxazine	PV23	dioxazine synthetic	organic	violet	II	T	G	M
graphite gray	PBk10	graphite	organic	gray	I	SO	G	L
indanthrene blue	PB60	indanthrene blue	synthetic inorganic	blue	I	SO	G	M
interference colors	N/A	metal oxide-coated mica	N/A	spectrum	N/A	T	G	M
iridescent colors	N/A	metal oxide-coated mica	N/A	metal colors	N/A	SO	G	M
iron oxides	PR101, PY42	iron oxide synthetic	inorganic	red, yellow	I	O	SG	L
iron oxides (transparent)	PY42, PR101	iron oxide synthetic	inorganic	red, yellow	I	T	G	M
isoindolinone	PY110	isoindolinone	synthetic organic	Indian yellow	I	T	G	M
ivory black	PBk9	amorphous carbon	natural inorganic	ivory black, bone black	I	SO	G	L
Mars black	PBk11	black iron oxide	synthetic inorganic	black	I	O	G	L

LEGEND: T = transparent, SO = semiopaque, O = opaque; G = gloss, SG = semigloss, M = matte; L = low, M = medium, H = high

PIGMENT CLASSIFICATION

Pigment Name	Color Index	Chemical Components	Pigment Classification	Hues and Color Names	Light-fastness	Relative Coverage	Gloss Factor	Price Series
micaceous iron oxide	N/A	micaceous iron oxide	inorganic	gray/black	I	O	SG	M
nickel azo yellow	PY150	nickel azo pyrimidine	synthetic inorganic	greenish yellow	I	T	G	M
ochers	PY42, PY101	iron oxide	natural inorganic	red ocher, yellow ocher	I	O	M	L
phosphorescent	N/A	phosphorescent	inorganic	light greenish yellow	N/A	T	M	M
phthalocyanines	PB15, PG7	chlorinated copper phthalocyanines	synthetic organic	blue, green, turquoise	I	T	G	M
pyrrole orange	PO73	pyrrolo pyrrole	synthetic organic	permanent orange	I	O	G	H
pyrrole orange (transparent)	PO73	pyrrolo pyrrole	synthetic organic	transparent permanent orange	I	T	G	H
pyrrole reds	PR255, PR254	pyrrolo pyrrole	synthetic organic	red (light, medium)	I	O	G	H
pyrrole reds (transparent)	PR270	pyrrolo pyrrole	synthetic organic	red (light, medium)	I	T	G	M
quinacridone orange	PO48	quinacridone	synthetic organic	yellow-orange	I	T	G	M
quinacridone red	PV19	quinacridone	synthetic organic	red, magenta	I	T	G	M
quinacridone scarlet	N/A	quinacridone	synthetic organic	scarlet	I	T	G	M
quinacridone violet	PV19	quinacridone	synthetic organic	violet	I	T	G	M
sienna	PBr7	natural iron oxide	natural inorganic	raw sienna, burnt sienna	I	O	SG	L
titanium whites	PW6	titanium dioxide	natural inorganic	white, unbleached, warm white	I	O	SG	L
ultramarine blue	PB29	soda, sulphur, aluminum	synthetic inorganic	blue	I	T	M	L
ultramarine violet	PV15	soda, sulphur, aluminum	synthetic inorganic	red shade, blue shade	I	T	M	L
umber	PBr7	natural iron oxide	natural inorganic	burnt umber, raw umber	I	O	M	L
zinc white	PW4	zinc oxide	natural inorganic	white	I	SO	G	L

Q&A: COLORS

What do manufacturers do when a pigment is discontinued? Artists ask, "Why is it gone? I use that color *all* the time. I *need* that color! Can't we just ask nicely to have it back?"

Unfortunately, it's not so easy. The amount of raw pigment used in the production of artist materials is a drop in the ocean of color production, a piddling amount in comparison to the massive quantities consumed by prodigious industries like plastics, automotive, industrial coatings . . . the list goes on. Pigments disappear as a matter of course, victims of the fickle waves in style trends. When demand for a certain color of car or wall paint dwindles, it no longer holds its place as a viable profit-generating product and is scratched off the production list. Sometimes it is a matter of natural resources running low, processes running at too high a price, or a combination of all of the above. At the art materials end of things, the effects can be disastrous.

When a specific pigment has been discontinued, manufacturers scramble to find a new source, and if that fails, the race is on to find an adequate replacement before stores of the original color are used up. This is not as simple as it sounds. First, there is all the testing to be done, particularly if this is a pigment used in production of multiple pigment colors. Masstone and undertone must be carefully tested, as well as its "mixability" with other colors. Pricing can be an issue, but for the most part manufacturers will

often absorb any difference to keep replacement colors in as close to the same price range as the original. Then there is the issue of literature—specifically, changing over all the data from labels, color charts, paint displays, brochures, websites, catalogs, and so forth. In the end, the amount of science, research, and the moving around of massive quantities of data that results in the discontinuance of a single pigment is astounding. As much as possible, manufacturers will match the pigment with something in the same pigment family. However, when this is not possible, a blend must be made from other pigment sources.

Acrylics are the vanguard of artist colors, ever on the evolutionary edge of new developments and trends. Are new colors simply variations on older themes? Are they necessary?

Sometimes. And perhaps. Sticking with the more traditional colors is not always the best solution. Oftentimes, painters choose colors because those were the colors their teachers used. This color list is passed down from generations of teachers, reaching back into a time when pigments like quinacridone and pyrrole simply did not exist as colors. It is time to break free of the classroom, put down the master list, and enter the new spectrum. It is the student's—and similarly, the emerging artist's—imperative to surpass our educators and embrace our full potential. When it comes to color,

these new hues deserve more than a cursory dismissal. Some of these pigments are improvements on older, more traditional pigments. For example, laboratory manufactured transparent iron oxides are rich and luminous pigments that hold a vitality and depth untapped in their original, opaque ancestors. Modern chemistry has made it possible for us to use and enjoy pigments of extraordinary brilliance, lightfastness, and chroma. So while some of the more geriatric choices are still fantastic pigments, there is a lot to be said for the new generation. They are developed not simply for color, but for longevity and exceptional quality. And they definitely merit a second look. In the case of pigments, what is new is usually what is better.

Which pigments will I not find in the acrylic palette, and why?

I was shopping at my local art supply retailer when I overheard a conversation about why a particular color was only available in a hue and not in the true pigment. So to clarify, here are a few answers to the most commonly asked questions about "missing" colors: Prussian blue is unstable in an alkaline environment, which is what acrylics are in their wet state. Manganese blue bears the same sensitivity and in addition is a particularly rare pigment. Another pigment that is not usable in the waterborne environment is Naples yellow, which also bears the unfortu-

nate characteristics of being expensive, rare, and rather toxic. Other lead-base colors—such as flake white and lead chromate colors (chrome yellow, chrome orange)— are not available in acrylic lines due primarily to health concerns.

Interference turquoise and interference red dance over phthalo turquoise and quinacridone magenta.

Glitterati

Note: If you have never used—and have no intentions of using—these shiny upstarts, skip this section and go straight to page 40 for a peek at their less flashy functions. You may be surprised to find that they can fit into your palette after all.

It's almost shameful how excited grown people can get over the shiny stuff. Sparkles, metallics, opalescent surfaces . . . they seduce us with their glow and glitter, and we are kids again, seeing the magic in reflections. There's a certain mystery that we connect to glimmer and shine.

The opulence of precious metals gives way to the impression that something has value, is rare and luxurious. There are iridescent colors in most acrylic lines, and those populating the artist-quality lines generally have a great deal of mica-based pigment in them, producing colors with mercurial sheen and shimmering color. These are specialty pigments, what the die-hard traditionalists would call "nonessential" colors. For some, however, they form the backbone of the palette, upon which the other hues can dance.

Detailing with these colors gives a different effect altogether. The gloss pulls them forward, drawing the eye while catching the light. A dry sweep of metal cresting the wave of impasto paint pulls the texture into clearer focus, pinpointing ridges and valleys that can otherwise get lost in a colorscape. Garishly kitsch or delicate and subtle, these gems can impart a dimensional quality to a surface. Their very reflectivity can transform a flat composition to what can look like burnished metal.

Piles of epoxy-coated Mylar sparkles wait (on a ground of tinted, self-leveling gel and spectral color) to be added to an acrylic medium or composition.

Iridescent

Iridescent colors, in the acrylic palette, are the metal tones. Produced with a combination of mica platelets and pigment, these colors have the appearance and sheen of metal and pearls. They are semiopaque to opaque, and though they look like molten metal, they behave like any other color on the palette. What can be achieved through their use, however, takes them into a separate category, where they join the rank of a medium—in the sense that a medium has the ability to modify the characteristics of a color by manipulating its luster.

The reflectivity of these colors imparts a deep sheen, an earthy resonance to transparent colors. Used as detailing paints, an iridescent color pulls the eye forward as the light catches on its surface. As underpaint, they illuminate the groundworks, adding a rich depth to glazes. A dash of iridescent color imbues a glaze with a provocative glimmer, adding an opulence to a surface. However they are used, these types of colors suffuse a painting with depth and luminescence.

Interference

Interference colors have an "ooh" factor. These are mighty unusual pigments, and whether you use this sort of thing or not, there is no denying their allure. They are definitely difficult to ignore, as they flash from the color charts with a lustrous changeability that captivates the eye. The play of light created from these pigments poses a challenge to painting technique and color mixing while at the same time opens up fresh possibilities for unusual painting methods.

Left: These two images show the effect of interference turquoise mixed into dioxazine violet when viewed from two different angles.

Right: These two diagrams illustrate the passage of light through iridescent and interference pigments. Though similar in composition, the two varieties of pigments display very different optical properties.

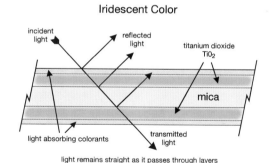

Iridescent Color

incident light / reflected light / titanium dioxide TiO$_2$ / mica / light absorbing colorants / transmitted light

light remains straight as it passes through layers

Interference Color

• Angle of observation for the color.
• At all other angles the diffused complement is observed.

incident light / reflected light / titanium dioxide TiO$_2$ / mica / light bends as it passes through layers / transmitted light

Liquid Mirror

Crazily reflective, Liquid Mirror, a color exclusive to the Tri-Art Finest Quality Acrylics line, adds a new level of brilliance to the acrylic color palette. Almost platinum in color, Liquid Mirror changes to a mercury tone when coated with a layer of high-gloss, self-leveling acrylic. This whisper-fine pigment, applied in a smooth, continuous film, when so glazed, exhibits the reflectivity of chrome.

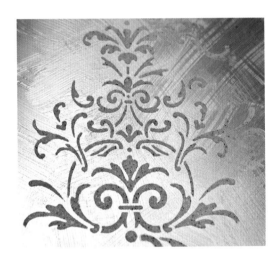

Left: A play of contrast between two neutrals. Liquid Mirror paint decorated with a stencil of nepheline gel.

Right: Liquid Mirror is platinum in color and hyper reflective, particularly when it is coated with a generous layer of clear medium.

Micaceous Iron Oxide

This is a singular color, unlike anything else in the acrylic palette. It is at once a texture medium, a dry-media ground, an iridescent color, and an unparalleled neutral tone. No other color crosses over into so many arenas, yet remains distinct.

The unique physical appearance of micaceous iron oxide makes this pigment a standout from a surface point of view, but it should be noted that along with its sparkly coat, it has many invisible assets. The lamellar quality of the pigment particles provides an extremely effective barrier to UV penetration and corrosion. In fact, this pigment is used to protect metal structures from the ravages of the environment. The next time you visit the Eiffel Tower in Paris or the Tower Bridge in London, take a closer look at their surfaces, as both are coated with this pigment.

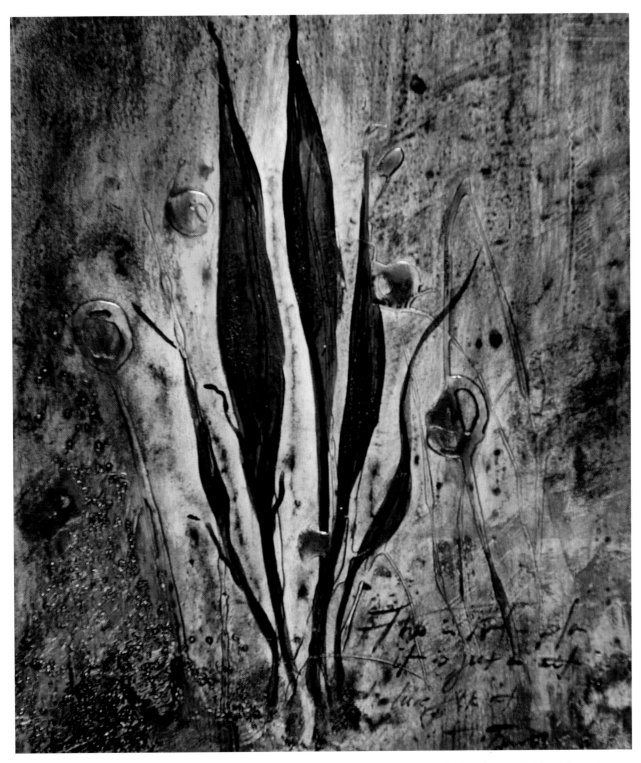

Rhéni Tauchid, *Sprout,* 2008, acrylic on Sintra board, 6 x 4 inches (15.2 x 10.2 cm). This demonstration piece shows how thick and thin mediums, micaceous iron oxide, and lush, organic colors can be used in tandem to create striking effects. In my painting demonstrations I generally stick to abstract forms, as they simplify things. However, in some cases I find that adding recognizable shapes helps to anchor the composition.

ACHIEVING GLAMOUR WITHOUT THE GLITZ

We are not all fans of the ostentatious bling of iridescent and interference colors, and many dismiss them out of hand as facile gimmicks to spice up otherwise ho-hum paintscapes. Nevertheless, do not underestimate their more subtle selves, the subsurface boosters of light that can add nuances of depth and reflection that can heighten the substance of the paint film without being blatantly overt.

Underpainting with metallics is a fantastic way to bring added reflectivity into a painting—a base upon which rich translucent glazes can be layered. Where the traditionalists support the use of a white ground for generating maximum light output, adding some punch to that can only help, rather than hinder. Light bounces off of that backdrop with amplified intensity, while the veils of color tone down the brash glare, giving surfaces an elusive depth, even after repeated glaze applications.

Sometimes a dash of glitz can transform any color from drab to bright. The trick is in being light handed while mixing. Too much iridescent or interference color will turn your mix to a pearlescent or opalescent version of itself. A conservative pinch, however, can bring just the right amount of "light" into the color

to lift it almost imperceptibly, so that it pushes forward in a composition or gives a glaze an added glow. Likewise, a wash created by mixing a pinch of interference color to the base color will exhibit a touch of the interference shade while keeping the chroma of the color center stage. Though camouflaged within the color wash, the interference color can add a delicate echo to other colors in the painting, unifying the composition.

Matthew Haffner, *Stray,* 2007, silver leaf, vinyl, and spray acrylic on panel, 32 x 72 inches (81 x 182 cm)

"My paintings explore ambiguous, urban narratives. The spray paint stencil technique that I use is rooted in graffiti, but is made exceptionally more complex because I incorporate up to seven unique stenciled layers to create a multitonal effect. First, I use acrylic and medium sprayed through an airbrush to create the stenciled figures. The acrylic paint dries quickly, which is a great advantage when applying multiple layers of paint to build up the images. This imagery is then combined with various materials, such as vinyl and silver leaf, to reference both photography and street art."

—Matthew Haffner

Chapter 3
the mediums

"Acrylic paint, the

consummate

mimic,

metamorphoses

into all the things

it isn't."

One of the most frustrating aspects of exploration and advanced education in the acrylics field is the concept of mediums. Not because they in and of themselves are difficult to comprehend—that is only part of it—but the largest block against understanding mediums is that they are too often portrayed as something *other* than acrylic paint. The truth of it is mediums are as much acrylic paint as a color is—perhaps even more so. Why do I say this? Because mediums are more purely acrylic than the colors are (due to the simple fact that they lack the addition of pigment). Consequently, they are variations of the acrylic emulsion vessel.

Being portrayed as accessories or accompaniments to an acrylic line, mediums often take on a separate entity. However, they are, in fact, the backbone of any line to which they are constituents. To understand mediums, one must first understand acrylics, from both a technical and mechanical standpoint.

There is no ancient lexicon that documents the evolutionary movement of mediums, nor is there much to date on how to make effective use of them. When it comes to color theory and the mechanical science of painting, there is an abundance of documentation to access and peruse. This issue is compounded by the fact that many of the mediums bear more than a degree of similarity to each other. Much of the variation that does exist is seated in luster and viscosity. What can be learned about these tools is available in a handful of new books (including this one), on Web sites, and in manufacturers' brochures, but precious little is discussed in the art classrooms. Up until now, artists have depended primarily on experimentation to gain a rudimentary grasp of the tactile aspects of the nature of acrylic mediums.

Acrylic paint, the consummate mimic, metamorphoses into all the things it isn't. It isn't magic, or even terribly complicated; it is more a matter of working some of the wizardry of the acrylic mediums family. From water to self-leveling gels, mediums mold, fold, flow, and bend the paint into multiple facets of its various possibilities.

The Homonym

Before I can expound on the multitudinous virtues of acrylic mediums, I need to go on a bit of a rant about the word itself—as it has bred almost as much rampant confusion as has the actual group of materials. First of all, the word *medium* is a homonym, defined as a word that shares the same pronunciation and spelling but that has completely different meanings. This is problematic in the case of acrylic mediums, as many of the word's incarnations are also used prolifically in this type of reference. Therefore, because of the polysemantic character of this word, it is imperative that we go through a bit of a disambiguation process.

"About ten years ago I discovered how acrylic paint could help me create a perfectly smooth surface. Through extensive trial and error, I managed to mix the paint to the consistency of light cream and then flow it on the panel in a series of layers. I also added medium to achieve translucency between the layers. I continue to use this process today. While it is slow and painstaking, it reflects the meditative quality inherent in my painting."
—Hester Simpson

In reference to the acrylic family, mediums are the accompaniments to the colors. Their purpose is to manipulate aspects of texture, sheen, and viscosity. Some specialty mediums can also impart other characteristics to the paint film.

Paint medium:
What do I use to manipulate the surface and texture of my acrylic colors?
"Acrylic mediums are designed to accompany and change the physical or visual characteristics of the paint."
In reference to color, medium connotes a middle shade.

Color medium:
How many tones of cadmium yellow are there?
"Cadmium yellow light, medium, and deep."
In reference to art in a broader context, medium refers to the materials or methods used to produce artwork, the vehicle through which one expresses one's artistry.

Art medium:
In which medium do you work?
"Acrylic is my medium of choice."
Then, of course, is the common usage of the word *medium* in reference to volume.

Size medium:
I'd like to purchase some gesso, please.
"Sure thing. Would you like a small, medium, or large amount?"
And now that we have had this little lesson in semantics, we can move on to the subject of acrylic mediums with what I hope is a clearer understanding of the term.

Hester Simpson, *The Natural World,* 2007, acrylic on wood panel, 12 x 12 inches (30.5 x 30.5 cm)

The Products

Acrylics are the masters of diversity when it comes to surface. From providing a whisper-thin veil to chunky extrusions, these paints are capable of morphing into anything. The multiplicity of acrylics is enhanced manifold by the addition of its accompanying mediums. These are the manipulators of surface—from velvety smooth surfaces to excessively craggy and coarse relief fields.

Acrylic mediums, when used to their best advantage, are the body, the groundwork, the structural support of an acrylic painting. They are the bones, the muscle, and the flesh. Colors adorn and augment them, acting as spice to a soup or cosmetics to an already finely structured face. Artists are understanding more and more that the role of the mediums goes beyond that of diluents and producers of incidental texture. They carry the acrylics out of their infant role of plain paint to the metamorphic chameleon capable of mimicry and invention far beyond that achieved by any other art material produced to date.

While dipping my curiosity into the vault of contemporary acrylic painting, I have come across applications and techniques too profuse and diverse to be contained in a single reference. In an effort to provide a sampling of how acrylic mediums and additives can influence the direction and structural aspects of an art piece, each family of mediums will be explored using rudimentary but varied examples. This is really just a starting point from which to grow and leap.

Left: Matte and gloss polymers show a contrast on black matboard.

Liquid Mediums

There are so many liquid mediums, and within the years to come no doubt there will be several more. To describe them all would not only confuse but take up more room that I've allotted for this chapter. Suffice it to say that they are the largest group of acrylic mediums. What this collection consists of are glazing mediums, low-viscosity polymers, UV reactive polymers, polymers with added UV protection, polymers that make paints more flexible, polymers that make paint films harder, polymers designed to work in conjunction with digital imaging, increase adhesion during laundering, and so forth. The list goes on and on.

Simply put, the acrylic polymer emulsion, in its more liquid state (which is both easy to control and apply), is an ideal vehicle for additives and enhancers that serve to further modulate the paint film, and therefore it gives us more application possibilities. Liquid mediums are generally

offered in gloss, semigloss, and matte formats, thus providing color extension and manipulation along with luster control. Whether they are added directly to a color or layered on top of them, these mediums give the painter control over varying degrees of gloss. Liquid mediums can be tinted with color in any proportion to create glazes. The more medium, the more transparent and desaturated the color will be, though the addition of the medium brings light into the surface and creates a feeling of depth.

INCORPORATING MEDIUMS IN YOUR WORK

Process, though rooted in some fairly solid rules, is ultimately a personal journey, one that is developed through inspiration, practice, and creativity. As acrylic mediums are profuse and varied, it is impossible to set up a recipe book that can encapsulate the possibilities they offer, particularly as there are often no limits as to how much or how many can be used. Throughout the pages of this book are an abundance of images that exhibit an array of cominations, which I hope will inspire you to create your own.

Droplets of gloss polymer medium amplify the depth and darkness of the black ground.

Droplets of matte polymer medium have the look of frosted glass drops—translucent and smooth.

Self-leveling gel is a viscous sea upon which colors float and can be manipulated to create sensuous designs.

Gel Mediums

Gels, by definition, are a dense, viscous material in a semisolid form. In the paint world, this single medium is recognized as the undisputed mascot of the acrylic team. The term *acrylic medium*, though ridiculously diverse in scope, is very often narrowed down in the public mindset as one thing—the basic gloss gel medium. Just as paste or high-viscosity acrylics remain the emblematic form for the entire range of paints, so too the gel medium stands as the most recognized representation of all acrylic mediums. This is in part attributable to their resemblance to the high-viscosity colors (whose physical characteristics they share), but primarily it is due to the sheer scope of application possibilities they offer.

Gels cover a larger format range than their liquid counterparts. Their physical states fluctuate from short to long rheologies, they vary in viscosity, and they come packed with a staggering amount of additives. The working properties of gels are dictated largely by their rheology. Their appearance when wet is whitish. And, unless they contain colored additives, they will dry clear. Although this viscous stuff will hold a sharp peak, when used in a large quantity the sheer weight of gel will cause it to appear somewhat softer and in possession of a certain flow. And now let's take a closer look at two of the most common gels.

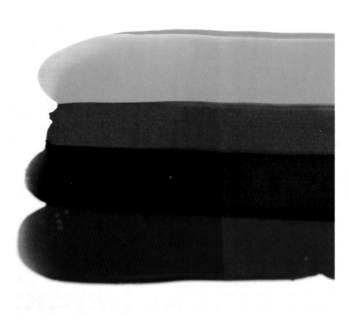

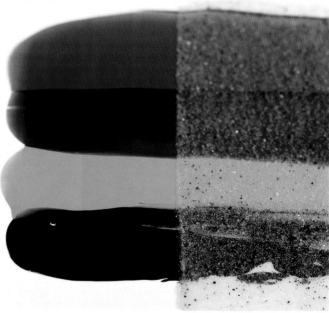

Matte polymer spread over glossy liquid color dulls the sheen and mutes the chroma.

Nepheline gel, though full of dark speckles, still allows colors to remain true beneath its granular blanket.

Self-Leveling Gels

Self-leveling gels are viscous and smooth. They ooze into thick, smooth pools. They can be used to extend color, although any additions into this type of gel needs to be capped and left to rest for a few hours after mixing, to allow air bubbles to escape. The long rheology of self-leveling gels gives them a tarry consistency, and they can be drizzled in long strings to produce smooth-edged relief lines.

These types of gel have a tendency to dry a little more slowly than regular gels. Therefore, they need to be given time to set and cure before applying additional layers. Although a thick application of self-leveling gel will dry relatively thin, once it has leveled out as much as possible, it is thick enough to capture a great deal of light and gives the appearance of a lacquered surface. But not all self-leveling mediums are thick. There are also some more liquid-style mediums that exhibit self-leveling properties. Glazing mediums and low-viscosity polymer mediums will also self-level, although into much thinner films than self-leveling gels.

Texturizing Gels

Some manufactured gels are filled with all sorts of texturizers, including granules of nepheline, pumice or quartz, crushed gemstones, and glass balls. In fact, gel mediums are so graciously accepting of these inert fillers there is no reason why you can't make some of your own. (For more about this, see the sidebar on the following page.)

This detail shows the play of contrast between smooth drips of self-leveling gel and rough patches of nepheline gel.

PREPARING CUSTOM GELS

Just about any inert materials can be added into a clear-drying gel to add either texture or color. Additives should be compatible with the acrylic environment, so do not add metals that will oxidize, foodstuffs that will spoil, or anything that is oily, greasy, waxy, or salty. This leaves a massive menu from which to choose, so experiment with whatever your imagination can conjure up, and create gels that are distinctly your own. A word of caution: Some metal beads and fillings may at first look stable in the gel, but as they dry, some will discolor. Always test a custom gel prior to applying it to a painting, just to be sure of good adhesion and stability.

Right: Add pizzazz to your mediums and transparent colors with a sprinkle of reflective elements.

Silver threads weave in and out of this granular gel application.

A thin glaze of transparent color acts as binding medium to these iridized beads.

MEDIUMS USAGE

Acrylic Medium	Format	Other Names, Similar Products, and Derivatives	Relative Coverage	Adhesive	Extender	Holds Texture	Dries Clear	Clear Coat	Filler	Other Uses and/or Specific Directions
gel medium	G, SG, M, LV, etc.	gel medium, heavy gel, high solids gel	T	X	X	X	X	X	X	Gels can be used for acrylic transfers. They are very strong and thick, thus well-suited for sculptural work. Their strength provides good support for heavier collage elements.
polymer medium	G, SG, M	gloss, semi-gloss, or matte mediums, liquid medium	T	X	X	X	X	X		These can be used as clear-drying, archival adhesives for sensitive artwork or photographs. They make an excellent decoupage medium. They can be mixed with a retarder to create a slower-drying glazing medium or on their own as a clear coating.
low-viscosity polymer medium	G, M	airbrush medium	T	X	X		X	X		(See Polymer Medium) Low-viscosity polymer mediums should be applied in thin coats, as they may crater if poured liberally in thick puddles.
nepheline gel	F, C, XC	none	T	X	X	X	X		X	These can impart a granular texture to create rough surfaces. The finer versions make a suitable drawing ground for dry media. The translucent quality of these gels allows for tinting in any strength.
pumice gel	F, C	none	O		X	X			X	The opaque gray tone of this gel is ideal for creating brittle, granular surfaces. To improve flexibility, mix in some additional gel medium.
modeling paste	light, clear, heavy	molding paste	T or O	X	X*	X	X*		X	For ideal results, build high relief in a series of thin applications, allowing ample drying time between coats.
gesso	white or colored	acrylic dispersion ground, absorbent ground	O	X		X**			X	Gesso generally self levels, however, it can be used to create some smooth bas relief such as pastiglia.
clear gesso	clear	transparent gesso	SO	X	X	X**	X	X	X	(See Gesso) Clear gesso still contains a quantity of calcium carbonate and matting agent, which gives it a translucent appearance. The absence of pigment increases the flexibility of the film and allows for tinting in any strength.
dry media ground	N/A	pastel ground	SO	X	X		X			This is a toothy, absorbent ground suitable for all dry media. It is also well suited to wet media. If intending to use this as a ground for oil-based media, layer it over a well-gessoed surface.
final finish	G, SG, M	polymer varnish	T	X	X		X	X		Final finish can be used as an alternative to a glazing medium, as it tints well and will self-level. It can also be used as an isolation coat between layers.
hard resin top coat	G, M	none	T	X			X	X		Top coats are (usually) acrylic/urethane hybrids, carrying characteristics of both types of coatings. These should only be used on fully cured, 100% acrylic surfaces and will perform best on rigid surfaces. These are not a removable varnish.
self-leveling gel	G, SG, M	tar gel, string gel	T	X	X		X	X	X	When mixing self-leveling gels with color, mix well then allow mixture to settle for several hours to release air bubbles. For the most uniform applications, apply with spreading or pouring methods. Thick applications of matte self-leveling gels have the appearance of melted wax.

LEGEND: G = gloss, SG = semigloss, M = matte, LV = low-viscosity, F = fine, C = coarse, XC = extra coarse; T = transparent, SO = semiopaque, O = opaque

* Only clear modeling paste
** Pastiglia-like applications

Q&A: MEDIUMS

What is the most important thing to be aware of when working with acrylic mediums?

Time.

The oft-quoted and very misleading statement "acrylics dry very quickly" becomes inaccurate when working with mediums. Relative to the drying time of a fine layer of pure color, when any quantity of medium is added to the mix, the open time increases significantly. This is due to two things: 1. more water is being added, which increases the moisture content and keeps the paint hydrated; and 2. more solids (in the form of acrylic polymers) are bulking up the acrylic mass, which slows down the evaporation.

Not all of this "gained time" is working time, however. Once the surface of the medium-enriched paint has begun to form a skin, it should be left to dry, undisturbed. Continuing to poke at it will only cause mess and frustration. Curing time for mediums is similar to that of pure color.

The drying time of mediums varies. Liquid mediums will dry more rapidly than their gelled counterparts. One simple test that can be performed to determine whether the paint film is still drying is to place your hand on the surface, then on the back of the support. If the paint and support feel cool, evaporation is still taking place.

Ideally, a thick layer of medium should be left to dry overnight prior to adding new paint layers. This is of particular importance when working with transparent and translucent layers. Failing to wait the appropriate amount of time will result in blocking the channels through which volatiles are evaporating in the underlying film, causing milkiness that may not eventually disappear.

Some mediums have hidden components. For instance, some brands of glazing medium contain a larger quantity of propylene glycol, which increases the open time of working the paint. This type of glazing medium will require longer drying time between layers to ensure proper adhesion. Adding a wet layer over uncured glazing medium with added propylene glycol content could cause the additional layer to blend with the underlying paint. These factors vary from brand to brand, so testing is important.

And the second most important thing?

Change.

Mediums are white. That is to say, they appear white in their wet state and, with the exception of those that contain pigment, they will dry clear. It may not seem like such dramatic change when you add a small blob of gel or squirt of polymer to your color mix; however, the more you add, the whiter your color will appear. This can throw you off quite a bit as you strive to blend your tones or perfect a glaze—and the more you add, the longer it takes to dry. Some really thick applications do not show change until you've left the studio, gone and eaten your dinner, had a good night's sleep, and meandered back in the next morning. If you are hesitant about using large quantities of medium for this reason, do a test batch first. Though the shift is more dramatic in economy paints

(because of their low pigment concentration), the change from wet to dry color is due to the clarification of the paint film. Colors deepen, and those that are transparent show their true depth.

How is an acrylic medium different than an additive?

Generally, a medium is a substance that is mixed or used with paint to impart a particular physical characteristic. An additive is a substance that is added to a color or medium to facilitate a process but that does not remain in the paint once its job is done. An example of this is acrylic retarder. This is added to paint to increase the open time, and during the curing process it will evaporate completely from the paint film.

What role does water play?

Water can do more than act as a diluent while painting; the acrylic water wash is only one of its functions. While water is often considered to be the first acrylic medium, or additive, it is also an exceptionally useful tool in manipulating the other mediums. To use it effectively, certain aspects of water usage must be clearly understood.

Acrylic formulations are all complex recipes within which a crucial balance must be kept among each of the components to produce a paint film that is both durable and flexible. Water plays a major role within these formulas. This begins with the acrylic base itself—the raw acrylic dispersed in water. An acrylic dispersion is a suspension of finely dispersed acrylic particles in water. The acrylic has been fully whetted-out, meaning that each particle has become encapsulated by water. The second component of acrylic paint to contain water is the aqueous pigment dispersion. The concept is the same, only this time the pigment is surrounded by and suspended in water. Both the acrylic and the pigment are hydrophobic, making it necessary for surfactants to be used in order to lower the surface tension of the water barrier and facilitate the blending of the components. Once the acrylic and the pigment dispersions are stable, they can be combined within the acrylic paint recipe. In addition to the dispersions, deionized water (quantities of which vary according to paint quality) is added during the production of colors and mediums as part of the carefully balanced liquid-to-solids ratio crucial to the formulation of a stable paint film.

During the drying process, all of this water has to evaporate. This can take more time than you realize and can affect the paint in ways that may not at first be apparent. The more water that exists in the paint, the greater the number of micro-fissures it forms in the film surface as it leaves. The more of these pathways that are left behind, the more porous the dry film remains, and the more matte the surface appearance becomes. The addition of water into paint also serves to scatter the pigment and acrylic particles, making the dry film less cohesive than one that contained less water. This is why it is generally recommended that only a modest quantity of water be added to colors or mediums during paint application.

Chapter 4
essential materials and supplies

It may not be your ticket into the world-class galleries or the answer to solving all of your artistic dilemmas, but materials knowledge will provide you with the infrastructure imperative to producing work that is physically and chemically sound. Start by learning about your materials inside and out— the grand ideas will have time to come to fruition later. Imagine trying to improvise on a classical piece of music without first having taken the necessary years to master the instrument. The uneducated effort would be insubstantial, and clumsy—much as the art created by unskilled painters tends to be.

Because of their relative newness as an art material, acrylic paints do not hold the same degree of regard in many a traditional art classroom. And, to be fair, many educators have not had as much time to become familiar with acrylics as they have with more traditional materials. We are now still in the developing stages of creating a comprehensive acrylic paint materials database. It exists only in a smattering of books and Web sites.

Generally speaking, acrylics are understood more thoroughly by organic chemists than artists. At the same time, acrylic paints and mediums are the largest family of paint materials on the market, taking up easily twice as much shelf space in art supply stores than oil or watercolors. For a material this diverse and well accessorized, surprisingly minimal information is to be found. I hope to unveil

much of its mystery here. Although, as painters, you owe it to yourselves to seek out information—not only through books like mine, but through your own experimentation and through sharing information with manufacturers and your fellow artists. Everyone will benefit when the world database is so complete that acrylic paint will be more fully understood and appreciated as the viable and exquisitely versatile material that it is.

The biggest question for many people who are just starting to work with acrylics is, "How do I start? I have an idea . . . but how do I choose the right materials for the job? How do I translate it to the support, and for that matter, which support, which format of paint, which mediums?" While I cannot hope to provide the definitive answers to these questions, perhaps the next few pages will trigger recognition and you will decipher them for yourself, for your style.

Ultimately, the deciding factor will be determined by first understanding what your options are. Having but a cursory knowledge of materials may serve you well enough while you dabble, but a more thorough familiarity with each component will take you the extra step into the professional realm. This is what separates the cooks from the chefs. The more intimately one is acquainted with the variety of painting materials, the better one can make proper and efficient use of them.

Supports

The automatic assumption, when it comes to what to paint on with acrylics, is to go with canvas. It is what we think of first when we think of painting, and what the art supply stores have in most prominent display. Canvas and linen are the standard supports for acrylics. However, since acrylics are a water-based paint, paper also provides a sensible substrate for acrylics. This said, canvas and paper are certainly not the only choices.

Many artists are straying from the traditional supports and have questions about how to prepare, paint on, and clean nontraditional supports to make them compatible with the acrylic medium.

The choice of supports for the acrylic family is profuse and diverse. We take for granted, oftentimes, the simple fact that acrylics are extremely adhesive to a wide range of surfaces, most of which are provided in a ready-to-use format in art supply and craft stores. What sometimes escapes our attention is how successful the bond between paint and substrates is over time and the physical stress that can be brought on by atmospheric and climactic changes.

When moving on to less conventional supports, this issue becomes paramount, and several precautionary steps should be taken prior to committing paint to substrate. Know your support prior to applying paint. Its porosity is one, but not the only, consideration. How dry a surface is also will affect the way in which the paint will absorb into it. Imagine soil that has suffered desiccation from a drought. When the rains come, the drops will roll and bounce off that hardened soil, whose very dryness repels the water. Only after the moisture-starved surface is breached will the soil

Decorative papers are usually paint-friendly and create beautiful grounds and additives for collage work.

Linen is a natural choice for both acrylic and oil paintings.

drink hungrily from the rain, and in short measure succumb and turn to mud. Similarly, many extremely dry surfaces will initially repel the wet paint until the preliminary soak penetrates. Always test a new surface—this is your best insurance against adhesion failure.

Some supports come pretreated with a sizing agent, which serves to inhibit or control the rate of absorption. Others will soak up any amount of moisture like a sponge. In the art-paper world there are papers specifically designed for water media and those designed for printmaking. Both are suitable for acrylic use. However, those made to bear water will more readily take acrylics. Some printmaking papers are too absorptive and will not stand up to heavy water use; they may also tear, blotch, or absorb unevenly. That is not to say that a printmaking paper cannot be used for acrylics. To render these a bit more friendly, a light layer of undiluted liquid matte medium can provide a suitable ground. Using an acrylic gesso can also do the trick, but it is not necessary. If utilizing such a product, be aware that an artist-quality gesso should be used, rather than a bargain brand. Only use gesso that is labeled 100% acrylic.

Wood supports, being rigid and smooth, offer strength and excellent adhesion for acrylics.

A sheet of metal provides a smooth, reflective ground. Emboss it with a stylus to create additional texture.

Support	Adhesion	Cleaning	Priming	Additional Preparatory Procedure	Don'ts and Potential Problems
canvas or linen	E	none	Gesso: Apply one to five coats. For a smoother ground, sand between layers. Acrylic polymer: Apply a single coat of polymer. This will effectively inhibit water and paint absorption, increasing the flow of paint on the surface while allowing the canvas to show through.	If priming with a polymer medium, using the matte variety will provide more tooth and improve paint adhesion.	Do not use a nonflexible primer on canvas (e.g., wall primer or house paint).
water-media paper	M	none	Although not a necessary step, applying a single, thin layer of matte polymer medium will inhibit absorption of the first layer of paint.	Stretch paper (wet paper, tape down, and allow to dry). Tape lighter-weight paper (140 lbs. or lighter) to hard surface while painting.	When framing behind glass, allow a space between the glass and the frame, as acrylic will stick to the glass. Work should not be framed behind glass until curing has completed.
wood (kiln dried)	E	Wipe to remove residual sawdust or dirt.	Gesso: Apply one thin coat. Sand. Apply second coat. Clear coat: Apply two coats of polymer medium in thin layers. Allow proper drying time between layers.	Seal any knots with shellac (or similar knot sealer) and allow 24 hours to dry prior to painting. Cradled panels and layered wood panels help guard against expansion and contraction of the wood.	Wood should be kiln dried, as this protects against mildew and warping and allows wood to be more absorbent.
medium-density fiber-board [MDF]	E	Wipe to remove residual sawdust or dirt.	Apply a thin layer of gesso or paint directly to board to seal it.	Seal sides and back of panel with paint, gesso, or polymer medium to guard against water absorption.	Do not apply a very wet layer to raw board, as this can cause it to swell and pucker. When sanding or cutting MDF, wear protective eyewear and use a mask.
metal	M	Use alcohol-based cleanser to wash away any residual oil or grease.	Apply metal primer. Use the appropriate primer for ferrous and nonferrous metals.	Abrading the metal (by sand-blasting, etching, or wet sanding) will greatly improve its adhesion.	Metal surfaces should be placed away from sources of heat (because they conduct the heat, which can soften the acrylic, making it more susceptible to damage).
Plexiglas	E	Use glass cleaner to remove residual oil or grease.	Clear: Apply a single coat of matte polymer medium. Frosted: No priming is necessary.	Lightly abrading the surface can be used as an alternative method for adding tooth.	none
glass	M	Use glass cleaner to remove residual oil or grease.	If applying paint to clear glass, it is not necessary to prime the surface; however, to improve adhesion and allow for more uniform paint application, a single application of matte polymer medium is recommended.	Abrading or etching glass will greatly improve its adhesion. Alternatively, frosted or etched glass can be purchased.	Washing painted glass is not recommended. Glass is not recommended for items that are intended to be used with food. Acrylic paint can be peeled or scraped off clear glass, although it will adhere well enough for temporary use.
concrete and masonry	M	Use TSP (trisodium phosphate) to clean the surface.	Freshly applied concrete should be left to cure for at least 4 to 12 weeks prior to painting. Prime the surface with concrete/masonry sealant that has stain-blocking capabilities.	Applying a ground layer of white acrylic or gesso will improve the brilliance of the colors and reduce paint absorption into the ground. For outdoor applications, follow instructions for proper mural construction.	Water, mildew, and mechanical changes could damage a painted concrete or masonry surface. Ensure that the surface is well sealed and clean prior to painting.
ceramics and stoneware	E–M	Remove any dust.	Bisque-fired surfaces accept acrylics well. Gesso will reduce aggressive absorption.	To increase adhesion, glazed ceramics can be lightly sanded.	Be aware that water can migrate through unglazed ceramics and lift paint from behind.

LEGEND: E = excellent, M = moderate, P = poor

Support	Adhesion	Cleaning	Priming	Additional Preparatory Procedure	Don'ts and Potential Problems
illustration board	E	none	Although not required, a single, thin layer of matte polymer medium or gesso will inhibit absorption of the first layer of paint.	Thick applications of paint, or very wet washes, will cause the board to buckle. Tape the edges with paper tape.	none
fiberglass	E	Wipe away dust from sanding.	Seal with industrial sealer. Ask at your local hardware store for a sealer that is suitable for water-based paints.	Sand or sandblast the fiberglass to provide tooth.	For outdoor sculptural pieces, finish with appropriate top coat.
foamed boards	E	none	none	Foamed boards, such as Sintra board, are a great lightweight surface. Lightly sanding will enhance adhesion.	Some foamed boards (depending on thickness) can be quite flexible, and thus larger pieces should be braced prior to painting and framing.
Mylar	M–P	none	none	Provided they are properly framed, works on Mylar will stand up very well. Painting on frosted Mylar provides increased adhesion.	It is possible to peel thick swaths of acrylic away from clear Mylar. It does, however, provide a beautiful surface for transparent painting applications.
synthetic paper (Yupo)	M	none	none	none	This synthetic paper is a favorite among mixed-watermedia artists; however, it is not an archival material by any means. While it is a beautiful paper to paint on, be advised that applications of acrylic can be peeled right off. Good for temporary or experimental work.
leather	E–M	Clean with a mixture of bleach, fabric detergent, and water.	The paint will absorb into the leather and reduce absorption of the second coat. If painting on dark leather with transparent or semiopaque colors, consider using titanium white as your base coat.	Flex the leather as the primer layer dries, as this will pull the paint into the skin to reduce cracking.	Use dry-clean methods for laundering.
suede	E	Clean with a mixture of bleach, fabric detergent, and water.	Suede is more absorbent than leather. Apply a thin layer of diluted paint to prime the surface.	none	Use dry-clean methods for laundering.
assorted plastics	E–P	Remove dust with microfiber cloth, as plastic surfaces are susceptible to static buildup.	Plastics that have moderate to poor adhesion to acrylics will benefit from a light sanding.	none	Many plastics will bond extremely well to acrylic paints while others will repel it. As these materials continue to evolve, it is best to do an adhesion test to determine compatibility.

USING ALTERNATIVE SUPPORTS

I was thinking about the chances that artists take, usually for the sheer exploratory thrill of it. Something along the lines of, "Hey, I wonder if this will work?!" Books, teachers, and staunch traditionalists preach the doctrine of "tried and true," the better-safe-than-sorry methods of art creation. ("If you want it to last, make sure you do it *this* way. . .") There is a strident and rampant discouragement against going off into left field, where dicey whimsy and that alarming cutting edge lurk.

Of course, there are countless reasons for sticking to the safe methods, those time-tested oldies but goodies, but where's the adventure in that? Part of art making is about breaking through the walls and stepping out into the unknown—or in this case, the untested. The nature of acrylics, being the freshmen of the paint formats, is such that we do not know with a high degree of certainty how they will weather the ravages of time and the environment. So while we feel quite confident about utilizing them on those "safe" supports, there is no guarantee even there that they will endure. Following this logic, we can then feel freer to take them tentatively beyond the traditional boundaries and try out some more speculative combinations. Why not incorporate our evolution as artists into the development of a larger database of alternative approaches and material amalgamations?

If you are keen to take the road less traveled, there are some basic survival rules that you should be mindful of.

Research your materials.
What is the common purpose for the material? Knowing the original purpose for which this support was manufactured is the key to a successful crossover into the acrylic painting world. This will provide clues as to its composition, what types of coatings (if any) are usually applied to it, its estimated longevity for indoor and outdoor conditions, and what some of the potential incompatibility issues may be.

Test the material before you paint.
Frequently, a simple adhesion test is all that is necessary to determine whether a particular support is compatible. Take the following steps:

1. Make sure the surface is clean and dry.

2. Apply a single, thin (but undiluted) coat of color or medium.

3. Allow the surface to dry for 48 to 72 hours. (Note: In a humid environment, paint can take up to twice as long to cure. Also keep in mind that paint will cure more quickly on porous than nonporous supports.)

4. Distress the painted surface with a sharp implement in a crosshatch pattern.

5. Apply high-tack masking tape to the paint surface, smoothing it down with pressure to ensure

adhesion. Remove the tape. (Note: Not all paint needs to be scored prior to testing with tape, and not all brands of tape have enough tack to hold fast to the paint.)

6. To further test adhesion, attempt to pry the paint off the support by lifting edges of the paint with a fingernail or blade.

Any artwork that is intended to endure excessive moisture exposure should be conceived after some simple research has been done. If you will be painting on a support that will be laundered, take the time to first thoroughly clean the support to eliminate the presence of sizing, starches, dirt, or other residues. Then apply the paint to a test section of the material in the same manner that you will be employing with the finished artwork later on. It is a good idea to launder, using both washing machine and dryer, at least twice to determine the durability and permanence of the paint layer.

Producing acrylic artwork for outdoor use requires a combination of art and industrial supplies. Artist acrylic paints, such as they are, have terrific light stability outdoors; however, they are not entirely weather resistant. Most commonly, it is the support itself that causes acrylics to fail in tough outdoor conditions. Porous materials that are not properly sealed will wick in moisture and begin to break down the bond between the paint and the substrate from behind, causing the paint to eventually peel off. Preparing the support—be it brick, plaster, wood, or terracotta—with an industrial sealant designed for that purpose will be the most effective way to produce stability in adhesion in the event of inclement weather.

When it comes to accelerated testing for the aging of acrylic paints, this is a task best left to paint chemists and conservation scientists. Chambers, often built in conservation labs, and other equipment are designed for this specific purpose. Exposing various materials to heat, humidity, and extended light exposure are some of the ways that paints are tested for their longevity.

Peaks of light gold and pearlescent high-viscosity paint float on an aluminum ground.

Grounds

Acrylics are a friendly paint, easy to get along with and not usually too fussy as to where they end up. They will make fast bonds with many types of supports without a ground to facilitate their union. Other supports, however, require a go-between, something to ease relations and keep the interaction harmonious. It is critical to know the difference!

Browse through the supports chart on pages 58–59 to make that clarification. Once you establish what you will be painting on, determining what you will use to prepare that support for painting depends on several factors. Grounds can be used to seal the support and act as a barrier to chemical or water migration. They can also create an acid-free buffer zone, add tooth, and provide a reflective or colored ground. The two most common grounds are gesso and modeling paste.

Gesso

The quintessential ground is gesso. In the context of this book, gesso refers to an acrylic dispersion ground, usually white. Nowadays, gesso, like most things, has evolved beyond the basic white. The basic formulation remains the same: acrylic, calcium carbonate, and matting agent. The variations occur in the addition of pigment. Clear gesso contains no pigment; white and buff gesso are stocked with titanium white pigment; black has carbon black; and brown contains burnt umber. To create your own colored gesso, start with clear gesso (sometimes called transparent gesso) and then tint it with opaque pigment.

A single application of gesso is all that is needed if you are going to be painting onto it with acrylics. It will keep the support from absorbing too much paint, particularly on very porous surfaces. You can apply more coats, sanding between coats, for an ultra-smooth ground, if you want to cancel out any texture apparent on the substrate. If you will be using oil-based paints, an acrylic gesso can provide an acceptable barrier, provided that you apply at least three coats to the support. If the gesso you are using does not completely self-level, it can be thinned with water until the desired consistency is reached.

Consider gesso as something more than a foundation builder, as it has a unique quality that enables it to be something else—a relief builder. Pastiglia is a centuries-old technique, a way of building up textural details on frames, furniture, and decorative objects. The heaviness of the gesso, and its self-leveling behavior, creates a stringy, dense stream when it is dripped or brushed onto a surface. The resulting design is rounded and smooth, but also tough and rigid.

Pastiglia is an ancient method used to create texture by dripping gesso in decorative swirls.

PINNING DOWN GROUNDS

In some segments of this book (most notably the Mediums Usage chart on page 51) grounds are lumped in with all mediums, primarily because this is how they are usually marketed. Retailers, catalogs, and Web sites more often than not place grounds right in with the mediums. However, in books they usually are placed within their own category, which is really where they should be. But it is a fuzzy thing, and not one that I think I can make a definitive distinction on in this book. Technically, grounds are a medium, in the sense that they are an accompaniment to the paint colors, made with acrylic and therefore part of the acrylic family. Grounds function as mediums when they are used to create effects and textures, taking them out of primary status as primers. In terms of how they work in the production of an artwork, they stand apart from mediums, as they are providing the beginnings (the groundwork) of a painting, both acrylic and oil. It is a subtle, but substantial, difference.

Rhéni Tauchid, *Dragon Bug Bones,* 2007, acrylic on paper, 12 x 22 inches (30.5 x 55.9 cm). For this demonstration piece, I flung white gesso into random patterns on watercolor paper. Next, I applied more gesso (instead of white paint) to the dried painting, which gave the image a matte finish.

Modeling Pastes

Though they contain similar raw materials, modeling pastes are significantly more viscous than gesso. Many different brands of modeling paste exist and all of them are slightly different. However, all modeling pastes are designed to be exceptionally tough, sandable, and capable of holding dramatic texture. Massive quantities of solids give them a reduced flexibility. For best results, apply modeling paste in layers, and limit thick applications to rigid surfaces.

Right: Both rigid and flexible, modeling paste lends itself to some printmaking processes. Here, it is on an embossing template, detailing part of the process that Jennifer Chin used to create, *I am everywhere,* 2007, embossed paper, 22 x 30 inches (55.8 x 76.2 cm).

Below: Jennifer Chin, *I am everywhere,* 2007, embossed paper, 22 x 30 inches (55.8 x 76.2 cm)

"Carefully observing the physical properties of materials and pushing them to their absolute limitations has been a preoccupation for me. The viscosity, density, and low rate of shrinkage of acrylic modeling paste allowed me to achieve the texture I desired and provided the durability required to create this piece. The diverse physical potentials and ever-increasing quality of these new acrylic products have widened the scope of my material vocabulary and provided new possibilities for my art practice."

—Jennifer Chin

These grounds are thick, some of them in the extreme. The sheer density of solids contained in a modeling paste causes it to dry quite slowly. As they do not generally contain a great deal of water, they will be touch-dry long before they have fully cured. Full curing, however, is necessary for carving and sanding. To produce precision detail, modeling paste can be extruded through a piping bag or similar tool. Rigid stencils can be used to make sharp edges that are extremely effective at creating bas-relief designs tough enough to be used on three-dimensional surfaces.

TROUBLESHOOTING POTENTIALLY PROBLEMATIC GROUNDS

Recently, a problem with some modern grounds has crept into recognition. As with all industries, manufacturers of grounds have taken shortcuts and created faulty advertising in the interest of cutting costs. The fallout from these types of practices is that often the shortcomings do not come to light until it is too late. One of the main culprits is the pre-gessoed canvas rolls and stretched canvases. Much of the so-called acrylic gesso is actually a poor substitute that can contain little to no acrylic binder. A fine-quality gesso should contain a large quantity of calcium carbonate, titanium white pigment, and enough acrylic polymer emulsion to form a flexible, water resistant, and durable film. The low-rent impostors have been found to suck excess moisture from subsequent paint layers, causing embrittlement of the film, in some instances, and in others allowing it to pull it away from the canvas weave altogether.

Manufacturers, conservation scientists, and other organizations are working to minimize this problem by establishing a standard for artists' grounds. As this is a current issue, if you are purchasing readymade supports of this sort, do some testing of your own before committing paint to canvas.

To maintain a more assured control over the quality in the construction of your painting, the best route is to build and prime your own stretchers from scratch. No doubt, this is a skill that all painters should learn. It is more work intensive, time-consuming, and potentially more costly than relying on the premade alternative, but what you lose in time and money you will gain in durability and peace of mind.

What if you choose to purchase the premade supports and take your chances with them? Or what if you already have a vast supply? It is messy solution, but one way to turn a bad thing into a good thing is to remove the part that makes it bad. An inferior "gesso" will lack adhesion and contain very little acrylic. I propose that you wash it away. Soak the surface with a generous amount of water, allowing it to sink in; then, working with circular movements, scrub the primer off using a scouring pad or something similar. If the primer is of poor quality, it will come off with ease. Once the offending substance has been dispatched with, allow the canvas to fully dry (overnight) then begin applying coats of the good stuff. (See the Groundworks chart on pages 58–59 for suggestions on the application of an acrylic primer.)

To check the flexibility and coherence of your gesso, pour out a small puddle onto a palette or other surface and let it dry overnight. Test the brittleness once the film is dry. If it cracks, the gesso does not contain enough binder to make it suitable for a flexible support.

EXPERIMENTING WITH PLASTIC GROUNDS

Given the "elastic" nature of plastics these days, there is no limit as to what you can experiment with. Many plastics share a basic chemistry with acrylics, but there is a division between those to which it will adhere and those to which it will not. Primers can facilitate binding between layers, allowing acrylic to go where they previously could not. Again, there is the issue of longevity and long-term compatibility issues between the combination of support, ground, and paint. However, most of these types of primers are formulated for industries outside of the artists' realm, and the contents of the stuff itself is more often than not proprietary (and thus difficult to diagnose without detailed information on their makeup).

There is an abundance of information available in chemistry texts and on various Internet resources on the various plastics that are commercially available. However, there is very little information on how well acrylic paints stick to each of them. There is such a variety of plastics. Some are only known by their brand names (e.g., Plexiglas, Lexan, and Mylar), while others are referred to with acronyms (such as HDPE [high-density polyethylene], PET [polyethylene terephthalate], and HDPP [high-density polypropylene]), which are more fully descriptive. Through my research I have found that acrylics stick well to Plexiglas and Lexan, moderately well to Mylar (best to use frosted Mylar for increased adhesion), and not at all to HDPE and HDPP plastics. These are very general guidelines, though, and if you are planning to work with plas-

tics, do as much of your own testing as you can. A great place to find sample plastics are sign manufacturers, as they will sell you smaller sizes of plastic sheeting.

Hologram Pearl Spectral color, by Tri-Art, contains minuscule epoxy-coated Mylar particulate resting in a liquid acrylic base. Here it is mixed with gloss gel for texture and painted in patterns onto a clear Mylar sheet.

Tools

Picking your tools is very specific to what type of painting you plan on doing and how detailed you want to be. However, certain basic pieces form a good utilitarian foundation and suit a variety of purposes for the artist who works in the acrylic medium. I suggest equipping your studio with the following: a selection of wash brushes (ranging from 2 to 4 inches), a handful of detail brushes, some inexpensive bristle brushes, a plastic palette knife, a wide gesso brush, and a spreading tool.

Beyond these basic elements, there is such a diverse and growing variety of implements that it is up to you to decide, based on your preferred process, which to choose. Many tools are designed specifically for the acrylic medium, and there are very good reasons to pick these. Synthetic bristles, such as Taklon and Interlon, are perfectly suited for use with acrylic products. They are resilient, soft, do not suffer from prolonged exposure to water, maintain their shape, and require no conditioning. Although most brushes labeled specifically for acrylics tend to have long handles, you will find that synthetic watercolor brushes have similar shapes and sizes on shorter handles; these provide greater control for detail work.

One of the fastest-growing tool trends designed specifically for painters are spreading tools. There continues to be a varied lineup of traditional sized palette and painting knives, but now they are finally getting bigger! This is a boon to painters who favor larger supports, and as well to those who use a great deal of mediums. When purchasing one of these extended palette

knives, check for flexibility and structural integrity. You will want to pick one that holds its flat edge and bounces back to a perfectly level plane after every flex.

Silicon-tipped spreaders, called color shapers, are indispensable tools for creating smooth swaths of paints, scrapping away layers and spreading thin glazes of color. As dried paint will peel cleanly off their surface, these tools will outlast most brushes and maintain their edge. In addition to these paint-specific tools, numerous other implements are terrifically suited to spreading paint around. For instance, metal rulers, window squeegees, and wall scrapers all make fine spreaders. In a pinch I have often used bits of cardboard or a piece of leftover matboard to produce uniform passes of color or medium over wide areas.

outlast most brushes

Massive painting tools can open up your technique repertoire and loosen your movements.

Chapter 5
shopping

"Each new color

was a miracle

more compelling

than sweets."

For painters, art supply shops are the ultimate candy store. We thrill to a new paint color, the supple bristles of a brand-new brush, a creamy watercolor paper, or just the right shape and size of stretched canvas. This is the stuff of inspiration. As a child, my dream gifts were that new set of markers—each tip perfect and pointed, the ink rich and dark—or a fresh pot or pans of paint, unsullied by the spill of another color. Each new color was a miracle more compelling than sweets, provocative and brimming with possibility.

I have seen the eyes of shoppers in art materials stores. Those tools become precious in their hands, the baskets fill fueled by the stimulus of creative energy and ideas. When we shop in places like this, we begin to dream, to create, and to connect the base tools to our imaginative oeuvres. Aside from the sheer fun of it, there can be an order and purpose to which purchases you ultimately decide on.

Akin to grocery shopping on an empty stomach, it can be overwhelming and expensive to let loose in an art supply store, though I'm sure we've all done it at some point. To conserve your reserves and direct your purchases, you should have not only a plan but also an idea as to what and how much you will be buying. Take the time to make your selections, and be careful to read labels and check quality. Talk to the staff as well, as they hold a wealth of experience and information, and can change a confusing shopping experience into an educational one.

Acrylic Paints

Acrylics have been the fastest-growing commodity in the art materials market. Every color manufacturer who did not have one at first now has at least a couple of different lines. At first glance, it may be difficult to distinguish between artist, economy, or student line, as the descriptives have a pesky tendency to all sound the same. Take note of the details, for therein lie the clues to what is *really* going on. If you are looking for a bargain brand, then obviously choose one that fits your budget. However, if quality is your objective, take a look beyond the bottom line and start reading that label.

What you need to look for first of all is the word *artist* in the name. Within the industry, this is used to connote top-quality materials. Like many things, it can sometimes be used arbitrarily on things where it does not belong, but by and large what is called artist-quality actually is just that.

A customer browses through the rainbow of acrylic color choices.

Next, check for pigment identification, relative coverage, ASTM lightfastness rating, and price. When it comes to top-drawer colors, price is not something that many can afford to drop too low. Pigments, used in sufficient quantity to merit the artist-quality meter, are not cheap. In a time when raw materials are coming at a premium, and shipping costs are skyrocketing, no manufacturer can afford to set the ticket price too low. So you can be reasonably assured that the higher-priced lines are so priced for a reason. As for ASTM rating, three ratings are specific to artist acrylic dispersion paints: ASTM D 5098, ASTM D 4236, and ASTM D 4302.

Before you set foot in the store, however, it makes good sense to have an idea of what you want to do—even if only a vague one. The acrylic paints aisle (or aisles) of an art supply store are usually large, ever expanding, and more than a little confusing. If you are not familiar with the various brands, ask the staff. In my experience, I have found that art supply staffers tend to know a great deal more about art materials than many art teachers. Look to them for guidance when you need to identify between a finest-quality and an economy product. More often than not, color charts and brochures are available and these will further inform you as to their quality level and usage. In addition, the vast majority of art materials manufacturers now have Web sites that you can browse prior to hitting the stores. This is a good way to familiarize yourself with the color and medium choices in any particular brand.

EXAMINING THE LABEL

Label information will differ slightly from brand to brand; however, most of them display the information necessary for an artist to make an informed choice. For the purpose of this illustration, I will be using a generic paint label produced for this book.

A label will give you four very important bits of information: pigment content, relative coverage, ASTM lightfastness rating, and price series. While manufacturers use a combination of chemical and traditional names for their colors, some colors are also named for the company, a well-known artist, or a historical precursor. Other colors are given a name based on their appearance, which may not correspond with the pigment in use. These are generally labeled as "hues," but this is a detail that is oftentimes overlooked. It gets tricky, so to be sure of what you are getting, a rudimentary knowledge of color chemistry will serve you well if you are concerned with using a particular pigment, or matching one.

You can refer to the Pigment Classification chart on pages 32–33 for detailed information on a selection of pigments used in acrylic paint production. Acrylic paint manufacturers have information available on their specific palettes in brochure form and/or on their Web sites. Easier to remember than the pigment ID numbers themselves, however, are the chemical names. The current trend in color naming is leaning more and more to the specific chemistry of the colors. Accuracy has replaced whimsical historical names, giving a further air of authenticity to the new age of the art material. Products manufactured to be sold in the world market must conform to several standards, and these make up part of the labeling requirements.

ASTM 4302

6 26309 04241 3

Artist Quality Acrylic

Lightfastness: II
Opacity: SO
Series: 4
PY 3 11710
PG 7 74260

Permanent Green Light

100% acrylic polymer emulsion. 8.45 fl oz Made on Planet Earth

Sample label. The label on a jar or tube of paint should convey all of the pertinent information on that product, including the brand, color, lightfastness, relative coverage, price series, pigment information, package size, ASTM labeling, and country of origin.

EVALUATING YOUR QUANTITY NEEDS

Before you find yourself in a store, it makes sense to ascertain how much paint you require for the job at hand, so you don't overbuy. Acrylics have a pretty good shelf life, but it is not as long as those of oil or watercolor paints. Oil paints form a thick skin that serves to protect the underlying paint, and watercolors are continuously resoluble. As acrylics are susceptible to drying (through the evaporation of its water and other volatiles), it is imperative that they be sealed and stored properly to maintain their wet state. Unless you have the need for large quantities of color—be it due to the prolific nature of your working practice or because you need to cover very large areas—keep your color purchases to the smaller sizes. (See also page 171 for tips about preserving and storing your paints.) Better to use up the full volume of a color than to have a significant amount of paint left over, dry in the jar due to neglect.

Some paint containers are induction sealed in the factories. The inner liner, which keeps the moisture in and the air out, increases the shelf life of a product and protects it during shipping. Once the container is opened, and the safety seal is peeled away, the paint is vulnerable to the elements, and precautionary measures should be taken to ensure their longevity.

Although purchasing larger quantities is generally more economical at face value, if you factor in the amount of paint that could potentially be wasted because it has either dried out or become otherwise unusable, you are better off buying smaller jars or tubes of a color. Stretching color is not only a cost savings, but it reveals the heart of the color—its undertone. Refer to chapter 2 for a broad look at the variety of colors extenders possible by using mediums, and note the glazing segment on pages 106–107 for methodologies on how to use them.

GETTING THE MOST
FROM ONLINE SHOPPING

Art supply stores are a tactile and visual feast. You can see the colors, feel the brushes, try the pastels, feel the heft of a carving tool, and take a very close look at the nap of a handmade paper. As artists, our senses are attuned to the textures and colors of our materials. Shopping online is like mail-ordering a perfume you've never smelled before, based on its name or ingredients. It is, however, a reality of the modern age, and sometimes it is the only alternative for sourcing mate-

rials that are not readily available to you in your geographical location. If you are going to take this route, make sure you do your research first.

Make use of the resources in a good retail art store—pick their brains, look at the stuff, try it out if you can, get a hand-painted brochure—and then compare the products on site. A hand-painted swatch of color is 100% more valuable than a computer-generated idea of what that color might be. Make sure you hold on to it,

bolt it to the wall, laminate it . . . what-ever you do, do not lose it! This is an indispensable resource and the first place you should look when putting together your shopping list.

Thankfully, as the age of communi-cation surges ever forward, we are fortunate to have terrifically informa-tive Web sites at our fingertips to keep us up-to-date on the vast cornu-copia of materials available to us. So if you cannot find what you need in the aisles of your local arts retailer, this is truly the next best thing. These are also places you can use to put together your wish list.

CUTTING COLOR CORNERS

How can spending a little extra money make a world of difference?

Is your budget a concern? There are ways to shrink the cashier total on your art material bill without having to drastically cut back on your colors. Be sure that you are making an informed choice about the colors you are choosing. Beyond the must-haves—those particular colors that live in your perennial favorites list—certain colors can be substituted for similar ones that are a fraction of the price.

Hues exist to stand in for colors that are particularly expensive, toxic, or unavailable in the acrylic format. They are made up of alternative pig-ments and are designed to mimic the masstone, undertone, and mixing capabilities of the original color. For example, going with a cobalt blue "hue," made up of phthalocyanine blue and titanium white, will generally cost you less than half the price of a tube of true cobalt, and unless you have a phenomenal eye for color, you will be hard pressed to spot the dif-ference.

If you have a fondness for a specific color, and you are certain to use a sig-nificant quantity of it, purchase the larger size. Bulk pricing is always lower.

Within paint brands, pigment load quantities fluctuate wildly, and if you are keen to be ultra-frugal, do the research and find out which ones pack more pigment in their paints. It is actually more economical to buy fully loaded colors in a small size than large quantities of a lower grade of paint that utilizes the same pigment. The rationale behind this is that the high load of pigment can be extended effectively with medium but the same pigment in a student or economy for-mat will have added fillers alongside it. These fillers add a translucency to the color, diminishing its chroma. Larger quantities of filler will impede the successful blending of colors, causing them to "gray out" when mixed.

Many popular colors are mixes, and if you are not too fussy about match-ing exact tones, you can mix them yourself. For example, Payne's gray is a mix of black, blue, and sometimes violet. Each tube or jar of paint displays the pigments utilized in the makeup of blended colors, so it is just a matter of doing your homework and you can reproduce them with ease.

Acrylic Mediums

Acrylic mediums are usually available in medium to large quantities, as they have a tendency to get used up more quickly than the colors. If you are planning to add a great deal of texture to your paintings, or to produce multiple glazes, consider going for a good-sized jar (16 or 32 fl. oz./500 mL or 1 L). For those consuming even greater quantities, big buckets of mediums can be custom ordered from your local retailer, and if properly sealed they will last you a long while.

If you are just starting out with mediums, by all means experiment. One of the best (and most economical) ways to do this is to purchase a set, as they usually have mediums in smaller packaging (trial sizes) and offer a varied grouping. While you may not necessarily think you want every single medium offered in the package at the onset, you may be surprised to find that the medium you never thought you would use becomes a favorite.

If you would rather try just a few jars instead, choosing the following three basic mediums will give you a good foundation.

Gel Medium
These range in viscosity from very soft to those that have the consistency and holding capability of modeling paste.

Self-Leveling Gel Medium
It's one thing to work with a viscous gel that will hold a texture and quite another to manipulate one that will not. As self-leveling gels exhibit a consistency that is unlike that of the paint colors, they encourage alternative tool use and require using applications methods outside of more traditional processes. They are also great for stretching your experimental muscles.

Polymer Medium
From extending drying time to providing the vehicle of glazing, polymer mediums are probably the most useful mediums to have on hand. They act as an adhesive, clear coat, extender, and all-around acrylic Band-Aid.

Of course, this list will not suit everyone, but it does provide a broad starting point. Most mediums currently on the shelves are variations on these three formats, ranging from gels filled with inert materials for providing texture, to polymer mediums infused with UV-reactive components that glow under black light. First you acquaint yourselves with the basic elements, then you find the specific mediums that most ideally exhibit the properties needed for your process.

Using a large-format broad palette knife, swathes of petal-shaped tinted gel were applied to a non-stick palette. Once dried, they had great sculptural appeal and adhered to each other with nothing more than a bit of pressure.

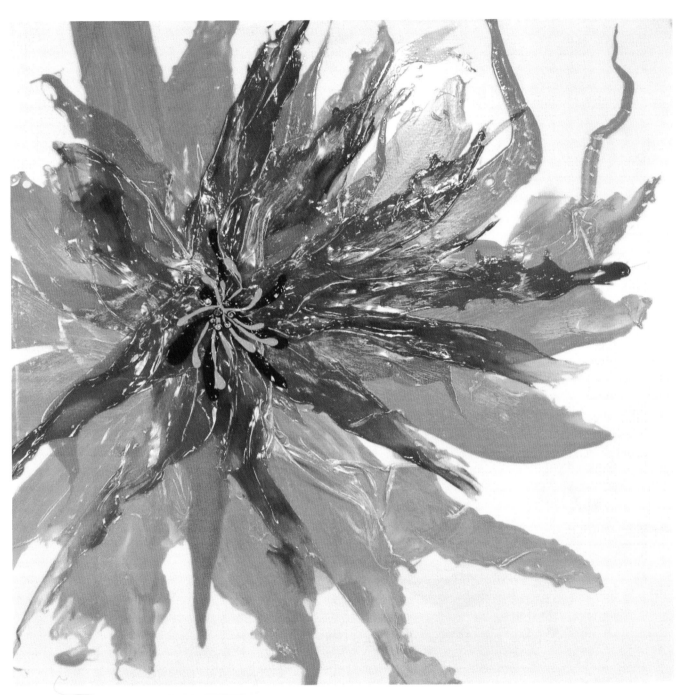

Rhéni Tauchid, *Sticky Stamens,* 2006, acrylic skins on painted canvas, 24 x 24 inches (61 x 61 cm). This demonstration painting was formed completely by using paint skins (comprised of 95% gloss gel medium and tinted with liquid acrylics) that were peeled from a non-stick palette. Each petal was first painted onto the palette; then, once dry to the touch, it was pressed to the painted background. No adhesive of any sort was used.

Q&A: SHOPPING

I'm a complete novice. What should I buy to get myself started with acrylics?

When starting out, I recommend that you get a bit of everything, and nothing in large quantities. Sample packages and sets are often a great way to begin. And, of course, talk with the folks at your local art supply retailer.

Here's a short list of supplies:

- gesso (acrylic emulsion primer, or whatever the term is for the particular brand)
- gloss gel medium
- matte polymer medium
- some colors you like (see following question)
- 140-lb. watermedia paper (hot-press is a good choice, as it will give you a better surface to try various textures on) and/or illustration board (cut to a manageable size)
- 2-inch synthetic wash brush
- assorted synthetic brushes (make sure to get a good variety of sizes and shapes)
- one or more hog-bristle brushes
- a palette knife (one with an offset handle is more comfortable for manipulating paint)
- a palette

What about color? Am I supposed to get the primaries to start with?

Only if that's what you like! A set of primary colors is very useful for color theory exercises; however, there is such a large choice of beautiful pigments in the acrylic color palette, it would be a shame to limit yourself to those basics. Just choose some colors that appeal to you,

and within that selection try to have some variety, enough lights and darks with which to mix. The main objective when starting with a new medium is to get the feel for it, so do that with colors that you are attracted to, thus making the preliminary exercises more visually appealing to you.

Be aware that colors go from very transparent to very opaque—a detail that is usually noted on the label. Not paying attention to this aspect of the colors could cause frustration. Also, make sure to get some of your colors in tubes and some in the liquid format. Don't limit yourself by sticking to a single viscosity format from the onset.

I've been working with acrylics for years but have never really tried working with the mediums. Where do I start?

It is not always an easy transition, going from using straight color to working with the awesome power of acrylic mediums.

Here is what you will need to get started:

- a set of assorted mediums (see below)
- an open mind

In addition, you'll also want to purchase the following tools:

- a selection of palette knives (small, medium, and large)
- a couple of color shapers
- supports (your choice, but try to go with a larger size to give yourself ample room to experiment)

If no set of assorted mediums is available, get some or all of the following:

- gel medium (G, SG, or M)
- polymer medium (G, SG, or M)
- modeling paste
- self-leveling medium (G or M)
- texture medium
- dry media ground

Purchase an assortment of matte and gloss mediums to experiment with various levels of luster and opacity. I also recommend purchasing both thick and thin mediums, as this will give you many more application options.

I feel as though I've painted myself into a rut. What should I buy that will shake my creative process up a bit?

We all experience this phenomenon. It is the necessary lull that occurs prior to any creative breakthrough. From a tactile point of view, one way to bust out of this rut is to let go of the components that make up a "safe" zone. The tools, the colors, and the formats that are the mainstays of your art practice need to be set aside for a time, as these

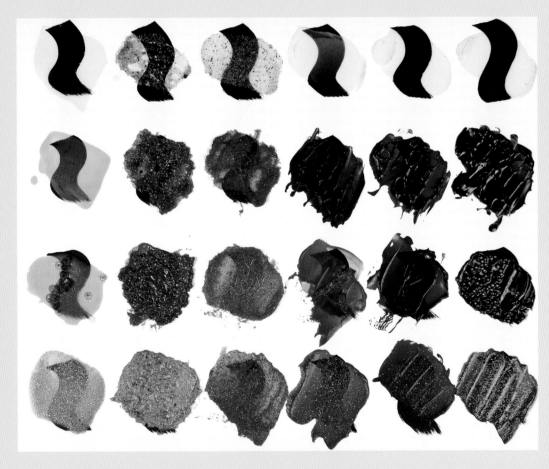

A few clear-drying mediums, both on their own and mixed with various colors and additives. From left to right: self-leveling gel; nepheline extra coarse gel; nepheline coarse gel; matte gel; semi-gloss gel; and gloss gel. From top to bottom: pure gel; gel plus transparent color; gel plus transparent color and embedded additives; and gel plus transparent color, interference color, and embedded additives.

can so easily become a crutch and an impediment to advancement. As artistic styles develop, it is as much a result of refining and honing physical technique as it is a stylistic evolution. When it's time for a change of technical process (for only you can dictate the content), I suggest these steps:

- Experiment with an unusually large painting tool. (Unless, of course, this is the type of thing you're trying to get away from using.) Large tools provide a perfect way to free yourself from the physical habits you may have formed using smaller and more precise tools. It will feel awkward and possibly frustrating at first, but persevering will push your creative muscles and open up your creative range.
- Try something new from the acrylic mediums shelf, regardless of whether it immediately appeals to you. You could surprise yourself

and find it is the tool that redirects your endeavors and takes your art into a new direction.
- Throw a new art medium into your experimentation. Shake up the surface with a creamy oil stick, or blow some graphite powder into a textured surface. Look to the mixed media and collage sections (on pages 128–141) for ideas on what to combine with your paints to add surface and texture variety.
- Return to practicing the basics. As no doubt you know by now, to keep a muscle toned, we have to work at it consistently. The art-making muscle requires the same attention, although as easily as we can put off that swim or run, we can neglect our drawing training. Regardless of which particular style of painting you do, a regular dabble into some gesture drawing or casual sketching will refocus your eye and bring discipline back to your hand.

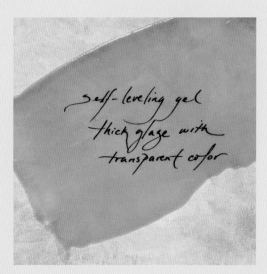

self-leveling gel
thick glaze with
transparent color

A thick glaze of self-leveling gel is transparent in its wet state, but once dry, the glaze color deepens, bringing the background text into sharp focus.

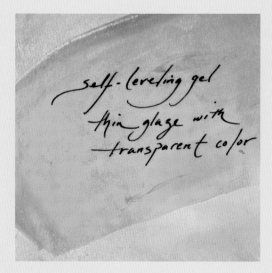

self-leveling gel
thin glaze with
transparent color

By contrast, the thin self-leveling gel layer is remarkably thin, but the even color adds depth to the surface without obliterating the text.

I have a limited budget. How do I get the materials I need without breaking the bank?

Be aware of the difference between buying "cheap" paints and taking an economical, but educated, approach. Cheap paints are generally just that—cheap, in both monetary value and quality. "You get what you pay for" is often all too true when it comes to art materials. Rather than gathering up an armload of those bargain pots, take the time to hone your list and make educated choices. A higher-quality paint, in a small quantity, will go further and perform and look better than a large amount of inferior paint. Mediums cost a fraction of the price of colors, so stock up on those; they will form the bulk of the paint film and showcase the colors beautifully. The key to being economical is to embrace those clichés: Less is more; quality not quantity. Hey, they're trite but true.

i've been painting with acrylics for decades, but I'm not very familiar with these newfangled mediums. Do I need them?

Need, in this instance, is not the right word. "Need to know" is perhaps the more apt phrase. Mediums are diverse and they are legion, and getting to know them is paramount to assessing their particular necessity. While, to some painters, mediums are indispensable, others paint successfully without mediums. This is a choice rather than an imperative. I will stress, however, that mediums not only serve to add variety and depth to a surface, but they are economical to use. The transparent and translucent mediums will also accentuate and bring out the chroma of acrylic colors. Acrylic mediums are designed to glorify and enhance colors. You would do well to give them a serious look.

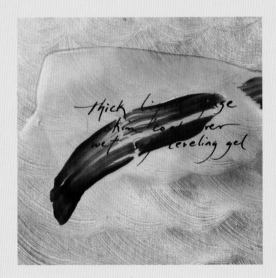

A sweep of thinned liquid acrylic is brushed over a pool of glossy self-leveling gel. As the gel dries, it spreads out, pulling the thinner layer apart and creating a crackle effect.

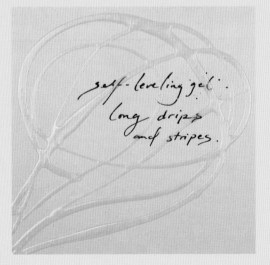

Dried strands of self-leveling gel distort the underlying text.

Chapter 6
basic techniques

"The trick is

to embrace

the qualities

of acrylics

rather than

fight them."

Acrylics are the pinnacle

of versatility within the art materials realm. They are the most plastic, the most malleable of any paint so far produced for artists. Though the term "plastic arts" refers to fine art in general, there exists no other medium, paint or otherwise, that can encompass the scope of possible creative manifestations like this revolutionary paint. By virtue of their binder (the acrylic polymer emulsion), acrylics can be molded to the artist's whim, directed and driven by imagination. When they are used in combination with the range of mediums—and further, with the range of supports with which they can bond—acrylics embody the spirit of les beaux arts; but more so, they embody the spirit of fine art now, today. Acrylics are truly the most expressive of all art materials.

The primary job of paint is to attach color to support, and it is to its great advantage that acrylic paints do their job with such effortless elegance. Basic painting techniques—from a la prima application to glazing and layering—take full advantage of the adhesive strength of the acrylics. Being sticky is not their only strong point, however. Indeed, acrylics add clarity of binder to the list of paint virtues, showing off modern pigments in all their glory. The colors bare their naked chroma to our eyes, unsullied by amber-toned binders. But take heed, as steps must be taken and rules observed to achieve and maintain this clarity. By understanding the paint vehicle, and taking to heart the rules by which to apply and manipulate them, basic acrylic painting techniques become uncomplicated. The trick is to embrace the qualities of acrylics rather than fight them. Use their quick-drying time, flexibility, and glossy appearance to your advantage and you will find that your work will gain depth, strength, and clarity.

The Time Index

Before getting involved with the nitty-gritty of acrylic painting techniques, we need to take a minute to consider an essential component of using acrylic paints—the time factor. You hear it or read it all the time: Those acrylics, they dry so quickly. It is the first characteristic of this paint to make it on anyone's radar. As you acclimatize yourself to the medium, this will come to mean many different things to you. It has a tendency to have a bit of a negative ring when coming from the mouths of die-hard oil enthusiasts, but an experienced acrylic painter recognizes it as one of the paint's most powerful features.

What gave Vermeer's and Rembrandt's paintings their profound depth and ethereal sheen was, at their core, excellent craftsmanship in combination with a simple system of glazing and layering. They accomplished these works using oil paints, mediums, and solvents—very different materials to our modern acrylics. Using the materials of our time, we can reproduce their processes to great effect but within a much shorter time frame and with significantly decreased risk to our health and environment. I have heard it said that oil paints are so much more difficult to master than acrylics, so much more sophisticated. I prefer to believe that to master oil paints all you really require is more patience. Every material takes time to master, and regardless of how complex the application process is, the first step toward real understanding is to become intimately familiar with the material. In accordance with this rule, the first step toward understanding

acrylic paint is to grasp the complexity of drying time.

Other styles of painting—in particular, fine detail work that requires sharp distinction between colors—are the forte of acrylics, when applied in thin films. Working with masking films, liquids, or stencils also takes advantage of the speedy drying time. Any layering that is done with acrylic paints or mediums is successful and effective if the drying time is well observed. (A word of caution, however: The timetable shifts considerably when mediums have been added to the paint; please see pages 52–53 for more about curing time for mediums.)

What happens when we do not heed the curing timetable?

This is one of the points where experience has a measurable advantage over the "just winging it" approach. The rapid-drying reputation of the acrylic vehicle can give artists a false sense of security and encourage them to forge ahead with applying layers too early or attempt premature varnishing. An uncured acrylic surface needs to continue to breathe. Volatiles are migrating through the film, and if they are blanketed by a fresh layer of wet paint, they can become trapped between layers. This will do several things. Initially adhesion will fail, and the heavier wet paint can slide on and around or off of the underlying film. Once the paint continues to dry, adhesion will improve; however, some volatiles may become trapped and remain visible. This is what gives the paint a milky appearance, particularly when a significant quantity of clear medium is used.

Akin to impressing a fingerprint in partially set gelatin, it is easy to damage the delicate structure of uncured paint. Whether it is your finger, brush, or palette knife that skirts dangerously near, the uncured paint film is a fragile surface. The uppermost layer of paint dries first, forming a skin of sorts, through which the water and other volatiles must push to evaporate. Applying pressure to this skin can cause it to rupture or take on the imprint of the tool.

Once a painting is finished, some of us have a tendency to rush the finishing stages, just so that we can be done with it and move on. Not heeding the warnings of some topcoats can be absolutely disastrous, and it all has to do with drying time. Topcoats, or final finishing coats, on acrylics can be several things. The safest are the full-acrylic polymers, as these have the porosity and flexibility to adapt to the painting, regardless of whether the full curing has been reached. Finishes that are considerably harder and less forgiving, like urethanes and epoxies, must be applied only once the paint has finished leaching volatiles, or they will become trapped there. Trapped water, glycol, and other volatiles can cause improper drying, adhesion failure, blistering, and even crackling. They dry to such a hard finish that they cannot adapt to the mechanical changes occurring in the paint film as it cures. So once your painting is finished, if you plan to add a final protective layer, follow package directions for the product to the letter, and if you have not already done so, test a small area first. It is better to exercise caution than risk damaging a piece with which you are otherwise satisfied.

When working with transparent glazes, why not create a key or a chart to remind you of successful color combinations?

Drying Time

Let us first be clear on the varying degrees of "dry" within the acrylic application world. There are three basic stages: dry to the touch, dry enough to paint over, and fully cured. The distinction between these can be a little blurry and are sometimes impossible to detect without scientific instruments.

The most deceptive aspect of drying occurs in thick paint films. Each paint film will not necessarily dry uniformly. Though they seem dry on the surface, thicker films will retain moisture for prolonged periods of time, as the volatiles contained in the bottommost layer make their way through microfissures left behind by those that escaped more easily from the surface layer. From application to full curing, this process can sometimes take from a few days to several months.

The factors that affect the evaporation process are ambient humidity, temperature, and, most important, paint content. A high-solids acrylic will dry more slowly than one containing more water. Inorganic pigments in a paint can speed up drying. The addition of mediums increase the acrylic emulsion component, increasing open time. Some mediums contain a larger degree of glycol (glazing mediums), and if a retarding additive has been used, the film will remain sensitive for a longer period of time. Given all of these scenarios, it is not possible to give a definitive set of parameters for drying time. What is possible, however, is to give you tips on how to detect at which stage your painting surface is. To that end, I offer a simple evaporation road map here.

"I taught myself to paint with acrylics. It seemed painful at first, like painting with glue, but now I can't imagine using another medium. I allow the underpainting to show through in the backgrounds as a textural element, and I juxtapose this with highly rendered details. I build layer upon layer of paint to help achieve luminous color, adding color glazes in areas. Sometimes I paint on grainy wood, which lends a folk art look to the piece. I am continually amazed at how forgiving acrylic paint is."

—Jody Hewgill

Touch Dry

The first stage of dryness occurs after most of the water in the paint has evaporated. During the evaporation process, there will be a marked temperature difference in the paint film. This can be felt through most thin porous supports, like canvas or paper. Checking to feel if the back of the support is cool to the touch will alert you as to whether the majority of the evaporation process is still occurring. Once room temperature has been reached, the majority of the volatiles will have been released from the film, and the more sluggish travel of volatiles, like glycol, continues until the film has cured.

Jody Hewgill, *Seasons,* 2006, acrylic on wood panel, 19.5 x 18.5 inches (49.6 x 47 cm)

Set Dry

The set-dry stage can last from a single day to several months, depending on drying conditions, support, temperature, and humidity. This is the delicate period for acrylics, as they are still quite vulnerable. At this point, the paint surface is tacky but no longer wet enough to be moved around. The deceptive appearance is inviting and looks ready to receive the next paint layer. If the paint film is firm and of moderate thinness, a fresh application of paint will not harm it. The greatest concern, however, is that the acrylic will not clarify, as some volatiles remain trapped in the paint film. This will be most noticeable with applications of clear mediums and lightly tinted glazes. Trapping moisture is of particular concern on nonporous surfaces, as the movement of the volatiles is limited to evaporation through the paint film.

Paint films that have been treated with retarding agents and self-leveling gels tend to take longer to fully cure. When layering thick coats of mediums, the second layer can rehydrate the first, if it is applied too soon. This will vary from surface to surface, dependent partially on the porosity of the support and the physical drying properties of the mediums. Self-leveling gel has a tendency to re-wet any uncured gel and cause it to lift in small folds and later level out, causing small craters to form.

Fully Cured

Although it is difficult to pinpoint the exact time at which an acrylic paint film is fully cured, it is still something that we should strive to predict with some accuracy. There are two primary scenarios where full curing is imperative—before varnishing and when creating dimensional work.

Some products labeled as acrylic varnishes or finishing coats are actually modified polymer mediums. These can be applied prior to full curing, as they will not inhibit the curing process. Those that will inhibit the curing process, however, are top coats and mineral spirit–based varnishes. These create a stronger seal and are tough, and some have a tendency to shrink as they harden. If the underlying paint has not cured properly, this can create an unstable bond or cause mechanical failure of the top coat.

"Acrylic befriended me at a very young age and has never let me down. He stood by patiently while I flirted with other sorts of paint and was ready for my return with a wave of sumptuous colors and an army of liquid and gel mediums. He meets all of my demands—drying fast or drying slow, standing in tall peaks, or laying flat and silky smooth. Layer after layer his color gains a rich depth and luminosity. What do I do for him in return? I lend him my voice and together we tell a story."

—Brandi Deziel

Brandi Deziel, *No Time to Talk,* 2007, acrylic on panel, 48 x 48 inches (122 x 122 cm)

The Water Element

Water is white. Well, not really, but this is the color it appears to be when it is floating around in the wet paint film. Although water is an important component of the paint, and a useful medium, once it is through doing its jobs, water needs to leave the building and leave no drop behind. As the film dries and the water evaporates, the film clarifies, suspending the pigment and showing it off in a virtually transparent film. Water molecules trapped in the wet acrylic emulsion soup take on an opaque white appearance. This is more evident in an acrylic medium than a color, where the pigment disguises much of the whiteness.

The addition of water can have a significant effect on the drying time of acrylic paints. As water spreads out the acrylic polymer molecules, it opens up more channels for evaporation. A diluted wash of color will dry very rapidly, as there is not enough acrylic surrounding it to hold it back. The larger the quantity of acrylic solids, the longer the paint takes to dry.

Self-leveling gel is a viscous sea upon which colors float and can be manipulated into sensuous designs. The gel changes from white to clear as it dries.

Phthalo blue paint brushed into wet gel medium on transparent Mylar creates a series of delicate, feathery swoops.

EXAMINING THE CONSTITUENTS OF AN ACRYLIC COMPOSITION

The construction of the core of a painting relies on two crucial aspects: adhesion and curing. You can build up a substantial and dramatic impasto, add heavy collage elements, and apply layers of luminous glazes without mishap when those two factors are dealt with responsibly. Ignore them and your painting could well fail. The bonds between substrate, painting ground, paint layers, and finished surface are what will give the piece stability and uniform flexibility. Curing time, if well heeded, will prevent the trapping of moisture in the paint film, which impedes clarity, compromises structural integrity, and causes poor adhesion between layers. The concepts are all very straightforward, logical, and simple to put into practice.

The basic components of a successful acrylic composition are as follows.

Groundwork

This is made up of substrate and painting ground, though in some cases no painting ground is necessary. Acrylic paint has the virtue of being the most adaptable paint available. What makes up the primary aspect of this reputation is its ability to maintain permanence on a huge variety of surfaces. Do not assume, however, that this feature is always a simple matter of slapping paint on support. Each type of support comes with its own particularities. In some cases, certain modifications need to be done for the acrylic to properly join with it. The preparation phase of constructing a coherent ground consists of cleaning, sealing, or abrading it. In simple terms, this is known as priming the surface.

Paint Layers

For a paint to adhere to a surface, the paint format and application need to be matched with the substrate. This said, the majority of properly prepared supports can become home to any of the acrylic formats—from high-viscosity paints to those having consistencies of ink. Explore the chart on supports on pages 58–59 to find out how to prepare your surface for optimum adhesion.

Finished Surface

To complete an acrylic painting you must prepare the surface to be maintainable within its environment. A solidly put-together acrylic painting, painted on to a semiflexible or rigid support (canvas, board, and so forth) will usually fare very well without any additional protection. The acrylic itself provides a significant amount of UV protection, water resistance, and physical durability and does not require framing behind glass or varnishing. In some cases, however (when a work is produced on delicate paper, or in very thin washes, for example), using glass as a protective barrier against the elements is a good idea. Some pieces, such as those that are meant to be handled or that are physically fragile, may require a more substantial and direct sealant. This consists of adding a finishing coat or varnish, if applicable. In addition, you might consider framing or otherwise presenting the work. (See pages 150–152 for a thorough discussion on this subject.)

Traditional Applications

In many texts, and in many minds, acrylic technique is not described as such. There is a tendency to talk about acrylic usage in terms of being watercolor-like or oil-paint-like. This informs us about acrylics' versatility but at the same time robs them of their stature as having endemic processes to call their own. What actually *is* the acrylic process? That is a tough thing to pinpoint, as it has too many facets to be defined by or limited to a specific methodology. And therein lies its strength and its beauty. There is no singular signature "look" for acrylic paints. They are a changeable, ductile creature, capable of masquerading as other media with ease. This is precisely their forte, but incidentally, this is also what gives them an elusiveness and what challenges art academics to pigeonhole them or catalog them into a limiting niche. Rather than try to cram this octopus of paints into a straitjacket, it is time to respect and celebrate its versatility. Let's take a look at some of the traditional and more common applications of acrylic paints.

Wet Painting Techniques

The techniques that fall under this heading include numerous variations on a water theme. When talking about watercolor paints, the wet-in-wet application is pretty much a single process. Not so with acrylics. The multiple personalities of the acrylic medium make this, the most basic of processes, a multifaceted one.

Basic Wet-in-Wet Application

This classic watercolor technique is equally effective with thinned acrylic paint. Wet the paper, water the paint down a heck of a lot (i.e., create a wash), and apply the paint to the paper. This will result in smooth pools of color with indistinct feathered edges.

Wet Paint in Wet Medium

Polymer mediums not only keep colors open longer, but they act as a floating platform for color. The basic technique is as follows: Apply a liberal amount of thinned polymer onto the support, then

Colors are blended using a very dry brush on a very dry ground.

Drops of watered-down liquid acrylic create blurry halos on a wet, absorbent surface.

Two colors are blended in a single sweep, using a very wet brush on dry paper.

add liquid color (which can be diluted for increased flow). Mixing the two creates a swirling, fluid pattern.

This technique can be varied in a number of ways, however. Using straight (unthinned) polymer creates another effect altogether, and this effect is further variable depending on which mediums are used. The interplay between disparate viscosities results in forming incidental textures, and these are exaggerated if the mix is not completely homogeneous. The greater the viscosity difference is between top and bottom layers, the greater the texture disruption. Mixing two layers with similar viscosities will result in more of a feathering and migrating effect, whereas mixing thin into thick will create some cratering in the paint, and some of the thinner paint will lay on top of the thicker medium rather than penetrating it and blending with it. Working the paint in will produce a more blended result.

Thick Color into Thick, Clear-Drying Medium

This is a messy process and in some ways it is the most freeing. It is nearly impossible to get finicky with details using this method, and thus it is a great way to loosen up and fly a bit blind. I find this method particularly interesting when working over an underpainting, primarily because the end result of working into the white medium will not emerge until it has fully clarified. Lightly working the color in will result in flowing striations throughout the gel, fluid movement trapped in resin.

Dry Brush Applications

A whisper of color on a dry brush does not seem like it can do much to modify a surface, but this is one of the most effective ways to change the appearance of a color or bring out the minute details in an impasto surface. What may not look like a lot of paint will actually cover quite a large surface area. To get the most even results when dry brushing, apply a small amount of paint to the brush and work it into the bristles so that they are all evenly coated. Then blot most of the paint off onto a porous surface (a rag or some scrap paper). Applying even pressure, sweep or swirl the brush, and it will leave a vaporous smudge of color. This can be used as a subtle blending method.

The addition of an opaque color, dry brushed over a glowing field of transparent glazes, pulls the surface texture forward.

Imprints and Tools

There are two distinctive methods of applying paints—those that use a guiding tool and those that use an application tool. The former process involves applying color to the surface indirectly, and the latter involves applying color directly.

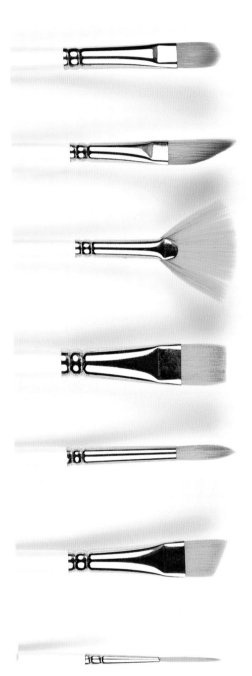

Left: There is a large variety of brush shapes, each leaving a unique imprint. From top to bottom: filbert, dagger, fan, flat, round, angled flat, and liner.

Right: Iridescent pearl shows off the individual strokes left by various brush styles.

Templates

Guides, or templates, can include stencils, masks, resists, or stamps—essentially, any tool that guides the application of color indirectly onto the surface. A template can add precision to a repetitive pattern and hard edges to a composition. Working with high-viscosity and liquid color with stenciling, stamping, and masking tools is both easy and effective.

Brushes

Application tools (most commonly, brushes) are used to apply paint directly to the surface. The placement of the paint is determined by hand/body movement. What acrylics give us, in their infinite versatility, is choice. Working with a single viscosity will dictate which tools to use for maximum effect. As acrylics are not limited to a single format, we can pick and choose which style of paint would be ideally suited to a specific technique.

GETTING THE MOST OUT OF YOUR TOOLS

In whatever format, thick or thin, acrylics are very well suited to a variety of brushwork techniques. There are many styles and bristles from which to choose, and each will add its unique influence to the resulting application. The viscosity and rheology of the paint format has a great deal of bearing on which brush you choose. A heavier, springy bristle will be more efficient in pushing around high-viscosity paints and mediums, while being too coarse to provide even coverage with a less viscous format. Detail work will be more effectively accomplished using paint with a low viscosity and short rheology, and for this purpose soft bristles (designed for watercolor applications) are perfectly suited to the job. Here are some tips to help you along the path to deft brush handling.

1. To add flow to your brush, first immerse it in water so that it is completely saturated, then dab the excess water off onto a rag. The wet brush will absorb the paint more evenly. Dip your brush into the paint, dabbing off any excess paint, and apply. A wet brush will apply paint more smoothly and with better flow than a dry one.

2. To create fine detailing, dilute a small amount of color on the palette with water, then use a wet (but blotted) brush to collect the paint. Run the edge of the brush along the side of your water container to sharpen its tip.

3. To achieve greater control on details, use a brush with short bristles or a brush with a short handle.

4. To add flow to a wet application, use a synthetic brush. It will not absorb the paint and will allow for longer sweeps of color.

5. To wick away moisture during a dry-brush application, use a hog-bristle brush. (Natural hair bristles are frequently more absorbent than synthetic bristles.)

6. To smooth out edges and create transitional blends between colors, try working double-handed. Painting with a loaded brush in one hand and a clean brush in the other can increase your efficiency and allow you to use multiple techniques during the short drying window.

7. To create a rough impasto texture, use a coarse bristle brush and create short, brisk strokes. Conversely, to create a smooth flowing texture, use a fine-haired brush and create consecutive, long strokes.

8. To decrease the appearance of brush strokes, dilute the paint to a waterlike consistency and use a finer bristle. The coarser the bristle, the more pronounced a texture the paint will retain.

BLENDING WITH ACRYLICS

Blending with acrylics; that's a ticklish subject. We make the broad assumption that it is easier to blend with oil paints than it is with a fast-drying paint like acrylics; and this is true, but only when it comes to certain types of blending. This is not a single-technique process. It actually is possible to achieve smooth brush blends with acrylic colors, but you have to either work freakishly fast or use a couple of tricks to facilitate and slow down the process. Clearly, the easiest route is to use an additive of sorts. Which additive you chose will depend on a number of factors, and each has its particular idiosyncrasies to be reckoned with.

Retarding Agents

The most basic additive is the acrylic retarder, an innocuous substance comprising mostly propylene glycol. It is fairly effective, though frequently overused. Too little acrylic retarder and the paint is unaffected; too much and it will not cure properly. Read the package instructions, as each manufacturer has its own ideal balance proportion. Suppress the urge to be liberal with retarding agents. An acrylic paint film that is overfilled with them will dry unevenly, could potentially be reactivated by new paint layers, and in some extreme cases may fail to cure at all.

Working on a surface that has been partially saturated with acrylic retarder is a boon to plein air painters. It minimizes the need for carrying nonessential mediums and cuts out onsite mixing. For good results, work a single layer of undiluted acrylic retarder directly into the substrate with a brush and allow it to dry completely. The time it takes to prepare a surface in this manner ahead of time makes up for itself by the insurance that no surplus of retarder will be used, and the evaporation process can occur unimpeded by overly glycol-soaked paint.

Retarding gels, which are the consistency of petroleum jelly, viscous and gelatinous, add another dimension to blending. They impart a slippery quality to thicker paints and are particularly useful for printing applications. As a blending medium, they also need to be used quite frugally, though their addition will render viscous paint considerably more workable. When adding this type of medium, take into account the time necessary for proper evaporation and curing. The thicker the acrylic layer, the longer one should wait. A period of 24 to 48 hours should be sufficient waiting time prior to applying additional layers.

Flow-release agent is an amplified version of an acrylic retarder. It comes under a few similar names, but essentially it is the same type of stuff. A fine line or mist of paint blended with this additive can dry in a relatively short period of time, as the volume of paint on the support is quite small. (Indeed, flow-release agent is intended to facilitate the flow of paint through airbrushes, pens, and other precision tools.) Applied more liberally, as with a brush or spreading tool, flow-release agent will result in a wet, sticky film that will not be workable but that will continue to attract dust and could be easily damaged for extended periods of time. This is a case where the addi-

tive should only be used for the tools and processes for which it is intended.

Water

Water hydrates, and if you want to extend the open time of paint, adding water will definitely help. It can be spritzed on to the paint on your palette to keep it from drying out before use, or onto the painted surface during or after application. Water also acts as a good floating and staining starter, when applied in such a way as to permeate the support prior to applying paint. It breaks down the surface barrier and allows the paint to flow more easily into the surface of the support. Liberally spritzing water on to your painting as you go can be unpredictable, however, and is not suited to all styles of painting—add too much of it and it will pool (horizontal surface) or drip (vertical surface). Adding water to the brush itself gives more control. This is sometimes better than adding medium, which can be too thick and produce a texture that will interfere with the blending process. Allowing pools of water to sit and absorb into a thick paint surface can cause it to craze.

If you are looking to break down a surface texture by smoothing it with water, I recommend using a soft, wide brush (a Taklon fan works well) and lightly blending the water into the topmost layer of acrylic. Wiping off the brush frequently and re-dipping it

A band of nepheline gel makes a great ground for blending colors.

into clean water will facilitate this process. Understand that water evaporates quickly from the paint, particularly if the atmosphere is dry. Using it when working en plein air may not do much to slow things down, as it will evaporate almost as soon as it is applied. In these circumstances, it is more effective to use more acrylic (i.e., an acrylic medium) as your hydrator.

Acrylic Medium

Adding a quantity of fresh acrylic medium to a blob of wet paint acts to keep it hydrated by creating a thicker slurry of solids and liquids. For blending purposes, an acrylic medium is more controllable than water; however, while it keeps the paint wet a bit longer, it may be trickier to use than a retarding agent, as it also adds volume to the paint, which has the potential of producing a texture that will interfere with the blending process.

Substrates and Underpaint

The surface is crucial. Check its porosity, and also how the paint flows over it when laid thick and thin. The type of surface you work on directly affects how rapidly and uniformly your paint will dry. The more porous it is, the more quickly the volatiles will be absorbed. A nonporous surface forces the volatiles to evaporate upward only, rather than in two directions at once. It will take around twice as long for paint on a nonporous surface to dry and significantly longer to fully cure. Fresh paint laid over a dry layer will partially absorb into it; the volatiles, through capillary action, slowly work their way into and through the paint, while the acrylic latches onto it and coalesces with the film. Papers

intended for water media or inks contain a quantity of sizing that will block some absorption. Synthetic papers have little or no porosity and allow for considerably longer blending times. The glossier the surface, the more it will allow the paint to flow on the surface. Mylar poses an interesting surface challenge; as it is nonporous, it allows the paint to flow longer. (Frosted Mylar is particularly effective in this respect.) Canvas, when unprimed, will soak up paint, allowing

Smooth rocks are a pleasure to coat with paint, as they are lightly porous and coarse. The paints blend silkily over their dry surface.

The reflectivity of the gold paper adds a glow to the phthalo blue glaze applied with a fingertip.

blending only in wet-in-wet applications. A primed surface is far less absorbent, allowing paint to be worked for several minutes before setting. A single coat of gloss medium will reduce porosity on a surface, while a matte medium will increase absorption but at the same time provides tooth for more uniform blending.

Technique and Brushwork

When blending paint, what demands the highest degree of skill is not what you put into it or what you put it onto, but what and how you put those elements together. Wet-into-wet methods are fine for loose color blends, but they are somewhat unpredictable, as they are affected by the porosity of the substrate, the tools used, and the fluidity of the paint. Very wet color is most easily manipulated with brushes, rather than rigid tools. The bristles take up the liquid, which helps to distribute it over the surface. Wide fan brushes, with their thin sweep of bristles, are the consummate blending brush. Angled flat brushes, ranging from the width of a finger to the breadth of a palm, are fantastic for directing paint in geometric formations, while small rounds can pull and coax paint into valleys and corners.

In every type of blending, fingers (whether wet or dry) are tools that are often used but barely talked about. Spreading and wiping colors using nothing but your fingertips can produce a surprisingly smooth texture, with subtle striations left by the texture of the skin.

All types of brushes can be used for dry brushing, but the coarser hog-hair brushes have the right bristles for the job. They are somewhat absorbent, soaking up the moisture of the paint but leaving the color clinging to the individual hairs. Scrubbing these brushes into the surface deposits the color, like dust, into the microscopic texture of the acrylic surface.

Waiting for the paint to be partially dry can help with blending processes. Provided the film has not yet reached the tacky stage, the top layer of color is loose enough to be lifted with a brush (filberts work exceptionally well for this) and worked into its neighbor. There is a relatively small working window for this technique, and it requires a bit of practice to perfect.

A light application of dry color to the ridges of the gel pulls the relief into sharper focus.

WORKING WITH TRANSPARENCY

While acrylics used to be uniformly opaque, an abundance of transparent colors liven up the modern acrylic palette. They range from deep, jewel-like hues to subtle earth tones. Their forte lies in layering, whether in a glaze or delivered a la prima. Repeated layers of a single transparent color will create resonance and depth that elude a single application of the same color in an opaque format.

What may not be initially apparent is that the majority of transparent colors are also among the strongest ones. Usually comprising high-performance synthetic organic pigments, and heavily loaded with minuscule pigment particles, a small quantity of these powerful transparent pigments can produce a large amount of color. This is a generality, however, and there are some exceptions. Ultramarine blue, for example, is a pigment with a fairly coarse pigment size, but those particles are transparent, resulting in velvety matte color that imbues a glaze with shimmering twilight tones.

A note on transparency: From thin glazes to deep color and clear sup-

ports, so many effects can be created with transparency. Acrylic mediums can be used to facilitate transfers, create lush glazes and transparent colors, or enhance layering qualities. With the addition of light, they can also magically enhance both colors and texture.

Transparent and translucent color has an elusive, seductive quality, urging us to look deeper into a composition, hunting for the elusive color veils laid layer over layer. The surface appearance of a painting rich with transparent layers, be they color or naked medium, carries a life and depth that is lacking in an opaque application. The rapid drying process of acrylics is a boon to color layering, allowing you to produce luminous color within a reasonable time frame. With their clarity of resin, acrylic mediums are in essence a vehicle of light. A glossy medium will produce a distinctive shiny surface, but beyond that, it will carry the light into the painting, deepening colors and imparting a glow to the painting. This is a tricky type of surface to photograph and is best viewed with the naked eye.

Transparent colors are especially well suited for glazing, tinting, building depth, staining, and subtle color mixing.

Like banners of stained glass, transparent color bands allow the light to pass through each color, enhancing its chroma, showing off its brilliance.

WORKING WITH OPACITY

It is sometimes assumed that if a paint did not cover well, then it is of poor quality, low in pigment strength, and somewhat inferior. The truth is a revelation: In the artist pigment world, the opaque colors—those "coverers"—are the ones that usually have low pigment strength. Nevertheless, they inhabit quite comfortably the role of quality pigments and are in no way an inferior paint.

Opacity is achieved primarily through the size and density of a pigment. Like large, ungainly boulders, they bounce around in the acrylic emulsion, blocking out the light with their mass—their surfaces impeding our gaze, their bulk adding subtle tooth to the film. Using these opaque colors is a boon to detailing and outlining. They allow for a sharp precision that is clearly separate from the tones around them, obscuring the underpaint and pulling the detail forward. For blocking out areas of color and distinctive hard-edge painting, these are the colors from which to choose. They provide you with the ability to create large swaths of uniform color, as the overlapping strokes of the brush do not intensify the colors as transparent ones would.

Opaque tones produce an air of mystique when used to tint a glaze. When working with these colors, it is imperative to be conservative in your proportions. Use too much color and you will lose the transparency altogether. A small amount adds an almost milky tone to the glaze, providing a translucent mass that softens and suffuses the glaze with a foggy aura.

Opaque colors are especially well suited for detailing, obscuring underpaint, pulling color forward, opacifying, adding translucence, blocking out color, and creating uniform color.

Blocking out areas with opaque colors creates dramatic contrasts, producing a sort of optical depth.

GETTING THE MOST OUT OF OPACIFIERS

A staggering variety of relative coverage and color is possible in the acrylic palette—from the lushly transparent to the stubbornly opaque. One would think that we would be satisfied with them as they are! However, there are times that we, either fueled by design or desire, want to change the covering characteristic of a color and make what is clear more obscured. A number of products, available on both the mediums and the color shelves, can be used to opacify your paints.

Whites

Two white pigments are available in the acrylic palette: titanium and zinc. Titanium white comes in several shades—from the brightest pure blue-white to a buff tone called unbleached titanium. Many lines will also have a shade in between the two, called warm white. Each of these is a variation on the titanium pigment and is extremely opaque. Used to opacify colors, they will transform it quite substantially. However, the best white to use for the purpose of opacifying your pigment is one manufactured with the zinc. This is a more semiopaque white, which will not alter the chroma as dramatically.

Opacifying Medium

Not every brand carries an opacifying medium, but if you can find one, it is worth having in your studio. The job of an opacifying medium is to increase the relative coverage of a color with the

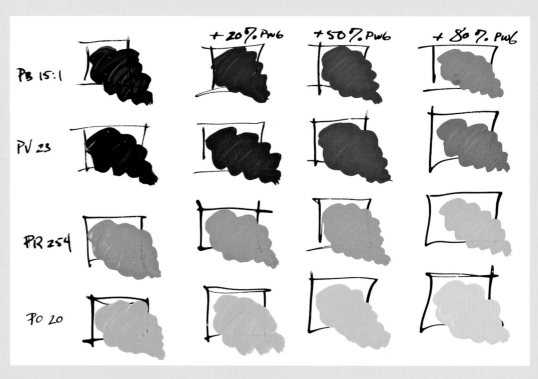

Colors tinted with different amounts of titanium white (from left to right: 20%, 50%, and 80% respectively) show their proportional staining strength.

minimum color alteration. There is no set amount of medium that can be added to the color, as each pigment exhibits a varying degree of opacity. Opacifying mediums show their effect only when totally dry, and thus experimentation is necessary when using this valuable tool.

Translucent Medium

Gloss mediums are the clearest vessels to extend color with because they contain no matting agents or other additives. The addition of these solids causes the dry medium to appear more translucent. (The medium will then be called a matte medium.) This can serve to slightly opacify colors, though it is a subtle change, like viewing a photograph through frosted glass. Clear modeling pastes and clear gesso contain even

more solids, in the form of calcium carbonate, which further add to the haze.

Opaque or Semiopaque Color

At times, the color shifts that occur with a white paint or opacifying medium are too dramatic. An alternative is to find a semiopaque or opaque color that is similar enough in tone to the color you wish to opacify.

None of these is working for me. What should I do?

If you want to simply see the true tone of a transparent color without modifying or obstructing it, apply it undiluted on a white or light ground. It is that simple. Lay down a new ground in that area, white it out, and add your paint.

Experimenting with opacifiers. Two transparent colors were used to show the opacifying strength of various paints and additives. From left to right we see the unadulterated color, the color plus zinc white, the color plus titanium white, and the color plus an opacifying medium.

The Great Resistance

Sometimes we want acrylics to be repellent, but in a good way. Playing with absorption, the push and pull of gloss versus matte can produce those serendipitous accidents that give dimension to an otherwise flat surface. Paint adheres in different measure to glossy and matte surfaces. A wash-thin application of color over a matte, absorbent area will saturate the surface readily, resulting in deeper color than if the same color were painted over a slick, glossy surface. As long as there are distinct variations in the degrees of gloss on the surface, a thin wash or glaze will adhere with visible difference.

A fun exercise, and an effective method for blocking out color in an underpainting, is to use a gloss polymer medium to "draw" onto an uncolored ground. Once dry, this drawing will resist the subsequent application of color, which will soak into the background. This works particularly well on watercolor paper.

Can you use masking fluid and/or tape when working on a synthetic paper surface?

Synthetic paper is predominantly a polypropylene product, a surface to which acrylics have fairly poor adhesion. The coating on the paper does allow for a certain degree of absorption, but it is largely water resistant and will not allow the acrylic to form a strong bond. It is fine to use synthetic paper when working with light paint applications, as it is a beautiful surface onto which to float colors, but it is a disaster when using masking tools of any sort. The reduced adhesion of the paint to the paper plays second fiddle to the great bond the paint has to itself. Given the choice, the paint will stick to itself and run away with the mask. I have had limited luck with very highly diluted paint; however, if precision is your goal, opt for a more absorptive surface and save yourself the frustration.

Gloss polymer, thinned down to an ink consistency, repels the sweep of color on this smooth, coated paper.

Masking Tools

Acrylics constantly borrow techniques and tools from other paint media. Delving further into the watercolor technique toolbox one discovers masking fluid, masking film, and masking tape. Working with these types of materials can be problematic and finicky when working with thick acrylic applications, but not so with washes. Reducing the binder in the paint film decreases the probability that the paint will adhere to the mask and be pulled up along with it. Masking areas of a surface works extremely well with wash applications as well as with airbrush work. However, unless the paint is extremely thin, it is a good idea to remove masking tape while the paint is still a little wet, as sometimes a heavier color wash can be cohesive enough to pull up with the tape when dry. Keep in mind that acrylic paints dry to a very strong bond, even at a high dilution. The more concentrated the acrylic, the stronger the film. If the paint over the masked area is too thick, it will be difficult to remove the mask cleanly once the paint has dried.

Adhesive masking film works beautifully to produce crisp imprints.

Here, Liquid Mirror has been applied through the stencil cut in the masking film and onto a wood panel to create a pleasing contrast of visual texture.

Mixed Media Resist

Art materials that comprise either oil or wax will naturally repel water-based media. There is an abundance of such media—many of which can be used to create a resist with acrylic paints. Some of them remain as part of the materials mix, while others can be scrapped, melted, or wiped away with solvent.

Wax comes in several forms. Ready to use and tinted, crayons aren't just for kids anymore. Though they don't leave behind enough wax to resist thicker paint applications, these little color sticks can create an interesting effect with thin glazes or washes. Pure paraffin, beeswax, and encaustic colors repel the paint more forcibly; they can also be scraped away quite easily, as they will not bond well at all to the paint surface. For some bizarre (though dubiously safe or permanent) effects, try heating the wax when the paint is in various stages of drying.

Oil-based media are more effective than wax in completely snubbing the advances of acrylics. The classic opposition between oil and water is exemplified beautifully by their combination in resist effects. Oil, as a physical repellent to the aqueous components of the acrylic vehicle, can be applied to a surface in the form of oil paint, oil stick, or oil pastel. The fattier the medium, the more readily it will repel the paint.

Resist elements must be removed with care and a light hand. If the paint has been laid into a thick layer, removing a wax resist can result in pulling and tearing some of the film. A razor blade can be used to scrape the wax away. Softening the wax with the heat of a hair dryer can make it easier to remove, although this can also cause it to melt into an unprimed support.

Some oil and wax media can be buffed away with a cloth; however, this will leave a residual layer on the paint surface. Using solvents will effectively remove oil-based media, but this can also significantly soften and potentially damage the acrylic film. Good results can be achieved by using a soft, lint-free cloth or cotton swab to apply a small amount of mineral spirits with light pressure. Scrubbing too vigorously will force some of the oil into the paint film, which will impede subsequent adhesion.

Hot paraffin wax pooled onto the painted surface and cracked after drying allows for a thin wash to seep through the crevasses and stain the underpaint. The wax can then be removed with the side of a metal palette knife.

Distress Techniques

Masking and other resist elements are not the only methods for removing or manipulating paint saturation and movement. Distressing acrylic surfaces by getting rid of some of the surface layers can be accomplished in both wet and dry states, using various tools to reveal the underpaint and create unexpected results. Wet paint can be lifted from the support washing, blotting, or scraping it away. Once dry, the paint can still be partially or completely removed with the use of acetone or by the more imprecise method of simply sanding it right off the support.

Most removal methods are just that—imprecise. Acrylic will bond to various surfaces according to the strength of the adhesion, and the uniformity of the bond will vary according to the textural structure of the underlying support as well as its porosity. Because of this, removing the paint from nonporous, untextured materials will be most effective and even. Removal from porous, textured supports, particularly those with varying degrees of surface porosity, will produce a more distressed and haphazard effect.

One effective dry-removal technique is to take off a layer of paint with a sandpaper pad.

Alternatively, a cotton swab dipped in acetone can easily lift the top layer of paint away.

Glazing

What does a glaze do? What is its purpose? Glazing is all about light and depth. Imagine panes of stained glass, one laid one on top of the other; together they build a tower from mantles of color, until the optimum saturation and luminance is achieved.

By virtue of the clarity of the resin, glazing is the forte of acrylics. The acrylic resin is a transparent conduit of light, pulling brightness down through the layers to the underpaint, reflecting it back, and imbuing it with radiance. This process sounds almost celestial, and to our eyes, it substantiates the difference between a lifeless surface and a color field that sings.

How to Glaze

So how does one glaze with acrylics? It is a fairly simple formula, with an infinite number of variations. As there are so many options, some of which are undoubtedly yet to be explored, here are the essential elements of the process:

Glaze only onto a dry surface. A glaze works to blend colors optically, creating lively, luminous colors. Painting a glaze into wet paint destroys this effect. The idea is to make an optical color blend. This is accomplished by overlapping veils of transparent or translucent layers.

Allow glaze to dry between layers. The more clear medium is used in a glaze, the longer the drying period will be. If the surface of the painting is still sticky, do not apply the glaze.

For the most transparent glazes, combine transparent pigments

Producing a glaze with just the right color mix or intensity may require some testing. First, create glazes of various strengths and colors.

Next, mix your sample glazes. Use a clean brush for each glaze to ensure that you don't cross-contaminate the glazes.

with a clear-drying, glossy medium. A glaze can be created with semi-opaque and opaque colors; however, to achieve optimum transparency (and unless a more translucent glaze is specifically desired), these kinds of colors should be used with restraint. Matte mediums produce more translucent glazes.

When making a glaze, take care to fully mix the color into the medium. If the two elements of the glaze are not properly combined, streaking or clumping will occur. Liquid, ink, and airbrush colors are ideally suited to tinting glazes, as they are already thin and will disperse more readily into the medium. If high-viscosity colors are all you have available, thin them with a small amount of medium or water prior to mixing your glaze. This will break down their viscosity and make them easier to mix.

Decide how saturated you want your glaze to be. This will determine how much pigment to use. Even a dramatically transparent pigment will appear somewhat opaque if it is used too heavily. It is like cooking with salt. Add a small amount at a time, as too much will spoil the soup. In the same spirit, add the pigment little by little, testing the intensity of the glaze on a white surface as you go, until the desired saturation point is reached.

Glazes unify areas with a common hue and turn up the wattage on the luminosity of a painting. If the tinting is applied in very low dosage, this veil of color is extremely subtle, almost imperceptible to the eye, but manages to harmonize the color composition. Finishing a painting with a lightly tinted clear coat is the ultimate act of color cohesion, where every element is brought together by a common tonal cloak.

Then, create a reference chart that lists the pigments and the rough ratios. Brush each glaze onto its corresponding number. When the glazes dry you will be able to determine the strengths of the various glazes.

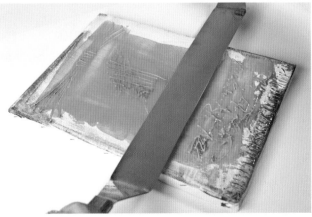

Transfer your desired glaze to your painting surface. Here a giant double-handled palette knife was used.

Kinds of Glaze

The acrylic glaze can be thin, thick, glossy, matte, or any variation in between. What you can learn to control is the subtlety of combinations and layering. A great deal of visual depth and richness of color can be achieved through tricks of light and a practiced hand.

The intensity of a glaze is most simply adjusted by varying the quantity and type of pigment. Not all transparent pigments (those most suited to glazing) are equal in strength. Some transparent colors are so deeply staining that to use too much of them will oversaturate the glaze and obscure the underpaint almost completely. Be careful to adjust your glaze in small increments to achieve more precisely the saturation you require. There are instances when the palest of glazes can enhance a colorfield almost imperceptibly, and it is at times like this when the clarity of the acrylic mediums show their value, holding a gossamer blush of color suspended.

Building up color with glazes takes patience and a good knowledge of pigments. Take the time to experiment with different degrees of saturation to get precisely the intensity of the color you want. You can take shortcuts by slightly overloading a glaze with pigment, so that it lays down deep and rich in fewer layers. However, keep in mind that you will have greater control using a larger number of less saturated, thin applications.

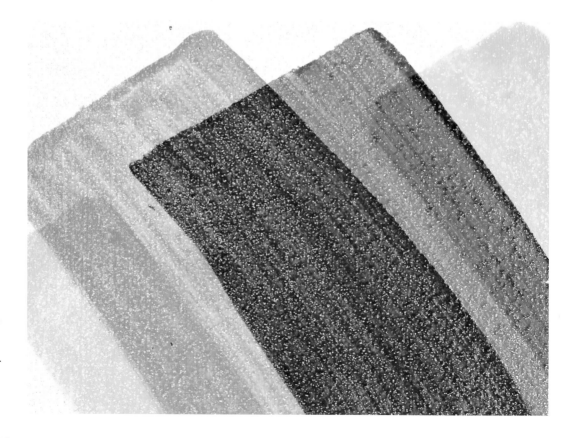

Add a little pizzazz to your glaze by underpainting with some glitzy specialty paints. In this example, hologram pearl spectral color by Tri-Art offers up a touch of bling.

Thin

There are many mediums with which to glaze, each with its own effect. For a thin, level veil—the purpose of which may be to intensify a color or add a single tonal layer to a composition—you need to use a very thin medium. The thinner the better. Many mediums called "glazing mediums" exist. These generally are milk-thin, and some also contain a small amount of retarding agent. This increases the flow of the medium and gives any lingering brush strokes the chance to level out before drying. If the intention is only to add color (but not alter the texture in any way), this is the medium to choose. Then comes the decision about whether to go with a gloss, semigloss, or matte surface.

Thick

Gel mediums and self-leveling gel mediums produce slablike mantles of color when very lightly tinted. Glazes utilizing these mediums have the look of Lucite or gems. The light is pulled through the medium, the transparent colors glowing within them. Optimum transparency can be achieved if all the water in the paint film has the opportunity to fully evaporate. Hurrying to add new layers can trap moisture, causing the glaze to become milky. Thick glaze layers should be left to cure for 24 to 72 hours, depending on the ambient humidity and temperature of your studio.

Glaze overlays on Mylar sheets show the increased depth produced by layering.

Note: Glazing applications depend, above all, on light. A brilliant, white surface throws back a huge quantity of light. Using reflective paints magnifies the light effect manifold. Read more about this in the glitterati segment on pages 36–41.

Encased in a generous gloss gel glaze, ribbons of extruded acrylic texture create a enticing detail.

Gloss

The glossier the medium, the clearer it will dry. When clarity is what you are looking for, not only should the medium have a gloss finish, but it should be of a high quality. The finer the quality a medium is, the less water it will contain. What that means for the glaze is that there will be a less porous surface and thus a glossier appearance. As water evaporates from the paint film, it leaves behind micro-fissures (pores)—the more water, the more pores; the more pores, the more matte the surface. A larger water content will also mean that the acrylic molecules will be spread farther apart, which will in addition decrease the gloss. A high-solids acrylic is ideal.

"Working with transparent layers of acrylic color is like working with a gymnast. This kind of color is elastic. It can expand and contract. It can stretch, bend, contort, fold, flow, glow, hover, and so forth. It can inhabit space in a durational way that is both mesmerizing and enveloping. It can infuse the senses so you lose yourself. It can make time stop. It can exist in a continuum with no beginning and no end. It can fill you up. It can repel you. It can take your breath away."

—Marie Lannoo

Matte

A matte glaze can be a sensual thing. Mist and velvet, a subtle film that will create a softer blend than its glossy alter ego. *Subtlety* is the key word in this process. A light touch is recommended, as too much medium can hide too much of the underpaint and cease to be a glaze altogether. Successive thin matte layers of glaze can create the appearance of frosted stained glass. As with all layering, the trick is to allow enough drying time between layers.

Marie Lannoo, *Thin Places #23,* 2008, acrylic on panel, 36 x 36 x 2 inches (92 x 92 x 5 cm)

Washes

The counterpoint to the glaze is the acrylic wash, an approach to working with transparent colors that is adopted directly from watercolor technique. The acrylic wash is not unlike a watercolor wash, with the added advantage of being permanent. This does away with the unfortunate tendency of water-soluble color layers to blend into one another and make mud. In fact, multiple color-wash applications will intensify the chroma more effectively and more brightly than a similar application in watercolor.

As large amounts of water are added to acrylic color to create a wash, the surface of the paint becomes more matte, and more absorbent. The water spreads the pigment as well as the acrylic emulsion binder. In artist-grade paints enough binder is present to create a water-resistant, permanent film. The matte surface comes about from the mass exodus of water during the drying process. As it evaporates from the film, water leaves behind microscopic pathways through which other

volatiles will eventually escape. These tiny pinholes give the surface an increased porosity that allows for a uniform absorption of subsequent layers. As the acrylic solids are spread apart by the water, the gloss factor of the surface decreases, leaving a matte finish to the color. Surfaces of this sort, without the benefit of a layer of solid acrylic medium acting as a barrier, will attract more dirt than a glossy one. Framing behind glass is the suggested presentation for an acrylic painting executed in a series of thin washes.

The propensity for discouraging excessive water dilution should be heeded, although there are ways in which the use of very dilute washes can be successfully incorporated into a painting without leaving a vulnerable surface. The addition of a low-viscosity polymer to the wash will add binding strength and provide a less porous film. To maintain the appearance of the surface without increasing the gloss, matte polymer glazing medium can be used as a clear coat.

The thinnest of washes achieves two things in one application: It draws out the intricacy of the underlying textural detail, absorbing into the paper ground while resisting the gel, and it adds to the play of darks and lights.

EXPERIMENTING WITH ACRYLICS

By all means experiment, but do not assume that one product will work like another, no matter how similar the label information and apparent characteristics. From brand to brand discrepancies exist that could pose anything from a tiny unexpected result to a monstrously disastrous one. Prudence is advisable when using anything you have not used before. We know to test an untried recipe before serving it up as a main course at a dinner party. It is just common sense. But this rule, for unfathomable reasons, often escapes the attention of the artist. Never—and I cannot stress this enough—ever, apply a liberal dose of any paint medium or additive to a painting you are currently "happy" with unless you have tested it first on something you don't give a fig about. I don't know how many times I have heard the story of the one new product or process that absolutely ruined the painting or paintings on the eve of the art show opening. Tragic, yes, but completely avoidable. The same care we take for our dinner guests bears carrying into the studio. Within the whimsy and creative explosions that may be happening, it is imperative that we adhere to practical guidelines.

First, know your tools. In this context, that means know not only your colors but your mediums, supports, and any other art media. In particular, know how they all bond, or don't bond, with each other. (A chart of mixed-media compatibilities can be found on pages 130–131.) Without this, you cannot hope to have more than a vaguely speculative idea of what to expect from your trials. Second, keep an open mind. During experimentation, it is prudent to have at least a basic plan of action, and beyond that a hypothetical idea of the outcome.

The greatest thing about accidents is that they offer a glimpse into possibilities that we might not have discovered by following our own familiar process paths. For the more timid painter, experimentation is daunting—a dangerous playground where all the kids speak a foreign language and the jungle gym looks as though it were formed by aliens. Once there, all kinds of miracles become possible. It's hard, at first, to step out of the safe zone and into the fray. The mud is on everyone's hands, though, and after a while, you don't mind it anymore and dive into the randomness that may set you on a different course. I have a tendency to save many of my accidents. I have a file (okay, a pile) of them that I sift through from time to time to get a fresh perspective, or trigger an idea.

Note: Keep a scrapbook of inspirational tidbits. A book of ideas may get forgotten on a shelf for a spell, but once we open it again, that time lapse refreshes the contents and we see th again.

MANAGING THE PERCEIVED PITFALLS OF ACRYLIC PAINTING

There are dependable, traditional methods that, as artists, we ordinarily use as a foundation for our work. This is all well and good until we try a new technique or new product and something goes wrong. Whether or not you are the type of artist who can improvise around a "wrong" and make it right, there are some guidelines for troubleshooting your own process that are good to have on hand.

Back up, rethink, test, wait, cover it up, or start again. This is basically the sequence you should follow when you find yourself in acrylic crisis. Take the time to look back through your process and all of your material choices and try to find the point at which the problem could have started. Knowing your paints and supports is crucial to this reverse-discovery process. If you know how they should behave, you can most likely figure out why your surface has failed.

The next step is to rethink procedure and run some tests, using the method you used previously and taking care to correct any aspect of it that could improve it and change the outcome favorably. Sometimes a period of drying or curing needs to take place before you can be sure that your revised method won't fail. Be patient and take that time, as it may make the difference between solving the problem and repeating it. Slight problems with surface or texture can usually be covered up and reworked, though the more severely botched paintings should just be scrapped and started again. These tips may not solve your issues, but by following them, you will gain a better knowledge of your materials and their working properties.

Sometimes adding too much water to a surface can cause the underlying medium to craze and crackle. This does not damage the integrity of the paint film, however, and can produce unexpected results.

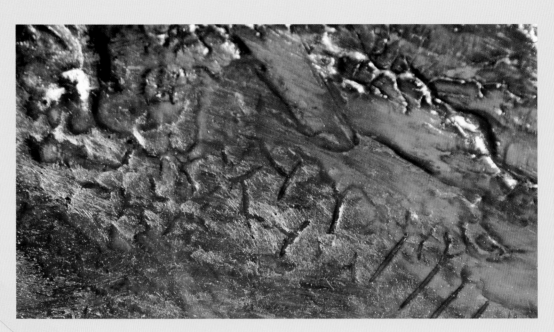

Certain aspects of acrylics are perceived as being problematic, or troublesome. Solutions are available for each of these, and in some cases, it is really just a matter of shifting your perspective. Here is an abbreviated look at a couple of the issues artists have asked me to address:

Drying
Don't get knocked down by the speed at which a thin layer of acrylic can dry. Many methods can be used to counter this characteristic if necessary, but for the time being, learn to work within its natural time frame. Instead of fighting with the paint, as it fails repeatedly to behave like an oil paint, accept it for what it is. The binder coalesces and dries through evaporation of the volatiles within the wet paint film. As this takes place, the paint becomes less malleable, finally becoming a flexible, water-resistant film. The upshot of this is that layering becomes the most obvious way with which to create depth and texture. Various materials can be used to extend the open time: water, acrylic mediums, acrylic retarders, flow-release agents; each of these is explored at length on pages 94–97.

Priming
The decision about whether to prime is not always one of necessity, but one of choice. There are times when it is imperative to seal or neutralize a surface, and others when the raw acrylic will bond quite comfortably with the substrate. Know your substrate, know your materials, and make your decision according to the best projected scenario for longevity and visual appeal.

What do I do if something goes wrong with my paint?

Almost every package of paint—from the tiniest tube to the largest jug of medium—will have a batch number either stamped, stuck, or printed on it. This is the most important piece of information for tracking the product. Manufacturers appoint a number designation to each and every batch of color or medium they produce. Usually there is a data trail that includes a wet and dry sample, the recipe, and precise information on when and by whom it was made. If you come across a problem with your paint that you cannot solve yourself, and that was not caused by an external influence, this is the number you must refer to when you contact the retailer or manufacturer.

Impatience can produce some fascinating results. This pool of self-leveling gel and color was aggressively dried with a hair dryer for several minutes and left to "rest." As the gel cooled and dried, these brainlike ripples began to form in the surface of the gel. As the gel fully dried, the ripples relaxed a little, but remained.

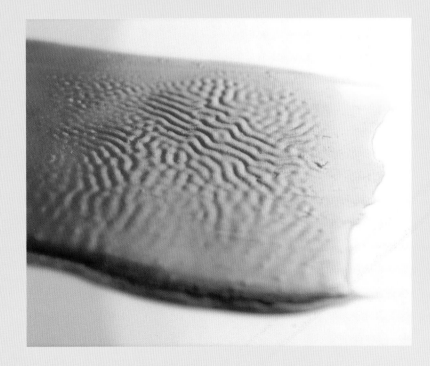

Chapter 7
beyond the basics

"A substantial amount of trial and error will, and should, come into play during any education process."

At first thought, you might assume that going beyond the basics involves larger, more substantial concepts. However, going beyond traditional technique with acrylics—and in so doing, becoming more of an expert in acrylic application—is accomplished through a subtle shifting of focus and through attention to the chemical and physical aspects of the medium. Once the big chunks of information are sturdily in place, tangential details come into play, and the development of the surface becomes enriched by a deft handling of color, medium, and tools. Timing should also be included in that list, as with acrylics this can mark the difference between a fully realized surface and one that bears the scarring of immature technique.

Technique is a language. The information we accumulate adds significant eloquence to one's expertise of application. Furthermore, translating ideas into paint is more easily realized when one is equipped with a broader vocabulary. Becoming a master of this medium is in part achieved by getting intimate with the nitty-gritty details from both the technical and scientific points of view. The rest of it, the "art" of it, comes with gaining expertise in how to then wield these tools and mold them to your will. A substantial amount of trial and error will, and should, come into play during any education process.

The art of extending the acrylic process beyond more traditional applications is achieved first through fully digesting the basic concepts in how the paints work, as this forms the backbone of the acrylic painter's skill. Once this armature is in place, the aspects specific to the acrylic medium come into play and offer up a new world of possibility. The unprecedented texture-holding capability of the mediums can give rise to structural pieces of great girth and complexity. The glass-clear resin can inspire a profusion of possibilities in combination with light effects.

Surface Tension

The surface of an acrylic painting is where the eyes rest after they have taken in the compositional elements and the color. The surface tension is affected by both light (as it travels into translucent pools of glaze) and shadows (as they are caught and held by the ridges and valleys of paint). There is a sort of vibration caused by the push and pull between light and dark, smooth and rough, deeply transparent and flatly opaque qualities—all of which can exist on an acrylic painting. When these elements come together in harmony with the composition and presentation, the intricacies draw us in with their complex interplay. Whether highly textural or seamless and smooth, surfaces are inevitably responsible for holding our gaze.

Textural Landscape

Dry brushed metallic colors and earthy tones adds a coppery patina to this surface.

Texture is acrylic paint's strong suit, a quality at which it truly excels. A vast range of textures can be achieved with

acrylics, a staggering variation of hills and valleys with character ranging from sharp to floppy. Acrylic mediums allow us to bend the paint to our will to produce textures ranging from subtle furrows to ostentatious spikes and bombastic protrusions. Texture is a language well spoken by acrylic mediums, the materials through which we can convey a tactile expression of our creativity. From hands to trowels, from extrusion to incision, tools and methods vary wildly as they take us through this jungle of acrylic paint possibility.

Visual Depth

Within an abstract or representational composition, the illusion of depth can be achieved by working with the luster of the paint to push and pull images backward or forward. Matte areas appear to recede, and glossy areas (which are always trying to steal the limelight) pop forward. The play of light bouncing back or being absorbed into the composition adds a clear and divisive sense of depth that does not rely on relief. The smoother the surface is, the more dramatic the effect will be.

This visual tango is not limited to luster, however. Setting transparent areas into opposition with opaque colors creates a similar, though more subtle, illusion of depth. Just as the light is, our eyes are tugged into the depths of a glaze. The thicker and more transparent the glaze is, the more it gains an inner dimension. By contrast, a strip of opaque color slashed across a color pool clasps and drags our gaze back to the surface.

Rhéni Tauchid, *Topography of Acrylics* (detail), 2008, acrylic on paper, 10 x 12 inches (25.4 x 30.5 cm). This demonstration abstract illustrates various textures created by tools, mediums, and applications. Pulling up paint with the underside of a palette knife produces veinlike ridges, while its thin edge strikes a crosshatch pattern.

Color Field Paintscapes

Although the concept of a "color field" was born many decades ago in a movement that bears this name, it continues to have a significant presence in modern painting. Consequently, this is an area that bears considerable exploration. No set technique or method can encapsulate the numerous and diverse incarnations of color-field paintscapes. I have been asked on many occasions to discuss or demonstrate how some of the iconic Color Field paintings of the 1960s were achieved. It was all about the nuances of color. The loose, liberal applications of paint became the primary focus of the artwork, eliminating the perceived facile nature of representational work. The most-recognized artists of this movement—Helen Frankenthaler, Jules Olitski, and Kenneth Noland— used vastly different techniques as well

as materials. Lucky for us, the acrylic vehicle is adaptable to virtually all of them.

The crux of color-field painting for today's artist is, in the simplest terms, to achieve a surface that stands on its own as an aesthetic commentary on the nuances of chroma. So really, it is an exploration of color depth. This could mean creating an opaque surface or layers of glaze. There is no standard, and therefore no attributed method. It is a literal interpretation by the artist of what the job of a paint resin actually is.

Many artists consider the essence of this job to be simply to attach pigment to substrate in some way. Some artists achieve the goal of articulating their artistic statement by using resin and dried pigment. (However, unless you are working in a controlled environment

This color field of thick bands of color was blended with the large flat edge of a giant palette knife.

and are utilizing a proper breathing apparatus, this is not recommended as a recreational painting method.) Still other artists employ variations on the basic (but classic) themes: pouring, staining, blending, and direct painting. Each of these methods is broad in scope and is able to be approached in innumerable ways. So let's explore the basic methods in turn.

Pouring

By this I don't necessarily mean pouring full-strength liquid colors onto your support. Unless your budget is such that you can afford to be unabashedly liberal with your paint consumption, I would recommend a dilution. Ideally, a low-viscosity paint should be used for this purpose, be that liquid, ink, or airbrush acrylic format. The reasoning for this is that it will disperse into the diluent with the most ease.

The diluent in question can be one of many things, the identifying characteristic being that it pours well. So, water is always a good choice. Keep in mind that the thinner the diluent is, the more easily the paint will be absorbed into the ground. This factor alone will help you determine which diluent best suits your purposes. An alternative to the elemental purity and easy access of water would be to use an acrylic medium that has a slightly higher viscosity, one that will float on the surface and be easier to manipulate for a time before it sinks into the support.

Just because high-viscosity paints have the ability to hold a peak, do not assume that they will not flow. Put enough force or volume behind a viscous blob of paint and it will move with surprising fluidity. Thick or thin, an astonishing variety of loose paint applications can be used to make up a color-field painting.

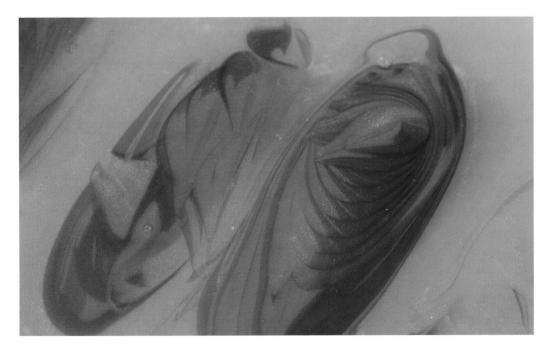

Successive drops of color, patiently dripped into a wet pool of self-leveling gel, create an unexpected pattern.

Staining

Staining, in the painting world, has good connotations. It is considered a bonus that strong, staining pigments cannot be laundered or otherwise removed from the support. When it comes to this application, probably the first image that comes to mind is one of a raw canvas stained with a fluid wash of color. This is not the only technique one can employ, however.

To stain is simply to infuse a surface with color. There are no rules as to how this should be done, how thick the paint ought to be, or what type of surface can be used. Obviously, more porous, unprimed substrates (such as canvas and paper) will soak up color more readily than wood, primed surfaces, or other semi- to nonporous materials. As long as there is some adhesion, however, staining is possible. As for color, all of them are capable of staining, though pigments that feature the finest particle size will stain most effectively.

Blending

Blending with acrylics is unlike working with other paint media. A variety of methods can be used to achieve anything from smooth to broken color blends. For some tips on how and what tools to use, see the sidebar in chapter 6.

Top Right: Blending color with a wide flat brush in staggered strokes creates a broken blend of color. *Bottom Left:* Blending colors with an angled flat brush produces a smooth, linear shift. *Bottom Right:* Blending color with a coarse bristle fan brush using short, sharp strokes gives the impression of crosshatching, weaving the colors together.

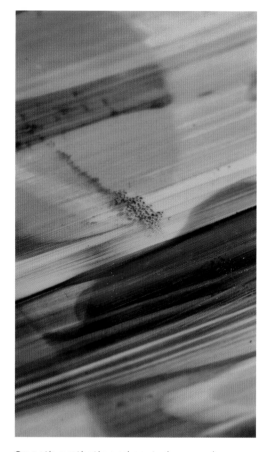

Smooth synthetic and coated papers have the unique characteristic of becoming easily stained by the application and quick removal of color. The effect achieved here was created with a wide flat color shaper.

Direct Painting

Direct (or a la prima) painting has a particular dramatic quality—one to which no other application comes close. Great swaths and waves of paint emit an energy and grace. They hold the imprint of the brush and contain the control and vigor it took to get it there. Freed from the (sometimes contrived) look of painstakingly overworked paintings, a la prima work displays an immediacy that is palpable and compelling.

Sure, these paintings can also sometimes appear clumsy and rushed, but what I want to focus on is the direct relationship between the painter, the paint, and the support—a conversation that is at the core of our desire as creative people to make our mark. Acrylics deliver with great gusto on this score. The snap of each peak, the grooves left by each

hair on the brush, every teeny bit of relief produced by each paint application is held in suspension by high-viscosity acrylics. Thinner paints, from liquids to inks, hold their own sort of gesture, caught in fluid motion as they dry, silken banners arrested in mid-flutter.

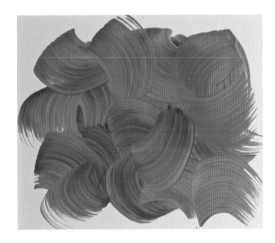

Though thin enough to flow, liquid acrylics hold a distinctive brushstroke.

By using tip of a palette knife, subtle relief and smooth, rounded edges can also be produced with liquid acrylics.

MANIPULATING ACRYLICS

With each of the other (non-acrylic) paint media, it is simple to give a credible example of what a typical painting made with that medium would be. By contrast, acrylic paints have no singular signature "look." They are changeable, malleable creatures, capable of masquerading as other media with ease. This is precisely their forte, but incidentally, this is what makes it difficult to define their appearance in singular terms.

We constantly seek to categorize and pinpoint the acrylic art, giving it names that do not belong to it. *Oil-like, waxlike, watercolor-style* . . . It will be a long time before we can let go of using those character descriptives and embrace acrylics as having a language of their own. In the meantime, perhaps the simplest, and somehow most accurate, way to describe it is to call acrylic paints the chameleon of art materials. They inhabit the definition of the word *plastic*.

I get frustrated when I read naive passages on acrylics that suggest there are only two methods for painting with acrylic paints: the watercolor-like process or the oil painting-like process. This shrieks of a lingering ignorance of the complexity and versatility of the acrylic machine. Acrylics can go so far beyond masquerading as other media, it is almost comical to me that I need to explain it. However, in an effort to indulge the desires of those eager to tap the mimic's abilities, I offer up some tips toward mirroring the material it is most frequently compared to—oil paint.

As concerns for our health grow in an era of massive environmental upheaval, fears surrounding the use of solvents in schools and studios increase as well. Oil paint, though it continues to be a hugely popular medium, is experiencing a decrease in favoritism in the academic environment, particularly since acrylic paints and mediums can easily and successfully mimic oil painting effects without needing to use any of the caustic materials associated with oils. Without giving them a good whiff, it can be downright impossible to tell the difference between a finished oil or acrylic painting.

Oil paints have a fairly uniform visual character. Other than its trademark tendency of being slow drying, probably the most significant aspect of oil paint is its lush saturation of pigment. Pigments can be added directly to the oil binder, without first being diluted into an aqueous dispersion, as is the case for acrylics. One of the upshots of this is that the shift in color from its wet state to its dry state is minimal. Knowing this, one could assume that oil paints can, and routinely are, more packed with pigment than acrylics. This is true in their wet state; however, because the water contained in acrylics evaporates almost completely as the paint cures, the ratio of binder to pigment in dry acrylic can be equal, or at least very close to, the same ratio in dry oil paint. With this fact in mind, if you want to mimic the saturated appearance of a la prima oil painting, do not extend your acrylics with any medium and use the highest

grade of acrylics available. It should also be noted that in oil painting practices, colors are often diluted with linseed oil to extend the color and reduce the saturation, and thus are not used directly out of the tube in their concentrated form.

The next challenge, then, is to reproduce the greasy sheen of oil paints using acrylic mediums. This is easily accomplished with any number of products. It is important to note that the sheen of both artist-grade acrylics (which contain no fillers) and oil paints will be partially dictated by the pigments themselves. (See the Luster and Relative Coverage chart on page 21.) The luster of oil paints can also be affected by the type of oil used, as there is a variable difference among the surface appearance of paintings created with linseed, safflower, and other oils. So what, exactly, are we looking to mimic? I think the best answer is that we are looking to mimic the assumed "typical" luster of an oil surface. As mired in vagaries as this may be, I will classify this as a semigloss surface. The acrylic bag of tricks contains any number of semigloss mediums. To arrive at a more "greasy" look, start with a gloss medium and dilute it with semigloss or matte medium until the acrylic has a greasy luster. To increase the color depth, you can apply a single layer of undiluted gloss medium (gel or polymer) over the finished piece prior to adding the semigloss layer.

Going further into the oil painting oeuvre, we get to the tricky bit—blending. The facility of blending with a paint that dries as sluggishly as oils do is unparalleled. Acrylic paints, with the exception of some newer formulations that have as yet not fully proven to be equal in quality, do not dry slowly. Working with retarding additives (either liquid or gel) can increase the ease of blending, as can adding some acrylic mediums. (For more details, consult the discussion on blending that appears on pages 94–97.)

If manipulating the drying time proves tricky or frustrating, optical blending, though a more time-consuming process, can generate satisfying results. Glazing in layers, creating multiple planes of color over your underpainting, will enhance not only the color depth but will add a glow that is impossible to duplicate with opaque applications. As a quick-drying material, acrylics have surpassed oil paints in the glazing arena. Oil paints were good role models. They taught the immature upstarts a thing or two. However, as is the student's due, acrylics had to push the limits and take things further. Paint volume and clarity are where acrylics have outstripped oils. Because they dry so slowly and must be carefully constructed, thick applications of oil paints are tedious to produce, cumbersome to manipulate, and can fail in their adhesion. Even the clearest of oil colors have a yellow cast, which gets deeper and more pronounced in greater volumes. By comparison, acrylics dry clear, thick or thin. Hence, thick glazes take in more light and show off colors more truth-fully. You can make them look as oily as you want, by manipulating their luster and warming up their tone with a touch of yellow, but let's face it, acrylics win at glazing.

To create the first of the background layers, a generous layer of gloss gel was applied to the prepared support. The mirrored photocopy of the drawn background image was then transferred into the gel layer. After 24 hours the paper was removed, leaving the image embedded in the gel.

A thick layer of self-leveling gel was added to the surface to create a smooth surface and produce more depth. A second photocopy, now of the foreground image, was adhered to the dried self-leveling gel surface. Once again the paper was removed to reveal the image. The final foreground layer was then painted using a variety of techniques and mediums.

"There is a tentative balance between understanding the nature of materials and mastering their use to venturing beyond the edge of the known, where many exciting and original things happen. The crossroad of control and experimentation is a good place for me—where ideas take precedence and often require pushing the materials and process so that the result is fresh and well-suited to my intention. In this image of a barred owl, I wanted there to be a kind of echo or communication between the gradual changes that occur as the seasons pass—when certain things remain present even though they may be masked or disguised. I like the notion of trying to show both the more constant elements (whether they're physical or metaphorical) alongside of the more transient aspects of what I observe.."

—Marion Fischer

Marion Fischer, *Who'll Blink First,* 2008, acrylic on panel, 30 x 30 inches (76.2 x 76.2 cm)

Mixed Media and Collage

As acrylics struggle still to gain a solid foothold in the realm of A-list galleries and museums, there seems to be confusion as to how to label artwork that has been created using acrylics. Too often I have seen the term "mixed media" applied to a work that is executed in its entirety with acrylic media. Where is the *mixed* element? One answer I have been given is that acrylic colors and acrylic mediums are sometimes regarded as two separate media. I say call it what it is. Whether a medium or a color, both products are created with acrylic polymer emulsion and are therefore 100% acrylic. It is about time that this type of paint was given its due and its name upheld.

What does a mixed-media work consist of, then? Within the context of this book, the components are acrylic paint and/or medium combined with one or more other media. The mixing bit is also a bit ambiguous. Mixed together, as in cake batter? Well, sure, for some media that works

fine, as, for example, blending graphite powder into the paint. Usually, though, mixed-media work is created through layering, producing a clearer distinction between the various components.

Adhesion is of paramount importance when looking to create a stable bond between various media. Beyond using wet and dry art media, there is the element of collage, where items are attached onto or are incorporated into a composition. A thorough examination of the rules and intricacies of mixed media and collage bears some discussion.

Sharlena Wood, *Wonderland Shoes,* 2007, pastel and charcoal on clear gesso tinted with iridescent silver on illustration board, 8 x 11 inches (20.3 x 27.9 cm)

"Acrylic polymer was born a perfect ground. I consider it the superhero of all media, strong and tenacious, it's saved my work on occasion. I work very intuitively, layering, sanding and diluting acrylic colors on a variety of surfaces. By adding in various mediums, I can have a toothy ground or a vellum smooth finish for drawing with pastel, marker, or charcoal . . . whatever I believe supports the subject and feel of the overall work. I love the endless combinations and how new acrylic mediums have established a sophisticated synchronicity between painting and drawing."

—Sharlena Wood

The Elements of Mixed Media

The term "mixed media" specifically should refer to artwork that has been produced using multiple visual-art materials. That could mean two to two hundred various mediums. Acrylics are unique in their ability to straddle the divide between water-, oil-, and wax-based media. There are adhesion issues to consider, particularly with oil- and wax-based materials. However, with an informed hand, a successful grouping can be achieved.

As previously mentioned, the primary factor in creating a successful composition is adhesion. Acrylic paints are at their strongest when they are used on their own, but they will bond well with other water-based media. Watercolor and gouache paints have a gum arabic base, which can be layered with acrylics provided that they are sandwiched between the acrylic layers. That said, there is no advantage to using either of these materials, as their physical appearances can easily be mimicked by acrylic paints.

Acrylic paints are the unequivocal leaders of the mixed-media pack, functioning as the glue that binds the disparate elements together to form previously unthought-of assemblages. The acrylic binder is so sticky that it has the ability to not only bond with but also envelop, fill-in, or seal almost every wet or dry art media that exists. There has been as explosion of collage, altered journal, and assemblage books on the market, all of which serve to invite artists and crafters to express themselves through combinations of mediums that, prior to the emergence of acrylics, were not considered compatible.

Sharlena Wood, *Pr-incest,* 2007, marker and pastel on unbleached titanium and gesso on illustration board, 10 x 14 inches (25.4 x 35.6 cm)

MIXED-MEDIA COMPATIBILITY

Medium	Adhesion	Preparation	Specific Instruction	Protection Before New Layer
charcoal	P	Will adhere best to toothy, matte surface. Dry media ground is recommended.	none	Can be set with a spray application of acrylic polymer medium or acid-free spray fixative.
clay-based media (colored pencils, etc.)	M	Will adhere best to toothy, matte surface. Dry media ground is recommended.	none	none
gouache	M	none	none	Resoluble. Can be set with a spray application of acrylic polymer medium or acid-free spray fixative.
graphite pencil or stick	E-M	Will adhere to all acrylic surfaces, though is more stable on matte surface. Dry media ground is recommended.	Graphite can be burnished with either a soft cloth or a smooth, rigid tool.	none
graphite powder	P	Will adhere best to toothy, matte surface. Dry media ground is recommended.	Graphite can be burnished with either a soft cloth or a smooth, rigid tool.	Can be set with a spray application of acrylic polymer medium or acid-free spray fixative.
indelible or acrylic inks	E	none	none	none
lithography crayons	M	Soft grades adhere to all surfaces. Hard grades adhere better to matte surfaces. Dry media ground is recommended.	none	Resoluble. Apply isolation coat of spray fixative or clear polymer medium.
oil paint	M	Apply sufficient layers (three to five) of acrylic gesso.	none	Do not overpaint oils with acrylics.
oil pastel	M	Will adhere to all acrylic surfaces, though is more stable on semigloss or matte surfaces.	none	Do not overpaint oil pastels with acrylics unless when using as resist.
oil stick	M	Apply sufficient layers (three to five) of acrylic gesso.	none	Do not overpaint oil sticks with acrylics unless when using as resist.

LEGEND: E = excellent, M = moderate, P = poor

Medium	Adhesion	Preparation	Specific Instruction	Protection Before New Layer
permanent and non-permanent markers	E	Some marker ink will bleed through paint layers and needs to be sealed prior to painting. My recommendation is to only use these markers as a top layer. If you plan to layer over the top, you may need to resort to a shellac-based sealant to prevent color migration.	Water-based, nonpermanent markers will wash off of acrylics quite easily. Archival art markers with acid-fee inks should be used for serious artwork. These can be used at any stage of an acrylic composition.	Certain types of permanent marker will not be affected by a coat of paint, but many will migrate through every layer added on top of it.
powdered pigments	M	Will adhere best to toothy, matte surface. Dry media ground is recommended.	Mixing powders into a polymer medium prior to application will increase its stability.	Can be set with a spray application of acrylic polymer medium or acid-free spray fixative.
printing inks (digital)	M	Will print best on to semi-gloss or matte surfaces. Some brands manufacture modified polymer mediums specifically for digital printing.	none	Test for adhesion and water solubility.
resoluble acrylics	E	none	Mix with permanent medium (acrylic polymer medium or similar) prior to application.	Resoluble. If mixed with permanent medium, no protection is necessary. Otherwise, apply single layer of polymer medium to seal.
rubber-stamping ink	M	none	As an alternative to stamping ink, use rubber stamps with acrylic paint that has been treated with a small amount of retarder.	Test for water solubility.
soft pastel	P	Will adhere best to toothy ground (e.g., dry media ground, fine grade nepheline gel, micaceous iron oxide).	Apply to completely dry paint.	Can be set with an acid-free spray fixative.
solvent based media (spray paint, etc.)	E	none	none	May migrate through layers.
watercolor	M	Will adhere best to matte surface.	none	Resoluble. Can be set with a spray application of acrylic polymer medium or an acid-free spray fixative.
watercolor pencil and crayons	M	Will adhere best to matte surface. Crayons can be used on either gloss or matte.	Dry media ground should be used for pencil application.	Resoluble. Can be set with a spray application of acrylic polymer medium or acid-free spray fixative.
wax-based media	M	Will adhere best to matte surface.	none	Do not overpaint with acrylic unless when using as a resist.

REVIEWING THE BASIC RULES

Mixing acrylic paints with other art materials can be a tricky business unless you know the basic rules. Here is a quick review of which types of dry and wet media can be effectively used in mixed-media acrylic projects. This includes working with dry pigment and other powders.

Water-Soluble and Loose Dry Media

A fresh layer of acrylic medium can dislodge the careful placement of compressed charcoal or reactivate a line of watercolor crayon. To arrest the movement of these media and preserve your composition, you can use one of several methods to affix them to the surface. A light spray of acrylic medium, thinned to a water-like consistency, will hold some materials. Those that are extremely lightweight, like graphite powder or soft pastel, will suffer less disruption from the application of an aerosol spray fixative. For optimum protection and longevity, use an acid-free, non-reworkable fixative.

Grounds for Dry Media

Acrylic paint is slick and smooth, and most dry media will not find purchase on its surface without a small amount of tooth to which to cling. Extremely fine materials will find sufficient grappling hooks on a surface treated with matte medium, while others will require a coarser mantle. The acrylic brands offer up an array of mediums, ranging from extra fine to extra coarse, suitable for every taste and inspiration.

Some mediums are designed specifically as grounds for dry media. Called a variety of names (such as dry media or pastel grounds), these mediums contain a quantity of abrasive particulate, usually have a medium viscosity, are self-leveling, and are translucent enough to be easily tinted. Other granular gels, such as nepheline and pumice, are available in a thick gel with a shorter rheology that holds more texture and offers a loose, granular surface. Micaceous iron oxide, which is made from lustrous specular hematite, is a unique color imbued with the added dimension of texture; it can provide a dark but neutral ground suitable for all dry media.

Gesso and modeling pastes, though not particularly coarse grounds, contain a large quantity of both matting agent and calcium carbonate. These solids are finely ground, but they still provide a subtle, velvety texture. Try these with graphite sticks, compressed charcoal, and colored pencils.

"To try and take iron-control of a painting is to kill it at birth. Yet, to let it run riot almost certainly ends in anarchy or mud. I've found that if I alternate between order and chaos, intuition and intellect, then the painting slowly reveals its needs."

—Nick Bantock

Nick Bantock, *Oregon,*
2007, acrylic and mixed
media on heavy board,
9 x 6 inches
(22.8 x 16.25 cm)

Q&A: MIXED MEDIA

When is permanence an issue with mixed media?

Mixed media is inherently problematic when it comes to permanence. There are too many factors at play, and artists, for the most part, do not necessarily pay inordinate attention to the chemistry at work therein, if at all. Stability becomes an issue if the artwork is intended for sale, as it is ethical to ensure the buyer a certain degree of confidence toward the longevity of his or her purchase. Mixed-media work created for reproduction, such as Giclée, art cards, or the like, can afford to be of a more ephemeral nature, as they only need to last as long as it takes to photograph or scan them. Regardless of their ultimate resting place, mixed-media works should be produced with an eye at least partially focused on quality of materials. Sometimes, however, working with a variety of materials is more about experimentation than the end product. If this is your intent, permanence is not an issue at all. The spirit of spontaneity in improvisational process should not have to be tethered to staying within the boundaries that permanence imposes on us.

What are the best choices for long-lasting materials?

Archival-quality paper and properly primed canvas or wood supports are the most stable substrates to which to anchor your project. Look for materials that are well stocked with lightfast pigments. Consult product labels for lightfastness ratings.

The most precarious aspect of mixed-media artwork is adhesion. This is truly the sticky bit of things. When it comes to ensuring the longevity of a piece, particularly in terms of its conservation and restoration, the fusion of material layers becomes paramount. If you want permanent results, only use materials that will bond well together, and use them in the manner that ensures this goal. Plan your layers, be aware of curing times, and know what will or won't stick to what. Perform adhesion tests prior to mixing media.

How can I protect fugitive colors and materials of flimsy stability?

While nothing that is inherently impermanent can be made fully "archival," certain protective devices can be used to prolong their lifespan. Keeping pieces of dubious lightfastness away from direct sunlight is a good idea; so is framing these works behind glass or Plexiglas, as these materials both block a substantial quantity of UV radiation. If you are using an image on poor-quality paper, consider transferring the image to a more viable support, or coat it with a UV-protective polymer medium.

Is mixed media the same as multimedia?

This is a common misconception, as they both refer to art forms and format, but no, they are not the same. As *media* is the plural for *medium*, on the surface both terms appear to mean the same thing: involving more than one medium. The precise definition goes further than that, however.

Multimedia within an art context denotes a presentation that combines more than one media, such as audio, video, animation, and so forth. Multimedia goes beyond the stuff that hangs on the gallery wall, as it incorporates ambient sound and/or visuals; it is often a full sensory experience.

Mixed media is not so wide a traveler and is thus relegated to being a staid, solid presence. The term is applied to work created with tactile media: paint, ink, collage elements, dry art media, and so forth. Basically, mixed media involves anything that can be combined onto a support and become part of an art object. So, while it is not quite as extroverted as multimedia, mixed-media work still manages to be extremely adventurous while staying anchored in three dimensions. The great thing is that acrylics can be a part of both.

Sharlena Wood, *Day Blossoms,* 2007, pastel, graphite, fine nepheline gel on illustration board, 4 x 6 inches (10.2 x 15.2 cm)

The Elements of Collage

Acrylics are the ultimate adhesive, so it is a natural for them to form the matrix of a collage, linking together ephemera, paper, scraps, metal, found objects, fabric, and organic materials in a web of flexible polymer chains. Choosing, preparing, and adhering all of these elements requires a balance—not only of composition but of physics and chemistry. The following chart outlines in detail what type of collage elements are compatible with acrylic media, how to prepare them for assemblage, and which acrylic mediums are best suited to do each particular job. It provides a visual roadmap through the art of collage making.

Rhéni Tauchid, *Cryptic Silence,* 2006, ink and transfer collage on canvas, 12 x 16 inches (30.5 x 40.6 cm). This demonstration piece shows transparent acrylic transfers overlaid on top of acrylic ink text. An enigmatic veil, which I created using dry brushed color applications, further enhanced and enriched the image.

ADDITIVES AND COLLAGE ELEMENTS

Additive Material	Adhesion to Acrylic Paint	Potential Negative Reaction	Additional Notes
acetone	none (It breaks down the paint film.)	Acetone is often used to soften and remove thin layers of acrylic paints.	If acetone has been used on a surface, clean it with water and allow it to dry completely prior to applying new paint layer.
ash	M	Do not inhale.	Ash can be mixed directly into an acrylic medium.
bisque-fired clay	E	Bisque-fired clay is quite porous and will absorb paint readily.	Apply a clear topcoat to dry paint to improve its surface resilience.
desiccated organic material (insects, flowers, seeds, leaves, shells, etc.)	E–M	Some dry organic matter may rehydrate and plump up a little when added to an acrylic medium. As it is absorbing the acrylic, this will increase its flexibility. Shells should be clean and free of any organic matter prior to painting.	If adding plant matter into acrylics, they will adhere best if completely dried out. Any remaining moisture could interfere with the drying of the paint and cause poor adhesion and uneven drying. For best results (and to inhibit bacterial or mildew growth), ensure that organic materials are completely encased with acrylic.
fabric: cotton, synthetic, or blended	E	Complete saturation of the acrylic may cause discoloration.	none
fabric: natural wool, felt, leather, and suede	E	Some leather may require cleaning prior to collage work.	none
fibers (untreated organic)	E–M	"Organic fibers" is a very general term. In this instance I refer to hair, feathers, or fur. Some fibers can be oily and will require cleaning prior to application.	none
fibers: natural and synthetic thread or yarn	E	none	Using fibers in an acrylic composition is a great way to provide extra structural strength, particularly with large-scale works or sculptural forms.

LEGEND: E = excellent, M = moderate, P = poor

ADDITIVES AND COLLAGE ELEMENTS (continued)

Additive Material	Adhesion to Acrylic Paint	Potential Negative Reaction	Additional Notes
glass	M	As oil is commonly used when glass is cut, any glass pieces should be washed completely with mild detergent and water.	Abrading glass lightly will improve adhesion. Glass beads can add an element of light and smooth texture to acrylics and do not require abrasion.
glazed ceramic	M	none	none
graphite powder	M	Graphite powder is hydrophobic. Avoid inhalation.	Graphite powder can be rubbed into a textured surface. To prevent movement, use a spray fixative.
handmade papers	E	May not be lightfast. Check for permanence of colored papers. Some colorants may bleed when moistened. This can be halted by sealing with a spray fixative.	none
household bleach	P	Could react with ammonia contained in some paints, causing toxic fumes.	If adding bleach to a wash to remove color, blot away excess immediately.
isopropyl alcohol	none (It evaporates from the paint film.)	Softens the acrylic and can make the acrylic film more porous. Both of these conditions allow more dirt to remain on the surface of the paint film.	Isopropyl alcohol is sometimes used to blend or "rub" away oil- or wax-based materials (pastels, oil sticks, etc.), but it will not remove them completely. The residue that is left on the paint film could potentially disrupt adhesion between subsequent layers and/or top coat products.
marble dust	E	High concentrations of marble dust will create a more brittle paint film. Due to its weight, marble dust will settle in low-viscosity mediums. Use with gel mediums or high-viscosity paints.	Marble dust is often used to add tooth and create a tough, dense paint film.
metal leaf	E	As it tears easily, metal leaf should be applied with a soft gilding brush.	Metal leaf is notoriously delicate and can tear with the slightest pressure. Apply a thin layer of acrylic medium, allow it to partially dry, then float the leaf onto it, smoothing with a soft brush. Allow the medium to dry completely prior to sealing the area with more acrylic.

LEGEND: E = excellent, M = moderate, P = poor

ADDITIVES AND COLLAGE ELEMENTS (continued)

Additive Material	Adhesion to Acrylic Paint	Potential Negative Reaction	Additional Notes
metal pieces	E–M	Determine whether the metal is corrosive in a waterborne environment. If it is, it will need to be sealed prior to adding it into paint to prevent further corrosion. If not, go ahead and stick it on.	To increase adhesion, abrade the metal. Metal produced for crafts (mesh, florists wire, etc.) can be collaged into an acrylic composition with no ill effects.
metallic powder (copper based)	M	Metallic powder will oxidize in a waterborne environment, causing discoloration (rust).	Once the paint has cured, oxidation will cease and the metal should remain as it is.
mineral spirits	none (It evaporates from the paint film.)	Mineral spirits can be used in very light applications to remove oily, greasy, or waxy residue. It will soften the paint film.	none
Mylar glitter	E	none	Mylar glitter mixes beautifully with acrylic paints and mediums.
newspaper and magazine clippings	E	Newspaper and magazine clippings have lightfastness issues. Items printed in black (carbon-based) ink are permanent; however, the colored inks used in this type of publication are not and will fade or change.	As the paper upon which newspapers and magazines are printed is not made for permanence, it should be fully sealed in acrylic to prevent or delay deterioration.
petroleum jelly	P	Petroleum jelly is sometimes used to create a resist layer. Allowing it to remain on the paint surface will seriously inhibit the drying process. Remove with a cloth, soap, and, if necessary, a bit of acetone.	none
plaster	E	When mixing loose plaster with acrylic, make sure it is well blended. This will help with adhesion and minimize cracking. Painting onto dried plaster must be done in stages, due to the extreme porosity of plaster. Use a diluted polymer medium as a sealant. This will create a barrier for additional layers. For a tougher basecoat, apply a second layer of undiluted medium or acrylic gesso prior to the color layer.	There are different varieties of plaster (including gypsum, limestone, and synthetic composites). Always test your materials prior to applying them to artwork.
powder dyes	M	Powder dyes may migrate through paint film. Seal between layers, avoid inhalation, and wear a protective mask.	none

ADDITIVES AND COLLAGE ELEMENTS (continued)

Additive Material	Adhesion to Acrylic Paint	Potential Negative Reaction	Additional Notes
raw powdered pigment	M	Avoid inhalation and wear a protective mask.	Hydrophobic powders are lightweight. Mix into a medium prior to application, or if laying onto wet paint film, apply a layer of fixative or sprayed acrylic polymer to seal the area.
salt	P	Salt on wet paint, particularly a wash, absorbs much of the water, creating snowflakelike patterns in the paint. This effect is used with watercolor techniques. Salt left on the surface could adversely affect subsequent paint layers.	Once the salted layer is dry, brush off any remaining salt. An isolation coat of clear medium should be applied to seal the surface.
sea sand	P	(See Salt) To remove the bulk of the salt from sea sand, place it in a fine strainer or cloth and rinse repeatedly with fresh water. Dry before use.	Once cleaned, sea sand can be used to create granular textures.
silica sand (craft)	E	Silica sand is potentially hazardous if inhaled.	For best adhesion, mix silica sand with acrylic medium prior to application.
snake skin, insect wings, etc.	E	Make sure the item is free of moisture and dirt to ensure uniform adhesion. Very colorful insect wings can be sprayed with a fixative to prevent marring the dusty color coating.	These types of collage materials can be quite delicate. A good method to employ is to apply the object to a thin layer of wet medium, allow it to dry, and brush a second layer of medium over the top, effectively encasing the item in acrylic.
stone	E	Remove any living moss, salt, or dirt prior to painting.	none
unglazed ceramic and stoneware	E	none	none
wood pieces	E	Sap is the only potential impediment to good adhesion between wood and acrylic. Seal wood pieces with a shellac-based sealant.	none

LEGEND: E = excellent, M = moderate, P = poor

Rhéni Tauchid, *Staccato Countries,* 2006, assorted collage elements, dry media, and acrylic on canvas, 20 x 12 inches (50.8 x 30.5 cm). During workshops I often produce pieces that demonstrate various techniques. This mixed media collage evolved over a couple of days into a coherent tapestry. Collage elements include a feather, printed papers, a metal nail, and dry-transfer lettering. Dry media elements include charcoal, graphite, and watercolor crayon.

NAVIGATING THE DIGITAL REVOLUTION

Working with digital media has become an integral part of modern art practice. Computer technology advances in mind-bogglingly giant leaps every time we blink. Likewise, the tools with which artists can manipulate and create digital artwork are becoming extraordinarily sophisticated and capable of producing images of great beauty and depth. It is a seductive tool, the shiniest new toy for the modern artist, but it does come with its share of danger zones.

Aside from the physical impediments of this medium, there is the tricky issue of copyright. It is ever so tempting to use any image found on the ever-expanding World Wide Web, as they are accessed with ease from our computers; but not all, and in fact very few, of these are up for grabs. The laws of public domain vary between countries and change in increments over the years. This term signifies a range of abstract materials that fall outside of the ownership of creative works, what are referred to as "intellectual property." So a photograph, for example, found on a Web site, cannot be arbitrarily used. Research must be done into the work to determine its availability, and steps should be taken to gain permission to use the image. The entirety of copyright law as it pertains to intellectual property throughout the modern world is so staggeringly multifaceted that it is simpler to err on the side of caution and avoid it altogether. A basic rule of thumb in this case is, if it's yours, or frightfully old, it's okay to use.

The next issue, one that is paramount to the longevity of the piece, is the quality of ink used in the printing process. Black is not a problem generally, as most black copier inks are carbon based. It's the colored ones you have to watch out for. Your basic domestic printer will use a color cartridge that is made up of fugitive inks. It is possible to find lightfast inks, however; they may cost a little more, but what you lose in pocket change you will gain in brilliance and

"For more than ten years the computer has been a valuable tool in creating some of my artwork. With training as an artist, graphic designer, and video artist, I enjoy blurring the lines between various media. Acrylic paint is one of the materials that I love to mold into the digital realm. Creating the work on the computer and then painting on prints is one of many techniques I like to employ. After the piece is scanned, once again the limits become endless on how to mix and master the final results."
—Cameron Tomsett

longevity. Inks are often paired with acrylics and are manufactured with a range of binders. The ideal inks to use in this case are obviously acrylic emulsion or acrylic solution inks. They share flexibility and adhesion, which reduces any potential separation issues. The term *ink* is frustratingly generic, as it can most simply be defined as a colored liquid. Its uses are myriad and include writing, printing, or tattooing on diverse grounds. Within the context of an acrylic composition, the inks used should have two very important characteristics: a compatible binder and pigment (rather than dye) as its colorant. Pigments are insoluble; therefore, once applied and dry, they will not migrate between layers, as will the soluble dyes, which can travel unchecked through multiple layers of acrylic paint.

Some inks have just enough binder to bring them from pen to surface, but not nearly enough to withstand the physical changes that acrylics go through (either during the curing process or during atmospheric variations). Seek out companies that utilize lightfast inks; as this trait is usually advertised, this is easily done if you are purchasing the inks for your own use. However, as it is not always possible to find detailed data on the inks used in copy shops and the like, make the effort to test any material that you have not printed yourself before committing it to your artwork.

Cameron Tomsett, *You-got-me-worried,* 2005, digital collage, 4.33 x 8 inches (11 x 20.3 cm)

Dimensional Works

Acrylics are a paint, but first, they are a plastic. By definition, this connotes malleability, durability, and variety of form. Outside the context of traditional painting, acrylics take on a multidisciplinary role—that of wrapper, substrate, collage element, adhesive, texture builder, and colorant. They are the most plastic of all the materials in the plastic arts arsenal. This had initially been a descriptive weighted in negative connotations—the polyester pant suit held up against its linen predecessor: not "the real thing." Though the implication that acrylic paints are an inferior material to the more traditional media is not nearly as pervasive as it once was, a residual whiff of this bias can be detected here and there. What is gaining ground, on the other hand, is the perception that acrylics are becoming not only the most durable material but, hands down, the most versatile.

Other than as color, a paint crossing over into the realm of sculpture is unprecedented. Acrylic paints, once dry, are a solid sculptural material—as supple as textile and as flexible as rubber. For producing three-dimensional works, acrylics boast strength and stretch, with the tensile muscle to hold great weight, and do so in a colorful way. In this book I show a few sculptural constructions. However, it should not be assumed that this is the extent of the capability of this material. The scope of acrylic paint sculpture is boundless, and by example on page 181 I hope to provide the groundwork and inspiration for more complex and varied ideas and projects.

In the early stages of my experimentation with acrylic paints—being bored in color theory class, having successfully mixed my tones, and finding myself left with puddles of color—I began to dip. First it was my glass bead earrings, then bits of stuff I found around the studio. It was like dipping berries into chocolate—seductive and gooey. Dipping lead to pouring, then stretching, then cutting . . . I crossed over into a new perception of this paint. From that point on, acrylics became something more, although it would take me another two decades to bring this compelling aspect into my expression as an artist.

Demonstrating the tensile strength of acrylic, these bands of tinted gel hold up 5- and 3-lb. barbells respectively.

"When acrylics are used, paint can take on a sculptural form that questions space and the meaning of painting. My 'painting' combines paint and man-ufacturing techniques to produce a hybrid that hovers between two tradi-tions of object making and between two ontological categories: art and industry. This pipe questions one's perception of the utilitarian and non-utilitarian. I enjoy objects that occupy this strange, ambiguous position, and question the nature of objects."

—Marc Courtemanche

Marc Courtemanche, *A Pipe*, 2006, casted acrylic modeling paste and paint on Masonite, 10 x 14 x 1 inches (25.4 x 35.5 x 2.5 cm)

Solid Acrylics

Working with a fluid medium in the world of solids took some time and some tweaking to figure out. Numerous aspects of acrylics may be terrific for painting applications, but these are the very qualities that can really gum up the works when acrylics are used as a sculptural material. The first thing that you should be aware of if you intend to use acrylics in this way is that acrylic sticks to itself. Trying to manipulate large sheets of something not unlike plastic wrap on a hot day is a quick route to absolute frustration. It is best to plan for this foray into three dimensions carefully. If you can, work in a space with a large, clean surface. In addition, good ventilation and a cool, dry ambiance help to keep the paint from becoming too soft and cumbersome to handle.

When selecting your materials for dimensional work, remember that tensile strength is of primary importance. Stretching and wrapping acrylic sheets require not only plasticity, but the material must be tough enough to withstand these mechanical changes without tearing or snapping apart. High-solids acrylics will hold up best under this type of force, and (to ensure that they maintain a high degree of cohesion) they should not be diluted with water.

When working in three dimensions, you'll also want to reevaluate the tools and materials you have on hand. Armatures are a necessity for heavyweight structural pieces, or those that need to keep a rigid, stable shape. As a thermoplastic compound, acrylic is sensitive to ambient temperature. Giving it the support of an armature will protect its shape and make it less prone to damage during transportation and storage.

Certain materials, especially those that are able to bend a bit, can be used to give reinforcement to acrylic works. Choose a frame that is compatible with the acrylic and can be manipulated within the paint. Many types of metal wire and mesh fit that category. If the acrylic film only requires a little extra help in the strength department but needs to be neither bendable nor rigid, a lattice of fibers is sufficient to add a touch of muscle.

The sculptural side of acrylics is one that increasingly is being explored. It is a tempting material to challenge in this type of scenario. We know how solid acrylic is as a medium for creating relief, but what about its stability as an object, something you can pick up and hold in your hands, prop on a pedestal, even wear? Take a look at a couple examples of how well acrylics stand up to the challenge of forming objects, rather than paintings.

In this detail of the image on page 147 a painted decorative brass piece is "stitched" onto the surface of the painting with extruded paint.

The Great Glue

The superior adhesive qualities of the acrylic resin goes beyond fusing layers of color together or binding disparate media into a single composition. Alongside the more painting-specific niche uses for them, acrylics are exceptional glues. From a thin, wirelike extrusion that stitches a paint seam to a glue that crosses over into archival framing, acrylic materials can bind with unmatched flexibility and strength.

Rhéni Tauchid, *Acrylic Sampler,* 2005, acrylic, watercolor crayon, acrylic ink, and metal pieces on paper, 30 x 22 inches (76.2 x 55.9 cm). This demonstration piece is a hodgepodge of acrylic, metal pieces, acrylic ink, watercolor crayon, acrylic transfer, and charcoal.

Acrylics and the Elements

Beyond the tools that we typically find in our studios, others exist that have the potential and strength to enhance and manipulate the acrylic painting process. The natural world has hands that can shape paint in arbitrary ways that no manufactured tools can achieve. The power of forces like precipitation, wind, and temperature fluctuations can effect massive to minuscule changes in the appearance of a painted surface. This, of course, is not an approach for everyone, particularly those seeking to exert exacting control over their surfaces and textures. Working with the weather can be an exercise in frustration. The results can go from fantastic to flop in the blink of an eye. The artist must perform a sort of dance, working in tune with the shifting conditions presented by a changeable atmosphere.

Drew Harris, *Fogwater Series #10,* 2008, acrylic on canvas, 4 x 5 feet (1.2 x 1.5 m)

PACKING FOR A PLEIN AIR EXCURSION

Yes, painting outside with acrylics is not for the faint of heart. As the term translates, the "full air" aspect can sometimes be like directing a massive hair dryer on high heat at full blast to your surface. No doubt, working en plein air with acrylics has its share of challenges. However, if you are armed with the right tools, you can face the great outdoors with confidence. (Though you may need a bigger backpack.) When preparing for a plein air session, make sure to bring a water spray bottle, acrylic retarder, plastic wrap, moisture-retaining palette, extra water, and tweezers. (The latter are for removing adventurous insects and atmospheric debris from your paint before it dries.) Of course, the outdoor air varies according to season and geography, so no one set of rules can apply to every time and place, but these items will expand your possibilities.

While painting en plein air, you might also take a minute to look around and see if any other inspiration strikes you. The natural world is cluttered with an abundance of useful collage elements.

"In a recent body of work entitled The Fogwater Series, my intention was to challenge the acrylic mediums I have employed for years—'muddying them up,' as it were, and allowing the painting to paint itself without intervention in the process. To my surprise, the natural materials I combined and manipulated just wouldn't 'deaden' the industry's new acrylics. Rather, the rich natural hues of acrylic emanating from and embedded in the canvas provided a vibrant luminosity that made the works come alive. The end result was a series of paintings that had seemingly steeped in years of well worn layers of history."

—Drew Harris

Presentation

By now you know that this multifarious material allows us endless possibilities—in both application and, ultimately, presentation. As such, there is no all-encompassing way to either protect or present the end product. But let's take a look at some of the more popular (or perhaps simply more tempting) options.

Varnishing

Before you varnish a work, consider why you are doing it, and if you really need to. As there has so far not been a truly archival, conservator-approved, removable varnish for acrylic produced for the industry, you are taking a chance by using any of the finishing products that do exist.

A straightforward painting that has been executed on a support capable of being mounted to the wall does not necessarily need anything other than a bit of framing wire on its backside to finish it off. The acrylic surface is a tough thing, a plastic skin. Varnishing is not often done because it is necessary but because people *assume* it is necessary. This is not the case. True, the acrylic film remains semi-porous after it has cured, which allows for the accumulation of environmental debris and for the possibility of light, water, or smoke damage. However, if the finest-quality products are used, the change to the paint film will not only be minimal but most likely will not be visible to the naked eye.

The bottom line is that to best preserve an acrylic painting, I recommend that no varnish of any sort be used upon it. This comment may seem a bit extreme in its finality, but I assure you it

is made in earnest. The tendency to treat acrylic paints like oil paints has lead to the widespread, and inaccurate, assumption that they are just as delicate and thus that they require some sort of secondary protection. Acrylic paints are nothing like their predecessors in any respect other than that they are a binder that carries pigment. This is a new material, to which we need to attach a new mindset as we move forward. Clinging to traditional practices will only serve to limit the way in which we consider and then handle acrylics.

The pull toward needing to "finish" a painting with a varnish is a relic of the old school of painting. Acrylics are a material that already have a UV shield, are water resistant, have a clear binder, are relatively easy to keep clean, and will last well in most environments. What a varnish is meant to do is to protect and/or enhance the painting, by providing a clear coat that, in the event of damage or heavy soiling, can be removed without damage to the underlying painting. There exists no material now that can safely be removed from the acrylic surface without potential damage to that surface. This is the bottom line. If you choose to add a clear coat to your painting, you can be fairly certain that it will eventually, if not immediately, become one with your painting. Dirt and dust will also show more over a clear coat than on an uncoated painting. Removable coatings are currently being researched, but they are a long way from meeting the aesthetic demands of artists, and there may still be damage to the acrylic paint surface if they are removed. So before you

go ahead and liberally slap on a clear coat, make sure you know what it is you are hoping to accomplish. (The sidebar on pages 154–155 may help you clarify your goals.)

Having said all of this, I will now proceed to provide instructions on varnishing. I do this with the full knowledge that regardless of my repeatedly and adamantly recommending against it, people will do what they want anyway. So here it is:

Step 1: Read and understand the label and application instructions.

If you are going to varnish at all, be sure you are aware of what you are using to do so. Many products are labeled as varnish, but in the loosest sense. A true varnish should be removable; if it is not, it should be called a finishing medium or top coat. For example, a polymer medium is not a varnish. It is liquid acrylic without pigment. It will bond permanently with the rest of the acrylic on your support, and to attempt to remove it would almost certainly result in the alteration (or destruction) of the color layer beneath it.

Having chosen the appropriate material for your piece, do not fail to read the instructions, as they can often be very specific. If you are tempted to disregard any aspect of the recommended instructions for use, protect yourself from potential disaster by testing the product first.

Step 2: Apply an isolation coat prior to application of varnish.

Once you have established that the product you are about to use as the face of your artwork is the right one for the job, set it aside and prepare your surface. Any material that is considered to be a removable varnish for acrylics requires strong chemicals for that event. These chemicals, likely to be acetone or similar, will also remove the paint that the varnish is protecting. Hence, the prudent route to take is to create a shield. Apply a single layer of clear medium, the glossier the better (unless you are rigidly dedicated to a matte appearance). This will not guarantee the absolute protection of the underpaint, but it will create a moderate barrier.

Step 3: Wait.

Being sure that the acrylic paint film has fully cured can be very difficult to determine, therefore err on the side of caution and wait. Paintings that are dry to the touch should be placed against and facing a wall on an angle. This will prevent dust from accumulating on the surface during curing. Heavy applications should be left to cure for at least a month or two before even considering adding a varnish. Thin paint films can be varnished within one week.

Step 4: Apply.

Application parameters vary between varnish types and brands. Follow the manufacturer's instructions to the letter. Consider investing in a good varnish brush, one with soft bristles and a strong ferule. Once your painting is so close to being complete, the last thing you want is a mess of stray bristles on your pristine surface. Cover the painting in a single, uniform layer, being careful not to overwork the varnish as you apply it or it will dry with some brush strokes still visible. Do not apply a second layer until the first has been left to dry for 24 hours.

Using Epoxy Resins

We've all seen them: the super glossy paintings. Impossible to photograph, impossible not to want to touch. Many varieties and qualities of epoxy resins can be used as coatings for acrylic paintings, and most will look fantastic upon curing. They are impervious to water and most chemicals and are almost glass hard.

What should be considered, however, is that all epoxy coatings are sensitive to ultraviolet light and will become brittle and show signs of yellowing in time. There are guards against these effects, but they only delay this deterioration. And once the coating fails, it is virtually impossible to remove from an acrylic paint surface. From a conservation standpoint, it is a bit of a nightmare.

Framing

No matter which style you choose to exhibit your work in, if you are framing it, make sure it can be removed from the frame at any time without damaging the painting. Artists may have a very different idea of how their work should be presented than the folks who buy it and put it in their homes. Keep this in mind before welding your painting to a frame and running the risk of mechanical damage to the work if and when it is in need of an image makeover.

Framing acrylic paintings behind glass is fine, though not necessary. If you choose this path, take two potential problems into consideration. Work that is still uncured needs to be free to expel its volatiles. Sealing it into a glass cage will retard the curing process and cause the volatiles to accumulate in the space between the glass and the paint film, where it could cause any number of problems, including mildew and bacterial growth or condensation, leading to water damage. The second potential problem is that the paint will adhere to the glass if no spacers are placed in front of the painting. In the early days of my painting career I put a painting directly behind Plexiglas, and now they are fused together. Glass will not bond quite as aggressively to acrylic, but it can still cling with some enthusiasm.

"Acrylics dry fast and they dry waterproof. This is why I began using them back in the 1960s. I work by exploring . . . always assuming that what I am doing is a good start and that I will change it as the painting evolves. I have been known to paint out several weeks worth of work, scraping the old paint off with a razor blade and painting a gray patch over the area to be redone. I work in layers, alternating between opaque and transparent, and mixing some white with almost everything. I achieve dusty effects by patting with a sponge. Remember, I work thin in many, many layers, including the misty bits."

—Robert Bateman

Robert Bateman, *Orca Procession,* 1985, acrylic on Masonite, 30 x 42 inches (76.2 x 106.6 cm)

Q&A: VARNISHING

I think that my painting needs a protective coating. Should I varnish it?

First, assess what you are really looking for. If you feel your artwork needs a protective coating, what is it you aim to protect it from? Generally, ultraviolet light, dirt/dust, water, and physical damage are the top responses to this question. So let's examine each of these in turn.

Artist-quality acrylic paints are produced using artist-quality pigments, those with superior lightfastness. Ultraviolet radiation in normal conditions (e.g., indoors in direct or indirect sunlight) should have no adverse effect on the pigments. The acrylic binder provides a certain amount of shielding, as does the window glass. Highly lightfast pigments will not shift under these conditions. If, however, you have used fugitive pigments, you can apply a clear coating (either polymer- or mineral spirits–based) that contains UVLS (ultraviolet light stabilizer). This is not to say that a coating of this sort will ensure longevity in fugitive pigments; it will not. What it will do is delay the eventual deterioration of the pigment by a few months or possibly a few years. UVLS is a booster, not a permanent solution. There is no practical solution to fully protecting fugitive pigments other than to store them in complete darkness in an airtight environment. If lightfastness is a concern, you should start out by using stable pigments, which will save you the extra work and worry in the long term.

Dirt and dust are inevitable byproducts of our living and working environments. Unless you store your work in a vacuum-sealed case, it will be susceptible to environmental contaminants and residue. This, however, is not necessarily as bad as it sounds. As acrylic films have a natural tackiness, they attract a certain amount of dust. This is normal and usually imperceptible to the naked eye. The recommended procedure for dust removal is to use compressed air to blow off the residue without making direct contact with the surface. Visible dust can also be swept off with a dry, lint-free microfiber cloth without visible damage to the surface, although there is the chance that in applying pressure, dirt can be pushed into the surface rather than off of it. If the surface is highly textured, use a soft, natural-hair brush to remove surface dust. In a typical domestic or work environment, this should be all that is necessary to keep your artwork looking fresh and vibrant. In the extreme case that a surface becomes contaminated with unusually heavy soiling, cleaning and/or repairs should only be performed by a trained conservator.

As for water damage, this is not something that one can expect from the normal display of a painting. If you are planning to immerse the painted surface in water, then by all means, find a way to seal the surface. However, keep in mind that once this is done, it will likely be permanent. During the curing process of the acrylic, fissures are left behind by all of the exiting volatile compounds. This creates microscopic pathways though which water or other liquids can migrate. Water can damage the normal paint film, causing it to swell and soften. In this state, the film is susceptible to

physical damage. Another consequence is that water, along with dirt particles, can be forced into the weakened film, giving the paint a cloudy appearance that will remain once the film dries.

I want to provide a unifying clear coat to even out the surface sheen of my work. Can varnish provide this effect?

Providing a clear, unifying layer to a finished work is easily accomplished with some of the many acrylic mediums available from acrylic paint manufacturers. Gels, polymer mediums, and any number of other clear-drying acrylic mediums can be used over the top of a painted surface and will bond beautifully to the surface. Most of these are available in gloss to matte finishes. Before you use one of these products, check the label information to see if it will hold texture or will self-level. Beware of products that are not 100% acrylic or are acrylic hybrids. These are specialized products that usually have a specific purpose and may not be appropriate for traditional paint applications. Again, check and heed all labels and manufacturer's instructions prior to use.

Art retailers are very savvy about the products they carry and are often helpful and inspirational sources of product and procedural information. Be aware, however, that as informative as they are, they may not be aware of some of the intricacies of product combinations. So for the most accurate and product-specific information, always contact the manufacturer directly. Take the time to test any unknown product prior to use; this is your best insurance against accidents.

I want a matte finish on my work. Will varnish achieve this?

Acrylics, in their most unadulterated state, will dry glossy. To tone down the gloss and impart a more subdued, matte finish, you will need nothing fancier than a matte polymer medium. To keep your colors bright, add this medium to the color as you paint, keeping in mind that in some artist lines the degree of gloss varies from color to color. A very thin final finish of a matte medium on the completed work will bring the gloss down effectively; however, this is much the same thing as "varnishing" with a polymer medium, and you should bear in mind that once applied, this layer is not removable. The thinner the layer is, the less it will dull the brilliance of the pigments.

I'm not sure why exactly, but I think that I'm supposed to varnish my painting when I'm finished. Is this always true?

If you feel that applying a varnish is simply the final step in producing your artwork, then don't, because it very likely isn't. A work of art made from good-quality acrylic products does not need to be varnished. If you are happy with the work the way it is, why potentially ruin a good thing? Unless you are planning to expose your work to some extreme conditions (say, outdoors in Florida during both sunny and hurricane seasons) or want it to be able to function as a bludgeoning tool, then you should battle down your urge to varnish, and consider your work finished, just as it is.

Chapter 8
conservation and environmental issues

"It is simply a matter of changing our habits and being conscious of our accountability."

Though this chapter falls at the back of the book, it is front-page material, containing timely issues that we seek to address and solve. The importance of conservation in art, and the impact of art practices on our environment, is more relevant now than it ever has been. Fortunately, scientific research and a growing, global database are facilitating the efforts being made by conservationists and manufacturers, providing them with the tools and the data with which to increase the longevity of art and reduce its encroachment on our natural world and resources.

As a painter and an inhabitant of this planet, you must be informed. This is a responsibility that we all must take to heart. Our libraries and universities are brimming with information and informed people whose expertise can be mined to expand our understanding of our materials. Augmenting our knowledge of how acrylics work helps us to not only use them to their full potential but to do so in a way that is mindful and responsible.

Art conservation is a field run partly on science and partly on assumption. Depending on the often insufficient, random tidbits of information left by artists more intent on getting their work noticed than on making sure it sticks around for a while, conservators must piece together materials-combination information through painstaking and time-consuming examination. Imagine the amount of time and energy that could be saved if artists documented their process and materials, kept a log of their progression, and made these materials available to whomever might need it. Restoration and conservation work would be cut in half! Here's to hoping some of you will take this to heart and make a push for a more informed future.

When it comes to the environment, we are becoming increasingly aware of the impact we have on our resources, both from a taking and disposing point of view. We take our pigments, our petroleum-derived acrylic resin, and numerous other raw materials that make up our tools from the earth's stores. We can either do this responsibly or wastefully. It is up to the individual to keep an eye on balancing consumption and choosing materials made with an eye to the environment rather than to the bottom line. How we use these materials and how we clean up after ourselves have repercussions on our environment. It is difficult not to sound righteous and preachy when addressing these eco-issues, but the simple truth of it is that if you are going to be using acrylics, you should be aware that it is impossible to have them be permanent and at the same time be biodegradable. So either accept this fact, and use your materials responsibly, or use something else. There are many ways to implement good studio practices that will reduce your impact on the water system, atmosphere, and landfills. It is simply a matter of changing our habits and being conscious of our accountability.

Documentation

The first and best thing that any artist with an eye toward the future can do is to document the process. This means naming your materials and tools, including details about the brand names and formats. The more details, the better. It is time to let go of any proprietary issues you may have about what and how you use your materials.

The cleaning and restoration issues that acrylic use brings up are entirely new and are as yet largely unresolved. Much of the difficulty with this lies in the fact that the acrylic recipe itself is exceedingly complex and varies considerably among manufacturers, all of whom maintain a proprietary hold on their raw materials data. Compounding this problem is the overwhelming propensity for artists to maintain a veil of mystery around their process and materials. In the end, however, it is in an artist's best interest to freely divulge his or her methods, as this information will help conservators and generations of artists for years to come. Information, in the right hands, will provide a valuable database for future research and development on the side of manufacturers, as well as a solid platform upon which artists can build works of enduring physical as well as visual impact.

Conservators collectively shudder at the mere mention of "mixed media" when the term is used to describe material used in a work of art. That could be *anything!* Thankfully, with processes like mass and infrared spectrometry and a broad collection of commercial paint samples, they are able to make some relatively accurate guesses on material components. It would be appreciated, however, for the artists themselves to help them along, and by doing so contribute to the ongoing understanding and appreciation of the acrylic medium.

Alex Colville, an icon of modern Canadian painting and a superb draftsman, had strong feelings about the subject of artwork and permanence: Throughout his long and illustrious career, he has sought to provide meticulous documentation on his process and materials, explicit saying: "I thought the more information I give for possible use by conservators and so on, the better."

Providing brief documentation along with artwork is a good practice. State the date the work was produced, information on the support (type, weight, and so forth), and all materials that were used (including the ground and finishing coats). Brand information, combined with the date of the work, can provide clues to conservators about the chemical makeup of the materials. Conservators work and communicate with many

> *"I really want the paintings to last. Right from the beginning, I've always felt this way. The idea that some painters have, that they actually like the paintings to age and transform . . . there's nothing I'd like more to avoid."*
>
> *—Alex Colville*

materials manufacturers, and through these contacts they can more effectively troubleshoot structural and chemical incompatibilities when repairing or cleaning the work. Further to this point, most manufacturers retain both wet and dry samples of each batch of paint produced. Should a particular paint composition come into question, detailed information on it can be accessed, keeping in mind that certain proprietary issues come into play at this level.

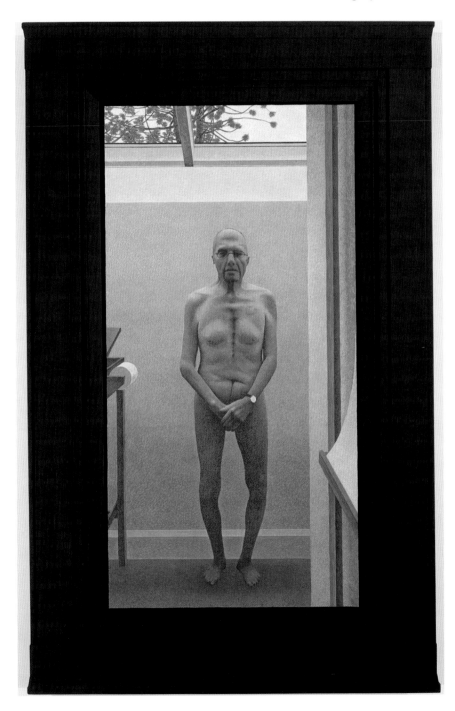

Alex Colville, *Studio*, 2000, acrylic on hardboard, 26 x 12 inches (66 x 33 cm)

Conservation Efforts

Are acrylic paints permanent? If they are not now, they will be. *Permanence*, when used in the art materials world, is a tricky term. How long is permanent? Is it 100 or 1,000 years? Or beyond? How long does it actually need to last? Even archival paper is subject to deterioration within a finite period of time, and besides that it can only remain archival if it is kept in absolutely pristine conditions, within controlled environments. So what are we really hoping for when we ask, "Will my acrylic painting last; is it permanent?" Within your lifetime? Sure. For 50 years? Most likely. For 100 years? Probably. Beyond that? Does it really matter? Yes, but those Egyptian encaustics lasted all those centuries. . .

Just about everything would last in a virtual vacuum, in an environment free of moisture, bacteria, mildew, UV radiation, and pollutants. Try propping those puppies up in a gallery window in Florida for a week, then see how long they "last."

Successful preservation depends as much on where and how your artwork is stored as on how you put it together. It is the construction of it, however, that you have almost absolute control over. I say almost because beyond choosing your materials and assembling them with an eye toward conservation, the materials themselves can range from the very stable to the dangerously shoddy—and unless you are privy to the inner workings of the manufacturers of every raw material and, in turn, every combination of how those are put together, you are working with no real guarantee.

The business end of a Fourier Transform Infrared Spectrometer. This essential equipment is used to analyze the materials from tiny samples taken from artwork.

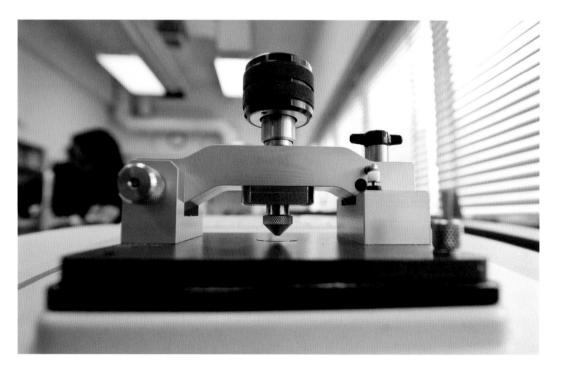

Jeremy Down, *Cornice,* 2006, acrylic on canvas, 20 x 40 inches (50.8 x 101.6 cm)

"As I live in the interior rainforest in British Columbia and all my work is done outside, I directly use my environment as a creation tool. For instance, when the temperature is below -10 degrees centigrade the gel medium freezes into a kind of scumbly paste, so I can build up texture with it. During our shoulder [off-peak travel] season rain is like being in a cloud; this is when acrylic gel comes into its own because it can hold itself to the canvas better than raw pigment. I also take painting tools from the immediate surroundings. I try to use at least one piece of drift-wood or ice in each day's piece to keep the work connected to the site. Most of these tools are used for scraping or drawing."

—*Jeremy Down*

Q&A: CONSERVATION CONCERNS

What is the general consensus on the status of acrylic paints as a viable, durable art material?

Though it has taken several decades to state this claim with near certainty, it is now apparent that acrylic paints are the most flexible, durable, and versatile painting medium available to artists today. The strength of their binder—its clarity, flexibility, and stability—gives it an unprecedented advantage in terms of both its longevity and its handling properties.

Every now and then a visible greasy film appears on the surface of a dried acrylic work. What is this, and how can it be removed?

One of the possible culprits is the surfactant, which is present in the paint to facilitate the blending of dry pigments into an aqueous dispersion and which does not fully evaporate from the paint film during curing. It should not be assumed that surfactants are the only additive that migrate, however, as other components, such as defoamers, antibacterial agents, and so forth, can also leave a film. Acrylics are a chemical soup, which in ideal conditions will dry clear, flexible, and durable; however, varying drying environments and conditions, support materials, and extraneous media can all have an effect on how that paint will ultimately cure.

This greasy film is not always present, and when it does appear it is generally due to several factors in the construction of the film and in the drying conditions. A slow-drying film, where either a retarding agent

or a slow-drying medium is present, will cause the surfactant to linger more readily. This is sometimes amplified by more humid conditions, which further slows the evaporation process. Of course, sometimes the film shows up and it is impossible to discern how it got there. It is not this bit that concerns us, but rather, how to get rid of it.

As with any cleaning process, it is best to first test the cleaning methods on either an alternate piece or on a small area where any subsequent damage would be the least noticeable. First, make sure that the surface is dry. A lint-free cloth will be an effective way to remove the film, using a variety of methods and solvents. In some cases, just a touch of water will do the trick, though sometimes using something a little more aggressive is necessary. I have found that a very light dilution of up to 3% mild dish soap in distilled water (which can be purchased at any drug store) is effective in removing the film. Always test a small area prior to attempting to clean the entire surface, and wait 12 to 24 hours for the surface to dry. If your test is successful, clean the surface in small sections, being careful not to allow the water to pool or remain too long on the paint film.

Is coating acrylic paintings with epoxy resin a viable practice?

Trends often dictate the direction that new art will take, if only for a while. A flurry of art produced in the last few years has been catching the public's eye, but it may end up catching the

collector's pockets in the long term. The question is how viable epoxy resins are as a top coat for acrylic paintings. This issue has come under scrutiny and has been found wanting. The reason for this is the durability and longevity of the resin itself. Epoxy is tough and shiny and will look great at first; however, it will age poorly. Epoxy resins will discolor, turning from clear to yellow or even brown with time. They can opacify and will become brittle, and to make things worse, there is the possibility that they will lose adhesion to the paint surface and simply just pop right off of it. So, how viable a practice is it to coat an acrylic painting with epoxy resin? It isn't. And don't even get me started on bubblegum paintings. . . .

Can and should acrylic paintings be stored under glass?

Acrylic paints are their own protectors, but at times elements in a painting require additional shelter. Paintings executed on delicate papers, particularly when any portion of the paper is not coated with paint, will be susceptible to damage from the elements and should be properly matted under glass. Be advised that any acrylic painting, regardless of its thickness, must be allowed to cure before being trapped under glass or any other nonporous protective layer, including varnishes and top coats. As the acrylic cures, it will off-gas, releasing its volatiles, which, if sealed in, will form a translucent film on the glass, rendering it cloudy or semiopaque. These volatiles, such as water and glycol, can become trapped in the space between painting and glass and create condensation,

which can in turn lead to water or mildew damage.

What are the conservation issues involved with mixed media?

It is safe to say that this is the headache, the conundrum, the nightmare issue, for conservators. Why? Because the term "mixed media" can mean anything! Mixed media is the most vague label that can be attached to any artwork when it comes to conservation. From paint to porridge, there's no telling what constitutes a mixed-media painting these days. If (for the sake of how it looks on the gallery label or because listing all the components is too long) you decide to label your work in this manner, do yourself and conservators a favor by listing the materials on a separate document or on an inconspicuous part of the support. (For example, fix your list to the protective backing board of a painting or on one of the stretcher bars.) This will save a great deal of time and frustration on the conservators' end in the long term. In some cases, artists will label paintings created with acrylic paints and acrylic mediums (gels, modeling paste, and so forth) as mixed media. These are not mixed-media paintings; they are acrylic paintings. When it comes to painting labels, stick with the truth, or an image may come at too high a price.

What is the recommended process for using acrylic gesso as a base for oil paintings?

The purpose of the gesso layer is to protect the support from coming

into contact with oil paints, which can cause the support to deteriorate. Acrylic binder is slightly porous, a characteristic that is greatly reduced in artist-quality gesso, which is loaded with calcium carbonate, titanium white pigment, and often a quantity of matting agent. These components add toughness, sandability, and buffering strength to the gesso. To create an absorbent but sealed ground for oil media, acrylic gesso should be applied the following manner:

1. **Clean the support well.** If you are dealing with linen or canvas, you should thoroughly wash and dry the fabric prior to stretching it. This will remove any bacteria, mildew, or sizing. The cleaner your surface is, the better the bond will be between it and the ground. So don't stop at a quick wipe-down; use a little vigor and make the support as receptive as possible.

2. **Apply the first coat of gesso.** This can be done in one of two ways. For very porous surfaces, thin the gesso lightly so that it will be readily absorbed into the substrate, and apply it as evenly as possible. A semi-porous surface can be treated with a heavier application, though care should still be taken to ensure uniform coverage. Another way to accomplish a good foundation is to scrape the layer of gesso on with a spreading tool, using pressure to force it into the weave of the canvas or linen. The idea is to create a strong bond between substrate and ground.

3. **Lightly sand the first layer.** For best results, allow 12 to 24 hours before sanding. Make sure to brush off all the dust as you work and be sure to wear a protective dust mask.

4. **Apply two to four more layers.** Again, allow 12 to 24 hours before sanding, and sand between coats. Make sure to brush off all the dust as you work.

5. **Allow the surface to dry for 48 to 72 hours.** Prior to painting on the surface, it needs to be fully cured. Waiting 72 hours may seem a bit excessive; however, when it comes to adhesion, durability, and longevity, the better your foundation is, the more likely it will be that your painting will endure.

Which solvent can be used to remove dried acrylic paint?

Acetone, toluene, d-Limonene, and ammonia can be effective in softening and removing dried acrylic paint from surfaces. As they are all volatile solvents, using these full strength or in dilution should always take place in a well-ventilated area, and when stronger aromatic solvents (such as toluene) are used, an organic vapor mask should be worn. In the case of a freshly dried paint that may not be fully cured, mineral spirits may be effective. The effectiveness of solvents for paint removal depends on how long the paint has been dry, what type of surface it is on (porous, nonporous), how well the acrylic has bonded to

the surface, and how thick the paint film is. Start with a small quantity of solvent (diluted is a good idea for thin paint films). There are many "home remedies" for paint removal, such as vodka, or a concoction of ammonia, vinegar, and salt, but when it comes to your artwork, or your painting tools, you may want to consult your art materials retailer or the paint manufacturer to hone your cleaning solution to your specific issue. Some solvents can bleach colored surfaces, so be sure to always test first. Some nail polish removers contain both acetone and d-Limonene and are very effective in breaking down acrylic paints, and, as a readily available household item, this is my preferred choice for quick cleanups or stripping down paint layers.

How should one deal with varnish removal?

If an acrylic painting has been varnished and it requires restoration or cleaning (these being the only reasons to remove a varnish), this should not be handled by the artist. Artists should not be repairing or conserving their own paintings, particularly if the integrity of the painting is at stake. This is a job for a professional. Art conservators are trained for this job and will have the tools, know-how, and delicacy to do it properly, and with the least amount of impact on the painted surface. In cases where a conservator

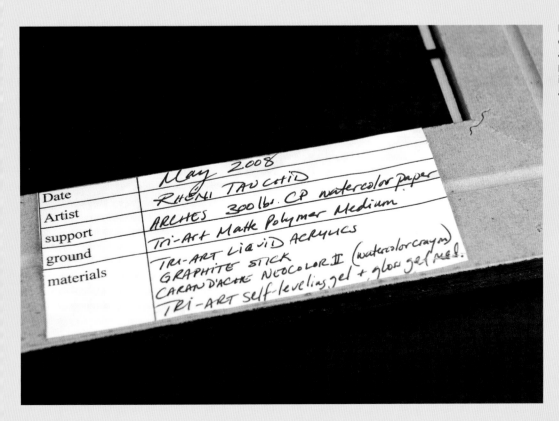

Documenting the components of your artwork on each piece provides indispensable information for your archives.

is physically unavailable, he or she can dispense valuable, general advice through electronic communication. The more information the conservator is given, the more efficiently and effectively he or she will be able to advise you. Retaining information from the manufacturer on products used (both the varnish and materials in the painting itself) is crucial to the information-sharing process.

What is the ideal environment for the storage of acrylic paintings?

Painted acrylic artwork should be kept clear of other materials while stored. What does this mean? Acrylics are notoriously sticky. Even when fully cured, an acrylic painting can latch on to other materials and incorporate them into its skin. Paper, plastics (though not all), wood, and many other materials will stick to the acrylic surface. It is, therefore, imperative that a nonstick material be used to cover the painting—or, better yet, that the painting be mounted into a storage box in such a way as to leave its painted facets untouched. To facilitate this type of storage, there are metal clips (Oz clips) that you can attach to the framework of a painting and then attach to the inside wall of a box, holding the painting in place and the surface untouched.

A cubby-type placement, where paintings are stored in vertical slots, is ideal in a studio environment. To protect them from dust, the entire storage unit can be draped with fabric or protected behind closed doors. At no time should paintings be stored face-to-face, as they will bond together, and eventually it will

be impossible to separate them without damage.

What can be done to assist in building a comprehensive database on acrylic materials for future conservators?

The single most useful tool to a conservator confronted with a soiled or damaged painting is information. Having a detailed breakdown of the components of the artwork is invaluable, as this information can give solid clues as to the strength and durability of the work, as well as help determine what the best materials and methods would be to repair or clean the work.

Attaching a list of materials to the frame of the work is all that is needed. This list should never be adhered directly to the back of a support (paper, canvas, and so forth) but on the frame or canvas stretcher bar. If there is no suitable spot for the label, consider keeping a record of your materials use in case of damage down the road. This document should include the following information: date of completion, support material, and surface materials. The list should be brand specific, as conservators will be able to consult with manufacturers to deal more accurately with concerns about the piece. If you want to be hyper-specific, record the batch number of any paints that you are using, as manufacturers retain a complete record of each batch of paint produced, from the recipe down to a physical sample. Batch numbers are labeled on all paint products, though placing may vary between container formats and brands.

Obviously the more detailed your record, the better; however, this may not always be possible or convenient. The extent of your commitment to transcribing your materials list should be driven by your interest in the maintenance and longevity of your artwork.

What is the general advice on varnishing acrylic paintings?

Don't. And if you really want to, ask yourself why. (See pages 150–151 and 154–155 for more details on this topic.)

Used to test their endurance and longevity, this Despatch accelerated ageing chamber bombards materials with heat and humidity.

Environmental Concerns

Eco-friendly paint practice and products are all the rage right now. It is an importunate, epochal topic—certainly not a trend, but rather a generational imperative. Clean studio practices and responsible use of materials will not only reduce the artist's impact on our environment but will conserve on many levels. The crux of this issue, as it pertains to the art and materials industry, is to be informed. The better we understand the components of our materials and their potential impact on our sewage system, air quality, and waste-disposal facilities, the more responsibly we can tune our studio practices to reduce it.

First, let us be clear on one point: Acrylics are a petroleum-based product. If you are looking to switch to a completely "green" product, this is not it. Materials that are produced for professional artists have to meet certain criteria, longevity being chief among these. Materials that boast more ephemeral qualities do exist. They consist of natural dyes and binders and will likely not last with any degree of vitality into the next decade. Artist-grade acrylic paints, on the other hand, will surpass that time marker and well beyond it with ease. Here is the fence upon which the dilemma rests.

In combination with the acrylic polymer emulsion binder, which in itself is a tough and resilient entity, the pigments offered at this level fall within the two highest categories for lightfastness as set by ASTM standards. The combination of these elements create, essentially, a "permanent" material—a tough, plastic shell that encapsulates even tougher insoluble pigments. This is exactly the opposite of biodegradable. It is not a compost-friendly combination, neither is it particularly recyclable. How then, can we establish a conscious and responsible response to the environmental issues that face us on a personal and global level?

Reduce. Reuse. Recycle. It is our global anthem. This mantra has become one of the top topics of the past few years, and is likely to continue to be at the forefront of artists' and manufacturers' focus in the decades to come. At first glance, as a petroleum-based art medium, acrylic paints are not considered the "greenest" of products. They are a plastic paint, a synthetic concoction, a non-naturally occurring material. What is considered good in terms of the longevity of artwork can be bad for the environment and vice versa. As environmentally conscious artists, we would love to have both, but the rules of chemistry cannot be shattered by a mere wish. Outside of what we cannot control lie the factors that we can manipulate responsibly: how we use these paints and how we deal with our wash water and leftovers.

The trilogy of these eco-buzzwords carry the answer to that questions. Each of these can be addressed within many aspects of art practices, from the shopping list, into the studio, and through to the end result. A conscientious effort on the part of each artist will go a long way to having a reduced impact on the planet, leading perhaps to greater respect on the global art stage.

FOCUSING ON THE PACKAGING

In addition to reusing the paint and supports themselves, consider the packaging of your materials. Nowadays, most acrylic paints (with the exception of those that come in tubes) are packaged in containers that can be reused. HDPE (high-density polyethylene; code 2) or PP (polypropylene; code 5) plastic containers can be easily cleaned by simply peeling out any remainders of dried paint. A quick wash with dish soap and water will render them good as new. These are then ideal for storing paint, solvents, dry materials, and so forth.

More and more, PET (or PETE-polyethylene terephthalate; code 1) is being used for acrylic paint packaging. In its amorphous form it is transparent and shows off the colors exceptionally well, while housing them in a recyclable, flexible, and durable container. Paint will not peel out of this type of jar as easily, but soaking it for a short period of time in hot water will soften both the paint and the jar, facilitating the process.

Note: Any container previously used for paint storage is not suitable for reuse as a food or drink container.

These Tri-Art high-viscosity colors are housed in the first collapsible plastic tube, made of recyclable plastic.

Reduce

It begins with shopping. For starters, as far as wet materials are concerned, it really is best to buy as you need, unless you are shopping for a long-term session. Most artist-grade acrylics will have an estimated shelf life of up to ten years, though certain environmental factors and storage conditions could reduce their durability. Keep in mind that this figure is attached to unopened paint. Once the seal is breached, the water-based environment of acrylic paints and mediums is susceptible to fungal and bacterial contamination (which is carried either through the air or tools that are dipped into it).

When investing in color, opt for smaller sizes. This is particularly advisable when choosing artist-grade colors, as they are significantly higher in pigment strength than the more economical varieties and thus can be extended with mediums. Reduce your consumption. An artist-grade paint with a high pigment concentration may cost a bit more than the same size jar of a student-grade brand, but it will go much further. On average, artist-grade paints carry 50% to 70% more pigment than a student-grade colors. (Think of it as frozen juice concentrate: Just add water [or medium] for rich, tasty color!) Although we are encouraged daily to buy in bulk, the inevitable outcome of that style of consumption is ultimately wasteful and hence more expensive in the long run. It may be a little more work, but it is worth your while to transfer smaller amounts of paint from a large container to a small one. The more airspace in the jar, the higher the potential for dehydration and trapping bacteria or mold spores.

Next, reduce the amount of paint you put out onto your palette. Acrylics will dry quite quickly if they are left neglected, airing out on a palette, especially in an outdoor or otherwise dry environment. Keeping paint wet on a palette can be a challenge in arid conditions. Using a palette with a lid and water reservoir will provide a clean, sealed environment, significantly decreasing the evaporation process that dries out the paint, as will misting the paint with water at regular intervals. Neither of these methods are ideal, though, as they could potentially invite mildew spores and bacteria to enter the paint. If the container-style palette uses a sponge as water reservoir, make sure that it is kept as clean as possible.

One way to keep excess palette paint moist is to give it an airtight seal. Wrap it securely in plastic wrap, smoothing out any air bubbles. Paint preserved in this manner will stay wet for several days. The ideal palette for this process is nonporous, made of either plastic or glass. A palette that the paint will peel away from is the best type of palette to use for the following three reasons:

1. These palettes are nonporous, which inhibits evaporation through the material, keeping the paint wet longer.

2. Once paint has dried on the palette, it can be peeled away cleanly, leaving a pristine surface on which to mix. (Dried paint can be collaged onto a support to add both fresh color and texture to a composition.)

3. Nonstick palettes are made of a resilient plastic that will not warp and is highly resistant to cracking or breaking, even if it is dropped from a great height. Short of coming into contact with a running band saw, they are virtually indestructible.

CRITIQUING YOUR STUDIO PRACTICE

There are many ways in which we can reduce the impact that our art-making byproducts have on our environment. These things are pretty basic, really, and easy to make a habit of. As tempting as it is to dip into that fresh and full new jar of paint, try to salvage the dregs of what is lying around your studio first.

In addition, here are two paint storage tips:

1. **Store your liquid paints and mediums upside down.** Aside from ultimately making them easier to get at, you will be blocking air from getting into the package. The air space behind the paint will be almost a vacuum of clean air, sealed from possible contaminants by the volume of paint in front of it.

2. **When a large container of paint gets down to below half, transfer the remainder into a fresh package.** This practice will prolong the life of the paint and is one that more teachers should take the time to embrace at the end of a teaching term. It will result in a dramatic reduction in the loss of paint, much of which is caused by drying and the fungal growth that occurs when paint is left unused for months at a time.

As part of my studio practice I recycle used canvases. Here, gesso and a glowing glaze gave a fresh start to a tired old piece.

Not finished yet, this work is host to all left-over paint from the production of the examples created during the making of this book.

Reuse

One of the things I have always enjoyed about using acrylic paint is the ease with which I could erase those failed paintings, ugly mistakes, and botched experiments. One coat of gesso, and I have a fresh ground on which to play. Nothing is lost, and only a new texture ground is gained. If texture is something that you want to get rid off, smooth on some modeling paste or matte, self-leveling gel with a long straight edge to fill in the valleys. Allow sufficient time for the medium to dry (if it's very thick, this can take up to a week) before beginning your "new" painting.

When re-priming surfaces, use proper ground, never wall paint. An artist acrylic gesso (more accurately called an acrylic dispersion ground or acrylic emulsion ground) is designed to be compatible with flexible and rigid substrates. Plus it is able to withstand the mechanical changes that take place during the curing process of the paint as well as the shifts in the support that can be caused by transportation or dramatic changes in humidity and temperature. A wall paint is designed for a flat, rigid surface and does not carry enough binder and thus will not adhere as permanently to the support, nor will it be flexible enough to weather any structural changes; this type of primer will crack or flake off and will ultimately have a negative effect on the permanence and structural integrity of the entire piece.

If an unwanted painted surface is too textured, an alternative to reusing the texture, or filling it in, is sanding it down. For this process you will need to wear a dust mask and protective eyewear. If the paint is not fully cured, it will be too soft to sand, resulting in a tarry mess. Sanding is only recommended for surfaces that have had at least two to six months to dry, contingent on the content and thickness (height) of the paint. Texture that has been built up with modeling pastes will sand more readily than those created with regular gels, which are much softer and contain fewer solids. Sanding with a fairly fine grit will leave a smoother surface and provide a good amount of tooth for the new paint layers. Wipe away paint dust with a lightly dampened cloth. As the friction from abrading the acrylic in this manner will heat up the surface and soften it, it is best to perform this process in stages, allowing the paint to cool and harden between sanding. If you are using an electric sander and you apply too much pressure, you could potentially damage the support, particularly if it is flexible. Canvas stretchers should be braced from behind with a rigid board to keep the surface flat while sanding.

Can dried paint be brought back to life?

There are varying degrees of dried or damaged paint. Some can be resurrected, and some can be reused—not as wet paint, but as sculptural matter. (See page 9 for a painting that incorporates leftover paint bits.) The chart on the facing page provides the ground rules for resurrecting damaged paint.

RESURRECTING DAMAGED PAINT

Problem	Solution	Use/Notes
mold (Areas of mold are visible, usually on the top of the paint.)	Scoop out all mold from the top of the paint and all mold on the inside of the container and lid. Using a clean tool (for extra precaution, the tool can be sprayed or dipped in isopropyl alcohol), transfer the remainder of the paint into a clean container with an airtight lid.	Once the mold has been removed, the paint can be used normally. Good ventilation is highly recommended in case of lingering odor and spores, which can cause allergic reactions. Mildew only affects the paint in its wet state. People with allergies to mildew should avoid using affected paint. If not all of the mildew spores have been removed from the paint, mold can form on the paint surface post-application. To date, there is no effective way to remove mold without adversely affecting the paint film.
gelled (It feels rubbery.)	Aggressively mix the paint, using a rigid tool.	Gelled paint can be used to create sculptural or coarse textures. Gelled paint cannot be applied with a soft brush. Use a coarse bristle brush or palette knife.
flocculated (It looks like cottage cheese, with larger clumps of paint mixed in with thinner more liquid paint.)	There is no way to solve paint once it has flocculated. (This chemical reaction cannot be reversed.) Acrylic paints can be disposed of in your regular household garbage; however, it should be solidified (allowed to completely dry out) prior to disposal.	Flocculated paint is not usable, as it will dry unevenly and will not construct a stable dried paint film. This is what can happen if a paint has been through too many freeze/thaw cycles. It can also occur due to the instability of its raw materials.
completely dry (It is hard and no longer malleable.)	If the paint has dried inside the jar, remove it if possible. Paint will peel out of certain plastics more readily than others.	Use as collage material to create relief textures. Dried paint can be sliced, carved, or otherwise cut. Although dried paint cannot be used as a wet paint, wet acrylics will adhere very well to it, and it is thus an extremely compatible collage element.
separated (It has a clear or milky layer of thin acrylic floating above the color.)	First, with the lid on, give the jar a good shaking. Then, using a palette knife or stick, stir the paint until it reaches a homogeneous mix and no longer has a marbled appearance.	After remixing separated paint, allow it to sit for a few minutes. If the mixture holds, the paint should be fine to use. If you notice that it begins to separate again immediately, there will likely be some adhesion or skin-forming issues, so do a test sample prior to use.
acrylic "skins"	If your acrylic paint has formed a skin, this dried paint cannot be reconstituted into a wet material. It can, however, be reused as a dry material.	The best method for obtaining paint skins is to employ a palette off of which the paint can be easily peeled. The skins can be used as collage elements, stretched and wrapped, reinforced with wire or other strong material, or cut into tiles or other shapes. If the skin is "fresh" enough—that is, if it is not fully cured—it can be applied to another paint surface. This can be achieved without the use of further acrylic as adhesive, as the paints will polymerize and forge a bond.

Recycle

Acrylic paint itself, once dry, is not the sort of plastic that current domestic recycling plants can break down. Many of the containers that house the paint, however, can be recycled in most urban and rural areas, but take care to remove residual paint prior to recycling. The metal tubes that are still in common use for smaller paint quantities are not recyclable. These are plastic-lined aluminium and, as a composite package, they must be thrown out. Tri-Art Manufacturing is the first company to introduce a collapsible tube made of PET plastic. These can be rinsed out and recycled where facilities allow. The same goes for the springier, HDPE plastic tubes used in student-grade paints.

"This painting is from a series of works that feature iconic trees, symbols of purification and rebirth. Using the recycled paint Sludge gives the work an earthy, weathered look and echoes the ecological concerns inherent in the piece."

—Lori Richards

This paint, produced by Tri-Art, is created by mixing their artist acrylic paint base with pigment mined out of the wash water from the manufacturing process. Sludge batches are different every time and can be used just like other paint colors. Sludge was initially produced to discontinue the reliance on waste companies and stop the incineration of acrylic solids into our atmosphere.

Lori Richards, *Giving Trees,* 2008, acrylic on canvas, 40 x 40 inches (101.6 x 101.6 cm)

Water Issues

Too readily we rinse a brushful of paint down the drain and wash wet blobs of it from our palettes. Clean tools are important, yes, as dried paint will completely ruin a brush, but we should rein ourselves in, as our haste to clean can cause long-lasting problems not just for our own plumbing systems but for our water on a larger scale.

Pigments contained in the acrylic resin are surrounded by a film of water, wrapped in acrylic, but they can seep into the water and can be of such minute particle size that they could potentially contaminate our water supply. So it is worth taking a minute to consider changing your patterns. Before rinsing your brushes, wipe the excess paint on a rag. Or better yet, keep a support nearby

to paint it onto. Many a painting has evolved in my own studio partially created from the leftovers of another.

Keep two water containers on your painting table: the first for the dirty rinse and the second for the clean rinse. (The latter is also handy for adding clear water to colors.) Having two containers keeps the bulk of the paint in the first one, which postpones the need to keep dumping and changing water as you paint. In addition, reduce the amount of water in your cleaning containers. With this system, a small amount of water will still get the brush clean, and in the long run, you will end up using less water.

Another way to reduce the amount of dirty water you put down your drains is to keep a large bucket or other vessel into which dirty water can be

Gregory Beylerian, *Medzmobile,* 2001, acrylic, resin, acquired toys, and a 1968 Volvo 144S, dimensions variable

disposed. Over time, much of the water will evaporate, leaving a sludge of pigment and acrylic at the bottom. This can be decanted into bottles and taken to a hazardous waste disposal site or spread out to dry completely and disposed of as dry garbage. Obviously this type of system works best where the climate is warm and dry, as keeping containers of this sort requires good ventilation, not to mention that any quantity of dirty water will encourage bacterial and fungal growth. If you have the space outdoors for a water-evaporating bucket, use a screen and make a sturdy lid to keep away debris and birds.

Hazards

Manufacturers of all art materials maintain and provide MSDS (Material Safety Data Sheets) for every product they produce. If you have any health concerns or queries, you need to look to these. They are available through schools, suppliers, and manufacturers and are updated on a yearly basis.

If you have a sensitivity to acrylics, or will be manipulating them with your hands for prolonged periods, take the extra precaution of using protective gloves or a barrier cream to inhibit the risk of chemical migration through the skin. (However, it is worth noting that, as our skin is oily and the paint is water based, this risk is minimal.)

Always—and this is certainly only not reserved for acrylic painting, but painting in general—provide good ventilation when you are working, particularly if you are using large quantities of mediums. Although the odor of acrylics is quite low, overexposure can cause headaches.

"I am inspired by the innovations that the modern world brings to the artist. Yet, I am fascinated by ancient methods and techniques. Acrylics are a beautiful fusion of these principles and integrate seamlessly into the multifaceted environments within which I work. Acrylics deny no surface, allowing for the creative experience to flow without disruption. They are malleable, mergable, durable, and elastic. They work in real time, allowing me to explore uninterrupted. These qualities provide me with a crucial component to my work ethic—a forgiving freedom."

—Gregory Beylerian

afterword

The Future of Acrylics

A certain arrogance commonly comes with experience from a chronological point of view. It is the tendency for those who have been working with any given material for a long period of time to assume that they "know" the material, that they have, in effect, solved it. Because of the relative newness of this medium, and particularly due to the evolving development within its existence so far, this is not a presumption that artists can truly make about acrylic paints.

Acrylics are not a fixed material, and their particular identity has been shifting continually since their initial production. Many plateaus have been reached, sustained, then inevitably surpassed over the years. The acrylic mediums are a convenient meter by which we can measure the development of the material as a complete entity. Looking to this group it is evident that acrylics are a material in a state of accelerated growth. To assume that complete mastery of something so evolutionary is possible is not only presumptuous but a practical impossibility.

Where do we go from here? The future of acrylic painting is to be determined by you, the acrylic artist. The next steps toward changing how the world uses, understands, and appreciates these vanguards of modern materials will be fueled by the information that modern acrylic artists will provide. Through access to a massive assortment of Internet resources, artists have been given the gift of an immeasurable quantity of materials information. At no other time has it been possible to view, participate in, and have an impact on the building of a comprehensive art database. With the wealth of knowledge thus growing, the scientific, aesthetic, and educational framework of how art is produced has the greatest possibility to be built upon a solid backbone.

As acrylics evolve, those seeking to express themselves through this medium owe it to themselves to fully indulge in a tactile exploration of all the new materials that are a part of that family. New and groundbreaking advances being made in acrylic research and development need to be tested in the big world. And all contemporary acrylic painters, including you, are part of the project, players in the acrylic team.

As artists, we can make the choice to be current not only in our themes but in our practice. To be a "master" acrylics painter is to be open to exploring them within your own creative context while maintaining an awareness and practicing a con-

current experimentation with the medium itself as it grows. There is no clear-cut road to achieving this state and, similarly, no defining apex to reach. Every artist branches out into his or her own expression of a vision—be it theoretical, allegorical, or figurative. How artists utilize their tools is too varied to be measured. Acrylics, in their multiple personalities, can span this immeasurable sea of expression, and then some.

> *"My paintings explore the astonishing, often unsettling beauty found in natural phenomenon through the use of hybrid, imaginary, and existent imagery. The work involves a great deal of layering, both visually and technically. Acrylic mediums and paint allow me to be flexible and spontaneous in my response to the work and allow me to achieve the depth, richness of color, and meticulous detail that I require."*
>
> —Laura A. Bell

Laura A. Bell, *Ottelia #2,* 2007, acrylic and ink on panel, 25 x 38 inches (76 x 101 cm)

When I first began my foray into the acrylic world, I thought this was pretty basic stuff—paint that was plastic, a simple enough concept. What took a while for me to glean was the complexity of this deceptively simple material. First there was the paint itself, metamorphosing into varying aspects of itself with each different application. Then came the confusion of differing formats. And finally arrived the labyrinth of mediums to sort through.

The rules seemed easy enough to follow: Dilute with water, do not apply on top of oil-based media, and work quickly! I soon learned that there is a great deal more to consider when working with acrylics and that what I had assumed were immutable rules were actually merely guidelines that could not only be bent but in some cases completely breached.

There is only one way to acquire mastery of such an enigmatic material, and that is to embrace its evolutionary character and progress creatively along with it. As artists working through the adolescence of this medium, we are in a unique position to map its progress through our work, just as the Abstract Expressionists did through acrylic's infancy. It is not the role of every artist to do so, but I do feel that we have a particular responsibility to become as informed as we can be to provide a substantial database of materials information for future artists.

Acrylics have evolved beyond mere pigment glue. They have stepped out into the world of dimensional sculpture, snuck into printing presses, and overlapped the canvas into the fine-craft world. Modern acrylic painters are pioneers of the plastic movement, the chefs in the acrylic

> "I have been playing with acrylics for a couple of decades now, and from the beginning, I wanted to do more with them, bend them to my will. Instead, I have found that they have bent me, bent my imagination and my curiosity. I paint and sculpt with these paints, write about and teach the intricacies of the medium. Why not also wear it? This jacket, inspired by theater costume design, was created with acrylic skins. Each pattern piece, including the darts, were fused together with polymer medium."
>
> —Rhéni Tauchid

kitchen. It is a historical imperative that we not only stretch the physical possibilities of the medium but that we endeavor to more fully define it. Further, to actively participate in the development of acrylic application we are required to achieve a thorough understanding of its present properties. Without this essential foundation, our development will not be comprehensive. Essentially, when we are at one with the rules of how the paint works, we can play around with them. This is the age of acrylic—and this is our plastic playground.

Rhéni Tauchid, *Drama Queen*, 2008, acrylic skins, acrylic-covered metal buttons, florist's wire, plastic gems, and polyester lining, dimensions variable. (Please see page 5 for another view of this work.)

glossary

ABRASIVE: Tending to wear down a surface by the friction of rubbing against it.

ABSORBENT, ABSORBENT GROUND: Being capable of being taken in and made part of an existent whole. A material is absorbent when it can soak up liquids. An absorbent ground is a ground or coating on a surface able to absorb the liquid from paint applied to it.

ABSTRACTION: Imagery that departs from representation. Often used interchangeably with *nonobjective*.

ACETATE: The common name for a type of strong, transparent or semitransparent sheet of plastic, available in various thicknesses.

ACETONE: A volatile solvent used with lacquers and in paint removers. It is soluble in water and alcohol and can be used to clean up epoxy resins, polyester resins, and contact cement.

ACID-FREE: Having a neutral or slightly alkaline pH. Art materials require certification to be labeled "acid-free." Acids in non-archival framing materials, such as regular paper and cardboard, can cause paintings and prints to yellow and become brittle over time. Professional framers and conservators preserve the art from acid damage by using acid-free archival materials and proper framing techniques.

ACRYLIC PAINT: A plastic-based, water-soluble painting medium that dries and cleans up easily. A product derived from acrylic acid, acrylic paint consists of pigments suspended in an emulsion of acrylic resin and water. Acrylic paints are flexible, durable, and non-yellowing.

ADHERE: To stick securely.

ADHESIVES: Substances (such as glues, pastes, and cements) that cause adhesion or stickiness.

AIRBRUSH: A device that sprays paint with compressed air to offer a broad range of applications, from wide patches of paint to thin mists that enable precise details.

A LA PRIMA: A method of painting in which the picture is completed with the first application of paints to the entire area instead of being built up with layers.

AQUEOUS: Having a watery quality. Often used to designate pigmented media in which water is an ingredient in the vehicle, as in gouache, tempera, and watercolors. Such media are water soluble.

ARCHIVAL: Having long-term stability; suitable for archives. Archival art materials are specially engineered to resist the deteriorating effects of aging, such as fading and yellowing.

ARMATURE: A skeleton-like framework to give rigid internal support to a modeled sculpture. The medium is modeled directly onto the armature.

BATIK: A method of dyeing cloth that involves the use of removable wax to repel (resist) the dye on parts of the design where dye is not desired.

BINDER: The ingredient in the vehicle of a paint that adheres the pigment particles to one another and to the ground. It creates uniform consistency, solidity, and cohesion.

BIOCIDE: An additive that destroys biological contaminants.

BLOCK PRINTING: A printing method in which a block of wood, linoleum, or some other material is carved so that an image can be printed from it. The uncarved areas receive ink, which transfers to another surface when the block is pressed against it. Also known as relief printing.

BRAYER: A tool used to roll ink onto a surface by hand, usually in block printing and in monoprinting

BROKEN COLOR: The application of colors that creates an optical mixture rather than thoroughly blending the paints.

BURNISHER: A tool with a hard, smooth, rounded surface used for smoothing and polishing in metal work, ceramics, and gilding. Burnishers are typically metal or stone and are held in a wooden handle.

CP: An abbreviation that stands for chemically pure. This designation is sometimes applied to commercial pigments that are entirely free of extenders or any added inert pigments (e.g., CP cadmium red).

CALLIGRAPHY: The art of careful hand lettering, handwriting, or the decorative art of lettering in an ornamental style using brushes or pens; the lettering that is produced in this way.

CANVAS: A heavy, closely woven fabric, usually made of flax or cotton. The term is also used to refer to the support for oil and acrylic paintings made by stretching canvas fabric over a wooden frame. Commonly used as a support for oil or acrylic painting. Canvas board is an inexpensive, commercially prepared cotton canvas that has been primed and glued to cardboard.

CHROMA: Among colors other than those in the black-white scale, the specific combination of a color's hue, intensity, and saturation; or the degree of a color's vividness.

COLLAGE: (From the French *coller*, to glue) A work made by gluing materials such as paper scraps, printed text, and illustrations, photographs, cloth, string, and so forth onto a flat surface.

COLOR FIELD PAINTING: A movement that grew out of Abstract Expressionism in which large stained or painted areas or "fields of color" evoke aesthetic and emotional responses.

COLOR INDEX: An internationally recognized reference text used to identify colorants according to type (dye, pigment), hue, chemical composition, or process of manufacture (e.g., titanium white pigment is PW6).

COLOR WHEEL: A radial diagram of colors in which primary, secondary, and (sometimes) intermediate colors are displayed as an aid to color identification, choosing, and mixing.

COMPLEMENTARY COLORS: Colors that are directly opposite each other on the color wheel, such as red and green, blue and orange, and violet and yellow. When complements are mixed together they form the neutral colors of brown or gray.

COMPOSITION: The bringing together of parts or elements to form a whole; the structure, organization, or total form of a work of art.

COOL COLORS: Colors that fall in the blue to blue-green families. Colors are often described as having temperature—warm (purples, reds, oranges, and yellows), neutral (violets and greens), or cool (blue-greens and blues).

DÉCOUPAGE: The technique of decorating surfaces by adhering cutouts, most commonly of paper, and then coating with one or more coats of a transparent (or translucent) finish, usually a lacquer or varnish. Or, work produced by this technique.

DEFOAMER: A chemical added to water to prevent the development of foam or suds. A defoamer destroys foam after its formation.

DEIONIZED WATER: Ultra-pure water produced by removing all ions of dissolved minerals using reverse osmosis and ion-exchange systems; DI water should also be free from particles, bacteria, organics, and dissolved oxygen; purity of deionized water is determined based on its resistivity.

DISPERSION: A suspension that contains finely dispersed particles. Dispersions can be gas, liquid, or solid.

DISTILLED WATER: Water that has been purified by passing through an evaporation-condensation cycle. It contains small quantities of dissolved solids. Multiple distillations will further lower the percentage of dissolved solids.

DRY BRUSH: A technique that involves applying relatively dry inks or paint lightly over a surface, creating an area of broken color, the new color having attached to the high spots but not to the low, so that traces of the paper or undercolor remain exposed.

EMULSION: A suspension of small globules of one liquid in a second liquid with which the first will not mix.

ENCAUSTIC: A painting medium in which pigment is suspended in a binder of hot wax.

EXTENDER: Material used to increase the bulk of a medium; the act of adding such a material. Often used in less expensive (sometimes sold as "student-quality") paints. Sometimes called filler and filling.

EXTRUSION: The process of making shapes by forcing material such as clay or dough through dies.

FIGURATIVE: Representing the form of a human, animal, or thing; any expression of one thing in terms of another thing. Abstract artwork is the opposite of figurative art in certain ways.

FIXATIVE: A thin varnish, natural or synthetic, that is sprayed over charcoal, pastel, and other drawings to protect them from smearing, rubbing, or falling off the paper.

FLAMMABLE: Easily ignited by a flame, spark, high temperatures, and so forth.

FOAM CORE or FOAM BOARD: A stiff sheet of Styrofoam laminated with paper on both of its sides. It may be of any of several thicknesses. Although more expensive than cardboards, it is preferred over them for its lighter weight, stiffness, and the ease with which it can be cut.

FREEZE/THAW STABILIZER: An additive that allows a substance or solution to undergo one or more freeze/thaw cycles without becoming chemically altered.

FUGITIVE COLORS: Short-lived pigments and dyes that are capable of fading or changing, particularly with exposure to light, to atmospheric pollution, or when mixed with certain substances; in each case the result is a chemical change.

FUNGICIDE: A chemical compound capable of inhibiting or destroying the growth of fungi.

GESSO: A mixture of glue and either chalk or plaster of paris applied as a ground or coating to surfaces to give them the correct properties to receive paint. Gesso can also be built up or molded into relief designs or carved.

GLAZE: In painting, a thin transparent or translucent layer brushed over another layer of paint, allowing the first layer to show through but altering its color slightly.

GLITTER: Sparkle or small pieces of light-reflecting decorative material.

GLOSSY: Exhibiting a lustrous, shiny, or extra smooth surface.

GOLD LEAF: An extremely thin foil made of gold. Available in various colors, each with a different proportion of copper or other metal in the alloy. Something to which gold leaf has been applied may be described as gilt or gilded.

GOUACHE: An opaque, water-soluble paint.

GRAPHITE: A soft black mineral substance, a form of carbon, available in powder, stick, and other forms. It has a metallic luster and a greasy feel. Compressed with fine clay, it is used in lead pencils (though contemporary lead pencils contain no lead), lubricants, paints, and coatings, among other products. Also called black lead and plumbago.

GROUND: A surface to which paint is applied, or the material used to create that surface. Within a picture, ground may refer to a surrounding or background area.

GROUT: A paste made of cement or mortar used for filling and sealing gaps (cracks, crevices, and joints) especially between tiles.

GUM ARABIC: Hardened sap secreted by acacia trees, used as a binder for water-soluble pigments.

HATCHING and CROSS-HATCHING: A technique used to create tonal or shading effects with closely spaced parallel lines. When more such lines are placed at an angle across the first, it is called cross-hatching.

HUE: The name of any color as found in its pure state in the spectrum or rainbow, or that aspect of any color. May refer to a particular wavelength. Pigment colors combine differently than colors of light.

HUMECTANT: A substance that retains moisture content and that keeps products from drying out; any substance that is added to another substance to keep it moist.

HYDROPHOBIC: (Literally, "water fearing") Not being capable of mixing with water. Non-polar compounds are immiscible with water.

ILLUSTRATION BOARD: A bristol board made with a close weave. Illustration board is a strong, heavy paper or card appropriate as a support for pencil, pen, watercolor, collage, and so forth.

IMPASTO: In painting, thick paint applied to a surface in a heavy manner, having the appearance and consistency of buttery paste. A thick or lumpy application of paint, or deep brush marks (brush strokes), as distinguished from a flat, smooth paint surface.

INCIDENT LIGHT: Light that hits an object's surface, rather than light that is reflected or scattered from it. The wavelength of incident light is usually more varied than that reflected from a surface, determining the colors perceived in the object. It undergoes selective absorption of some wavelengths as it is reflected. The law of reflection is a principle that when light is reflected from a smooth surface, the angle of incidence—the angle at which the light hits a surface—is equal to the angle of reflection, and the incident ray, the reflected ray, and the normal to the surface all lie in the same plane.

INCISING: Cutting into a surface, typically in metal, stone, or pottery. Often used for lettering and decoration.

IRIDESCENCE: Displaying a lustrous, rainbow-like brightness. Having a surface such as seen on oil slicks, in the plumage of some birds, and on the wings of some butterflies. Opalescence includes iridescence but on a base of whiteness.

LIGHTFAST: Resistant to fading or other changes due to exposure to light.

LUMINOSITY: A quality seen in some paintings of a glow coming from within, the illusion that there is actually a light coming out of the picture. Glossy colors are more likely to provide this luminous effect than matte colors.

MARBLING: Mottling or streaking that resembles the veined texture of marble. To mottle or streak with colors and veins using painting techniques to simulate the appearance of marble.

MASSTONE: A large area of a substrate evenly covered with one color; the top tone or body color of a paint seen only by reflected light.

MATERIAL SAFETY DATA SHEET (MSDS): A sheet that contains the basic information intended to help you work safely with a hazardous material. Some such information is likely to be posted as a label on the product. It might also be posted on the manufacturer's Web site. An international organization whose members are hundreds of manufacturers of art materials, the Art and Creative Materials Institute (ACMI), authorizes the placement of its seals (AP and CL) on packaging, in order to inform consumers of the safety and hazards of those products. In the United States the Occupational Safety and Health Administration (OSHA) is the federal agency that specifies what information must be given on the label and MSDS for every material that OSHA has classified as hazardous.

MATTE: Having a dull, flat, nonreflective, sometimes roughly textured finish, perhaps of paint, metal, paper, or glass; the opposite of glossy.

MEDIUM: A particular material along with its accompanying technique; a specific type of artistic technique or means of expression determined by the use of particular materials. In paint, the fluid in which pigment is suspended, allowing it to spread and adhere to the surface.

MINERAL SPIRITS: A petroleum distillate used as a paint thinner substituting for turpentine that is less expensive, sticky, and odorous. Hazardous in several ways, it is quite flammable, necessitating special care in its use, storage, and disposal.

MISCIBLE: Capable of being mixed. A miscible liquid can be mixed in all proportions to another miscible liquid, and the two will be completely soluble in each other.

MIXED MEDIA: A technique involving the use of two or more artistic media, such as ink and pastel or painting and collage, that are combined in a single composition.

MONOCHROMATIC: Consisting of only a single color or hue; may include its tints and shades.

MOSAIC: A picture or design made of tiny pieces (called tesserae) of colored stone, glass, tile, or paper adhered to a surface.

MURAL: A large design or picture, most commonly created on the wall of a public building, sometimes using the fresco technique.

NEUTRAL: A color not associated with a hue. Neutral colors include browns, blacks, grays, and whites. A hue can be neutralized by adding some of its complement to it.

OIL PAINT: A paint in which the pigment is held together with a binder of oil, usually linseed oil.

OPALESCENCE: Exhibiting a milky iridescence like that of an opal.

OPEN TIME: The interval during which paint can be manipulated or blended.

OPAQUE: Impenetrable by light; neither transparent nor translucent.

OXIDE: Any element combined with oxygen (e.g., common rust is iron oxide).

PALETTE: A slab of wood, metal, marble, ceramic, plastic, glass, or paper that an artist can hold while painting and on which the artist mixes paint. The term *palette* may also refer to the range of colors used in a particular painting or by a particular artist.

PALETTE KNIFE: A knife with a spatulate flexible blade, used to apply or scrape off a plastic material.

PASTEL: Pigments mixed with gum and water and pressed into a dried stick form for use as crayons. Works of art done with such pigments are also called pastels.

PERMANENT PIGMENT and COLOR PERMA-NENCE: Any pigment that can be expected to last or remain without essential change; a pigment unlikely to deteriorate under certain atmospheric conditions, in normal light, or in proximity to other colors. Color permanence refers to a pigment's lasting power. Tubes and other containers of paint are sometimes labeled with a code indicating a color's degree of permanence

pH STABILIZER: An agent that stabilizes the pH of a solution.

PIGMENT: Finely powdered color material that produces the color of any medium. Made either from natural or synthetic substances, pigment becomes paint, ink, or dye when mixed with oil, water, or another fluid (also called vehicle).

POLYMER: A chemical compound made by grouping molecules to form natural or synthetic resins. Acrylic resins are polymers in a thermoplastic or thermosetting form used to produce paints and such lightweight plastics and synthetic rubbers as nylon.

PRIMARY COLORS: Those hues that cannot be produced by mixing other hues. Pigment primaries are red, yellow, and blue; light primaries are red, green, and blue. Theoretically, pigment primaries can be mixed together to form all the other hues in the spectrum.

PRIMER: An undercoating paint applied to a surface, sealing it, creating a better bond (adhesion), and providing a ground for a painting.

PRINT (ARTIST'S PRINT): A multiple-original impression made from a plate, stone, wood block, or screen by an artist or made under the artist's supervision. Prints are usually made in editions, with each print numbered and signed by the artist.

PROPYLENE GLYCOL: A colorless, odorless, viscous, hygroscopic (a substance that tends to absorb water from the air) liquid. It serves as a humectant (a substance that retains moisture content, keeps products from drying out, or is added to another substance to keep it moist).

QUALITY CONTROL: Techniques that ensure a high quality is maintained through various stages of a process.

RELIEF: Also called bas, alto, or sunken relief. A sculptural term referring to the projection of the surface above or below the ground or plane on which it is formed. With bas-relief, the overall depth of a projecting image is shallow. Alto-relief contains highly undercut images and is rendered almost in the round against the background. Whereas sunken-relief, also called intaglio, features a flat background with an image that is etched or carved into the surface.

RESIN: An organic substance of natural or synthetic origin characterized by being polymeric in nature.

RESIST: A substance that protects a surface from receiving paints, inks, or dyes. Waxes are commonly used as a resist to the dyes used in batik.

SATURATION: A color's purity of hue; its intensity. A pure hue has the highest saturation.

SCRUMBLING or SCUMBLING: A technique that involves brushing a thin layer of color over another so that patches of the color beneath show through.

SECONDARY COLORS: Those hues that can be produced (in slightly dulled form) by mixing two primaries. Pigment secondaries are orange, violet, and green.

SEMIGLOSS: Having a surface finish that is between glossy and matte.

SGRAFFITO: A method of decorating or designing a surface, as of paint, plaster, slip, or glaze, by scratching through a layer of one color to expose a different color underneath.

SHEEN: A glossy, lustrous surface, such as found on satin.

SILK-SCREEN: A stencil process of printmaking in which an image is imposed on a screen of silk or other fine mesh, with blank areas coated with an

impermeable substance, and ink is forced through the mesh onto the printing surface. Also called serigraphy and screen-printing.

SKETCH: A quick drawing that loosely captures the appearance or action of a place or situation. Sketches are often done in preparation for larger, more detailed works of art.

SOLUBLE: Capable of being dissolved.

SOLVENT: Capable of dissolving another substance; a substance in which another substance is dissolved, forming a solution.

STENCIL: Stiff material with a design cut into it as a template for shapes meant to be copied. Ink or paint forced through the designs openings will produce a print on a flat surface placed beneath.

STRETCHER: Wooden bars that constitute a frame over which the canvas of a painting is stretched. Although stretchers can be any shape, most are rectangular.

SUPPORT: A physical material that provides a surface upon which an artist applies color, collage, and so forth.

SURFACE: The outer or topmost boundary or layer of an object. The material qualities of a surface, as well as its form and texture, further determine how it is seen.

SURFACTANT: A substance that changes the nature of a surface, including water surface tension; any substance that lowers the surface tension of a liquid. Surfactants are used as detergents, emulsifiers, penetrants, and wetting agents.

SYNTHETIC: Being produced by synthesis; artificial; not of natural origin.

TEXTURE: The visual and tactile quality of a work of art effected through the particular way the materials are worked; the distribution of tones or shades of a single color.

THERMOPLASTIC: A plastic that softens when it is heated and hardens when cooled without changing its basic properties.

TENSILE STRENGTH: The stress at which material strain changes from elastic deformation to plastic deformation, causing it to deform permanently. Ultimate strength is the maximum stress a material can withstand. Breaking strength is the stress coordinate on the stress–strain curve at the point of rupture.

THICKENER: A substance added to a liquid to increase its viscosity.

TINT: A hue with white added.

TONE and TONALITY: A quality of a color, arising from its saturation (purity and impurity), intensity (brilliance and dimness), luminosity (brightness and dullness), and temperature (warm and cool); or to create such a quality in a color. Tonality can refer to the general effect in painting of light, color, and shade or to the relative range of these qualities in color schemes.

TOOTH: A random, small-grained, even texture that provides for the attachment of succeeding layers of paint or drawing material.

TRANSLUCENT: Transmitting light but causing sufficient diffusion to prevent perception of distinct images.

TRANSLUCENCY: Capable of transmitting diffused light. A view through a translucent material is blurry or distorted. Opacity is based either on absorption or on reflection of the light falling onto the material.

TRANSPARENT: Allowing light to pass through so that objects can be clearly seen on the other side; the opposite of opaque.

ULTRAVIOLET or UV LIGHT: The light whose wavelength (about 380 nanometers) is just long enough not to be X-rays, but just enough shorter than violet light so that it is not visible to the human eye. Also known by the short form of UV.

UNDERPAINTING: The layer or layers of color on a painting surface applied before the over painting, or final coat. Underpainting can mean an all-over tinting of a white ground or a blocked-out image in diluted paints that serves as a guide for the painter while developing the composition and color effects.

UNDERTONE: A pale or subdued color. The tinge of a diluted color. The color of paint seen when it has been spread into a transparent glaze film. It may appear quite different from the masstone.

VALUE: The degree of lightness or darkness of tones or colors. White is the lightest value; black is the darkest.

VARNISH: A protective transparent finish applied in a liquid state to a surface. Available with a matte, semigloss, or glossy finish.

VEHICLE: Liquid emulsion used as a carrier or spreading agent in paints.

VISCOSITY: The relative resistance of a liquid to stirring or movement, and its stickiness. The thicker a substance is, the greater is its viscosity; the thinner it is, the lesser is its viscosity.

VOLATILE: Evaporating readily at normal temperatures and pressures. A volatile substance is one that changes readily from solid or liquid to a vapor.

WARM COLORS: Colors that fall in the purple, red, orange, and yellow families. Colors are often described as having temperature—as warm (purples, reds, oranges, and yellows), neutral (violets and greens), or cool (blue-greens and blues).

WASH: A thin, transparent layer of paint or ink.

WATERCOLOR: Paint that uses water-soluble gum as the binder and water as the vehicle; characterized by transparency.

WATER-SOLUBLE: Capable of being dissolved in water; soluble in water.

This transparent leaf, which appears to float on the clear Mylar, was created with gloss gel and phthalo green.

appendix

Bibliography

Gottsegen, Mark David. *The Painter's Handbook: Revised and Expanded.* New York: Watson-Guptill Publications, 2006.

Learner, Thomas J. S. *Analysis of Modern Paints.* Los Angeles: Getty Publications, 2005.

Learner, Thomas J. S. *Modern Paints Uncovered.* Los Angeles: Getty Publications, 2008.

Rossol, Monona. *The Artist's Complete Health and Safety Guide*, 3rd edition. New York: Allworth Press, 2001.

Materials Resources

The following manufacturers have been instrumental in the development of this book and in my growth as an acrylic painter. They are also producers of fine acrylic materials and tools.

Tri-Art Manufacturing, Inc.
4 Harvey Street
Kingston, ON K7L 1B5
Canada
www.tri-art.ca
1-888-541-0299
Tri-Art manufactures premium- to student-quality acrylic paints and mediums designed to satisfy the most discerning artists. This fifteen-year-old company produces more than 5,800 distinct acrylic paint products distributed throughout Canada, the United States, Europe, and Asia.

Jack Richeson & Company, Inc.
557 Marcella Street
Kimberly, WI 54136
1-920-738-0744
1-800-233-2404
www.richesonart.com
Jack Richeson & Company is an importer and manufacturer of fine-art materials. Established in 1981, Jack Richeson & Company is the manufacturer of Best easels, Shiva oils and caseins, Shiva Paintstiks, Richeson pads, Unison pastel surface, and a new line of palette knives that meet the needs of artists who paint large. It also serves as the importer for Unison pastels and Quiller watercolors and acrylics and is the U.S. distributor for Tri-Art acrylics.

Armadillo Art & Craft
P.O. Box A
Belle Mead, NJ 08502
1-908-874-3315
www.armadilloart.com

Armadillo Art & Craft has been importing and distributing a wide variety of high-quality and unique fine art materials since 1996. One notable product is their line of Colour Shapers. These silicone rubber-tipped tools are available in five different tip shapes (taper, round cup, cup, flat, and angle), three degrees of firmness (soft, firm, and extra firm), and five sizes (from 0 to 16). They are designed to move, remove, and spread color and can be used with any medium, including acrylic, oil, watercolor, ceramic glazes, and adhesives.

Artist Information

To illustrate the sheer vastness of the scope of acrylic expression, I was fortunate to have the honor of incorporating the work of a group of exemplary painters' works in this book. Through the variety of styles, breadth of their individual skill, and broad range of their themes, these painters show very clearly that acrylics are capable being applied using a staggering quantity of techniques. Indeed, they span the gamut of creative possibility.

Alex Colville	www.canadianencyclopedia.ca/index.cfm?PgNm=TCE&Params=A1ARTA0001782
Brandi Deziel	www.brandideziel.com
Cameron Tomsett	www.tomsett.com
Celine Cimon	www.celinecimon.com
Drew Harris	www.drewharris.com
Gregory Beylerian	www.gregandjude.com
Hester Simpson	www.hestersimpson.com
Jennifer Chin	www.jenniferchin.ca
Jeremy Down	www.jeremydown.com
Jody Hewgill	www.jodyhewgill.com
Laura Bell	www.laurabellstudio.com
Lori Richards	www.loririchards.ca
Marc Courtemanche	http://uregina.ca/cgi-bin/cgiwrap/courtemm/bio.cgi
Marie Lannoo	www.marielannoo.com
Marion Fischer	www.dalesmithgallery.com/artists/artist.php?artistId=24&page=0
Matthew Haffner	www.matthaffner.com
Nick Bantock	www.nickbantock.com
Olan	www.lipstickchic.com
Rhéni Tauchid	www.tri-art.ca/en/acryliced/instructors/rheni_tauchid
Robert Bateman	www.robertbateman.ca
Sharlena Wood	www.sharlenawood.com

index